SUSIE HODGE

ART

EVERYTHING
YOU NEED TO
KNOW ABOUT
THE GREATEST
ARTISTS AND

Contents

INTRODUCTION 6

Gothic to Early Renaissance

*c.*1300–1500

8

CIMABUE • DUCCIO • GIOTTO • DONATELLO
FRA ANGELICO • VAN EYCK • UCCELLO
VAN DER WEYDEN • MASACCIO
DELLA FRANCESCA • BELLINI • MANTEGNA
BOTTICELLI • GHIRLANDAIO • BOSCH

High Renaissance to Mannerism

*c.*1500–1600

36

LEONARDO DA VINCI • DÜRER
MICHELANGELO • RAPHAEL • TITIAN
HOLBEIN • BRONZINO • TINTORETTO
BRUEGEL • VERONESE

Baroque

*c.*1600–1700

58

EL GRECO • CARAVAGGIO • RUBENS
GENTILESCHI • POUSSIN • VELÁZQUEZ
VAN DYCK • CLAUDE

Dutch Realism

*c.*1600–1700

76

REMBRANDT • STEENWYCK • DE HOOCH
VERMEER

Rococo to Neoclassicism
*c.*1700–1800

86

WATTEAU • CANALETTO • HOGARTH • CHARDIN
BOUCHER • REYNOLDS • GAINSBOROUGH
FRAGONARD • GOYA • DAVID

Romanticism to Realism
*c.*1800–1900

106

BLAKE • HOKUSAI • FRIEDRICH • TURNER
CONSTABLE • INGRES • GÉRICAULT • COROT
HIROSHIGE • DELACROIX • MILLET • COURBET
MOREAU • ROSSETTI

Impressionism to Post-impressionism
*c.*1865–1910

138

MILLAIS • PISSARRO • MANET • DEGAS
WHISTLER • HOMER • CÉZANNE • MONET
RODIN • RENOIR • CASSATT • GAUGUIN
VAN GOGH • SEURAT • TOULOUSE-LAUTREC

Modernism to Pop
*c.*1900–1970s

168

KLIMT • MUNCH • KANDINSKY • MATISSE
MONDRIAN • BRANCUSI • MALEVICH • KLEE
PICASSO • BRAQUE • MODIGLIANI • BECKMANN
RIVERA • DUCHAMP • O'KEEFFE • MIRÓ
MAGRITTE • GIACOMETTI • ROTHKO • DALÍ
KAHLO • POLLOCK • LICHTENSTEIN • WARHOL

GALLERIES 218 GLOSSARY 220 INDEX & CREDITS 222

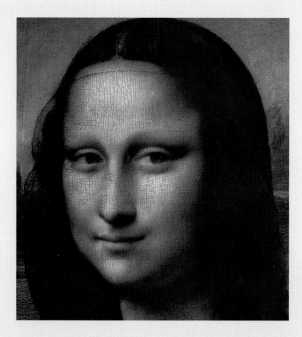

Introduction

Defining a "great" artist as opposed to a merely good one is always going to be subjective. But it is not just a matter of personal taste. Nor is it fashion—many artists have basked in the glory of their esteemed reputations during their lives, only to fade into obscurity after their deaths, and some artists are forgotten and rediscovered in later centuries. Which prompts the question: do all great artists withstand the test of time? There are no real rules. So, to select 100 great artists for this book, there needed to be some sort of criteria. However, artists before the Renaissance era were rarely named individually. In later centuries, different societies and technologies changed the purpose of art, which made the selection process even more complex. In the end, the 100 great artists— including painters, sculptors, and printmakers from the 13th century to the 1960s—were chosen because they changed art, and their work had implications on subsequent artistic developments. Although many worthy artists have been omitted, those included are among the most exciting, outstanding, and enduring.

We can only imagine the shock or revelation that some art provoked as conventions of the day were confronted. Art changed drastically when artists no longer had to rely on the patronage of the state or the Church. In addition, events in history, such as wars and scientific discoveries, have also had a major impact on artistic expression.

Although artistic influences and production should not be compartmentalized, in order to understand the evolution and reasons behind these developments and to explain connections in style or approach, the artists have been grouped chronologically into movements or eras.

Once an artistic tradition has been established, it takes imagination, skill, and courage to diversify from accepted customs. Most of the artists in this book have done that, standing out among their contemporaries, either at the time or in hindsight, revealing their insights and creative genius. The role of the artist as "genius" developed during the 14th century, with a status far beyond that of the skilled artisan or craftsman. The essential qualifications of "genius" were individuality and an art that released creative energy and allowed the artist freedom to challenge historical precedents. Although it is no longer relevant to evaluate great art in terms of skill in lifelike representation, great art has always been more concerned with perception or vision than accuracy of depiction.

Every artist featured in this book broke new ground in some way, influencing, inspiring, and setting new standards. Even though the art they produced is extremely diverse, the great artists all explore similar, universal themes—concern about the nature of human existence, the problem of mortality, and the social and moral issues inherent in our culture.

Progressive art can assist people to learn not only about the objective forces at work in the society in which they live, but also about the intensely social character of their interior lives. Ultimately, it can propel people toward social emancipation.

SALVADOR DALÍ

7

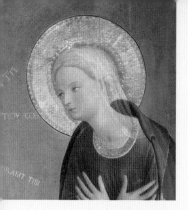

Gothic to Early Renaissance

c.1300–1500

During the Medieval period (5th to 16th centuries), the greatest influence on European art was religion. The Church commissioned the majority of art and it was usually produced by monks. The illuminated manuscripts, simple wall paintings, and carvings they produced were characterized by the flat, decorative style of the Byzantine Empire.

Drawing on tradition

From 1150 to about 1500, what became known later as Gothic Art flourished in Europe. The word was originally a term of abuse—it described the elaborate architectural styles, ornate altarpieces, embellished paintings, sculpture, stained glass, illuminated manuscripts, and tapestries that focused on Christian beliefs and were based on the decorative Byzantine style. During that time, even religious art began to be produced by lay artists, who learned to follow the accepted conventions of the Byzantine style. Realism was not valued and specific aspects of Christianity were traditionally portrayed. Gradually, however, shifts in theological beliefs and a more human-focused,

analytical and intellectual approach to life emerged. As attention moved from the heavens and saints to what was happening on Earth, art began to transform.

The rebirth

Artists worked in the guild system, whereby young artists trained as apprentices in the workshops of masters, learning all the necessary skills and practices. Once fully trained, they became masters with workshops of their own. For years, these rules were rigid, but as theological and humanist ideas spread, some artists moved away from the decorative, flat style of the Byzantine tradition, instead reflecting on the more realistic styles of art from ancient Greece and

1304–06
Lamentation (The Mourning of Christ), *Giotto* (1267–1337)

c.1395
Creation of the Wilton Diptych

1408
David, *Donatello* (c.1386–1466)

1420–36
Dome for the Santa Maria del Fiore, Florence, *Filippo Brunelleschi* (c.1377–1446)

1250

1400

c.1285–86
Maestà, *Cimabue* (c.1240–1302)

c.1308–11
Maestà with Twenty Angels and Nineteen Saints, *Duccio* (c.1215–1319)

1420–30
Portrait of a Lady, *Robert Campin* (c.1375–1444)

1426–28
Trinity with the Virgin, Saint John the Evangelist and Donors, *Masaccio* (1401–28)

Rome. For the first time since the classical world, there was a rebirth of interest, not just in art, but also in science, architecture, literature, music, and invention. The new ideas slowly spread from Italy to the rest of Europe and centuries later, it became known as the Renaissance or "rebirth." In art, classical artistic principles including harmonious proportion, natural postures, and expressions were followed. The main beliefs of the Renaissance were that through studying the learnings and discoveries of the ancient Greeks and Romans, artistic greatness, wisdom, and enlightenment would be attained. Figures became more lifelike, depth and volume was depicted, and Christianity was portrayed from a more human viewpoint. Emphasis was put on feelings, including vulnerability and suffering, in stories such as the Assumption of Mary, the Virgin and Child, Pietà, and Christ being deposed from the Cross. Whereas earlier artists simply copied from previous works, artists of the Renaissance used real people as models. Three of the most significant artists of the period were Cimabue, Duccio, and Giotto, who had been trained in the Byzantine tradition but became intent on representing three dimensions in order to illustrate convincing space and structure. Gradually other artists, such as Donatello, Masaccio, and Mantegna, produced art that gives even more of an illusion of reality. The new ideas spread across Italy in several different centers of art, initially in Florence and then in Siena, Rome, Venice, Milan, Urbino, and across the rest of Europe. In northern Europe, where the influence of Celtic rather than Byzantine art had dominated, the Renaissance arrived later. There, cultural centers had developed around trade, and merchants filled their homes with paintings to display their prosperity. Artists from the Low Countries and Germany, such as van Eyck, van der Weyden, and Grünewald, produced meticulous portraits and religious scenes in oil paints, incorporating new ideals of realism, combined with subtle and detailed religious references and symbols.

History and mythology

Most Renaissance art was still commissioned by the Church, with the greatest artists decorating churches and chapels for Popes and the aristocracy. Other patrons requested portraits, landscapes, scenes of Roman history, and mythology. In this way, artists had the excuse to depict nudes, to show dynamism, detail, and opulence and to represent nature accurately to surprise and impress viewers. As these Renaissance artists achieved recognition and rose above the status of craftsmen and artisans, they began to compete with each other, which spurred them on to even greater results.

1433–34
Annunciation,
Fra Angelico
(*c.*1387–1455)

c.1438–40
The Battle of San Romano,
Uccello (c.1397–1475)

1450s
The Baptism of
Christ, *Piero
della Francesca*
(*c.*1415–92)

1490s
The Virgin and
Child, *Bellini*
(*c.*1430–1516)

1491
The visitation,
Ghirlandaio
(1449–94)

1450

1550

1434
The Arnolfini
Portrait; *van Eyck*
(*c.*1390–1441)

1435
Descent from
the Cross,
van der Weyden
(1399–1464)

1445
First book printed in
Europe, *Gutenburg*
(*c.*1398–1468)

c.1485
The Birth of
Venus,
Botticelli
(1445–1510)

c.1490–1500
Sacra Conversazione
(Madonna and Child
with Saints)
Mantegna
(1430–1506)

c.1510
The Garden of
Earthly Delights,
Bosch
(*c.*1450–1516)

Cimabue

c.1240–1302 • GOTHIC, BYZANTINE STYLE

Very little is known about the life and works of Cenni di Pepo—nicknamed "Cimabue," meaning "bull-headed"—but he was one of the first Italian artists to begin to discard the formalism of Byzantine art.

It is difficult to appreciate today, when so many changes occur in art, how revolutionary minor adjustments were in the 13th century. An early account of Cimabue's career suggests that his modifications made him the leading Italian painter of his generation, although its accuracy is uncertain as it was written more than 200 years after his death. His workshop in Florence was acknowledged as the finest, and he also worked in Tuscany, Assisi, and Rome, where new religious and political reforms interested him.

Cimabue was one of the first painters to begin the change from the conventions of Byzantine art, but many of the works attributed to him are unsigned, damaged, or now credited to Duccio. Only a mosaic of St. John in Pisa Cathedral has been confirmed as his, but many of the works attributed to him show his impact on the development of art in this period. Although he largely adhered to Byzantine tradition, Cimabue also incorporated traces of emotion and perspective into his paintings, and rather than depict everything as flat, began to introduce a more lifelike treatment to the traditional subjects.

For centuries, it was assumed that Cimabue was Giotto's master, but that has now been thrown into doubt and some suggest that they were simply rivals. The confusion may have arisen because of a reference to the artists by Dante in his great narrative poem, *The Divine Comedy*: "Of painters, Cimabue deemed his name unrivaled once; now Giotto is in fashion and has eclipsed his predecessor's fame." Whatever the truth, Cimabue's move toward greater naturalism clearly inspired Giotto.

> ### KEY WORKS
>
> **Madonna and Child Enthroned with Eight Angels and Four Prophets (Maestà)** 1280, GALLERIA DEGLI UFFIZI, FLORENCE, ITALY
> **Crucifix** 1287–8, BASILICA DI SANTA CROCE, FLORENCE, ITALY
> **Madonna and Child Enthroned with Two Angels** c.1300, SANTA MARIA DEI SERVI, BOLOGNA, ITALY
> **St. John the Baptist** 1301, OPERA DEL DUOMO, PISA, ITALY

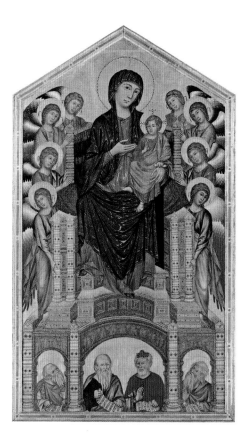

Madonna in Majesty (Maestà)

1285–6 TEMPERA ON PANEL

151½ x 88 IN (385 x 223 CM)

GALLERIA DEGLI UFFIZI, FLORENCE, ITALY

Originally on the high altar of the church of Santa Trinità in Florence, this panel still retains Byzantine traditions. Gothic painters reduced figures, faces, and objects to repeated flat shapes, but Cimabue has also subtly individualized the facial features and used tone to show drapery and solidity.

Duccio

*c.*1215–1319 • GOTHIC, BYZANTINE STYLE, SIENESE SCHOOL

Probably the greatest painter of Medieval Siena, Duccio di Buoninsegna combined formal Byzantine traditions with realistic elements, which made his art more accessible than that of his predecessors.

With no surviving contemporary accounts or personally written documents, not a great deal is known about Duccio's life. Through civic records however, we know that he lived in Siena, which at the time was the capital of one of Italy's northern states and Florence's major rival. Duccio is first recorded in 1278 and 1279 as working for the commune—a Medieval form of government in northern Italy. In 1285 he was commissioned to paint a large panel for the Florentine church of Santa Maria Novella for the wealthy Rucellai family, which became known as the *Rucellai Madonna*.

As the principal aim of art was to express strong religious beliefs in a highly decorative and spiritual way, Duccio followed the Byzantine tradition, as all Italian artists did. Figures were intentionally two-dimensional and little attempt was made to represent them or their surroundings realistically. Yet Duccio also introduced something different. At about the same time as Cimabue in Florence, Duccio's work also began to express the idea of living, three-dimensional figures. Although he continued to paint stylized figures against golden backgrounds, he also subtly introduced an impression of movement. Color too, was important to him and he created harmonious arrangements, rather than simply using separate colors to define discrete figures. The differences between Duccio's work and that of his predecessors were astounding at the time, and his work was enthusiastically received because it conveyed warmth and religious feeling in a far more accessible way than the flat, decorative art that everyone was used to.

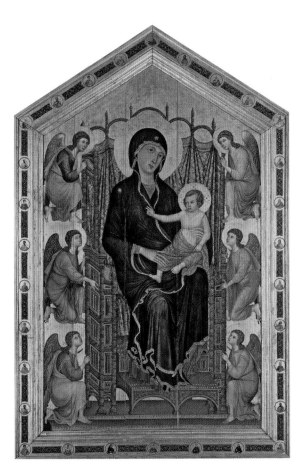

Rucellai Madonna

1285 TEMPERA ON WOOD

177 X 114 IN (450 X 290 CM)

GALLERIA DEGLI UFFIZI, FLORENCE, ITALY

In 1285 Duccio was commissioned to paint a large altarpiece now known as the *Rucellai Madonna* in the church of Santa Maria Novella in Florence. Retaining Byzantine traditions of painting the images as decorative symbols, Duccio has also imparted a poetic delicacy and naturalism to the figures.

Giotto

1267–1337 • EARLY RENAISSANCE

It is not certain whether Giotto was Cimabue's pupil, but his talents as an outstanding painter, sculptor, and architect were recognized during his lifetime. By moving away entirely from the stylized formality of artistic tradition, and giving his figures greater movement and credibility, his work had a profound influence on European art.

Giotto lived and worked in Florence during a period when religious subjects and styles had been laid down by centuries of tradition. As the first artist to depict human emotion, his influence set Western art on a path to the Renaissance. By making his images more natural, he gave moral weight to religious stories, rather than the usual displays of heavenly splendor. Other artists at this time copied their compositions and figures from earlier paintings, but Giotto moved away from the static, two-dimensional images of Byzantine and Gothic art.

Born into a farming family near Florence, most of Giotto's life was spent in Florence, but he also worked in Padua, Naples, Avignon, Bologna, Assisi, and Rome. He mainly used the fresco technique, a method of wall painting in which water-based pigment was applied directly onto wet lime plaster. The paint and plaster then fused together as they dried and became part of the fabric of the building. Giotto's frescoes became so well-known that he had to use several assistants to complete all his commissions. His patrons included rich merchants and bankers as well as the Pope, the king of Naples, and the Franciscan monks in Assisi.

One of Giotto's innovations was the placing of characters in natural-looking locations that depicted the real world; he also replaced traditional gold backgrounds with blue skies. Another revolution was the introduction of secular life into religious themes. He also emphasized physical characteristics in his figures, portraying the shape and weight of bodies under heavy clothing using light and shadow. Although, like other contemporary artists, he lacked specific knowledge of anatomy and perspective, his figures looked substantial and worldly, rather than decorative and symbolic. More than those of any other artist of his time, Giotto's figures seemed alive, physically and emotionally, and because his methods told biblical stories in this new, humanist way, his works became a source of education, enlightenment, and entertainment.

Giotto's earliest known works were commissioned by Enrico Scrovegni, a member of a wealthy banking family in Padua. He decorated the Capella degli Scrovegni (Scrovegni Chapel) with brightly colored, expressive scenes from the lives of the parents of the Virgin Mary, Joachim, and Anna, Mary herself and Jesus. The compositions were vividly colorful, simple, and dramatic, and through them the chapel displayed a powerful narrative of the lives of Christ's family. The stories were clear, human, and easy to understand, even by the illiterate congregation who prayed in the chapel each week. These frescoes, with their empathy and imagination, made Giotto the most famous and sought-after artist in Italy.

KEY WORKS

The Vision of the Chariot of Fire 1295–1300, ST. FRANCIS, UPPER CHURCH, ASSISI, ITALY

Madonna and Child with St. Nicholas, St. John the Evangelist, St. Peter, and St. Benedict (Badia Polyptych) c.1300, GALLERIA DEGLI UFFIZI, FLORENCE, ITALY

Joachim Taking Refuge among the Shepherds 1304–6, CAPELLA DEGLI SCROVEGNI, PADUA, ITALY

Madonna and Child Enthroned with Saints (Ognissanti Madonna) c.1305–10, GALLERIA DEGLI UFFIZI, FLORENCE, ITALY

Stigmatization 1319–28, BARDI CHAPEL, CHURCH OF SANTA CROCE, FLORENCE, ITALY

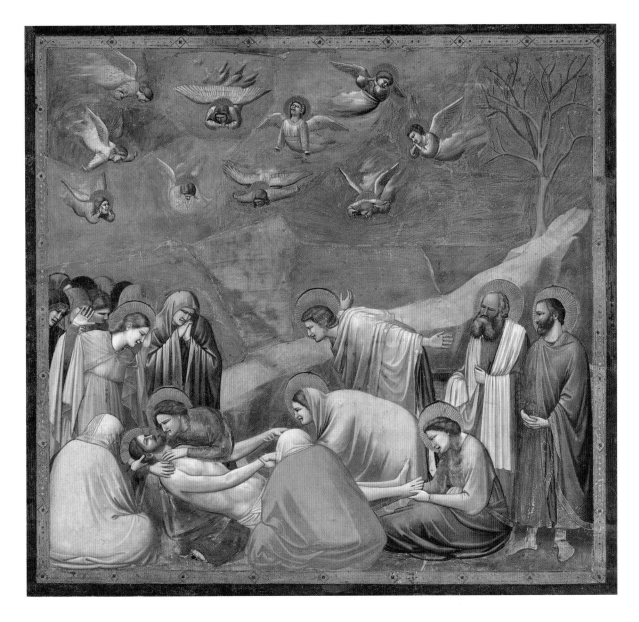

The Lamentation

1304–6 FRESCO

78¾ X 73 IN (200 X 185 CM)

CAPELLA SCROVEGNI (ARENA CHAPEL), PADUA, ITALY

In contrast with the flat, expressionless paintings of Byzantine art, Giotto created a more realistic style that made the biblical events seem more real to viewers. The diagonal rock focuses attention on the group of mourners. Christ's body has been taken from the Cross and disciples cluster around in grief. Mary cradles her son on her lap; Mary Magdalene holds his feet; John the Baptist throws out his arms in anguish and mourners weep on the ground, while angels weep in the sky. In front of Christ's body are two cloaked figures, their backs toward us—this draws viewers into the picture.

Donatello

*c.*1386–1466 • EARLY RENAISSANCE

The son of a Florentine wool comber, Donato di Niccolò di Betto Bardi established a new, humanistic style of sculpture that moved away from accepted Gothic representations of the human form.

The first sculptor since classical times to develop a broad knowledge of ancient Greek and Roman sculpture, Donatello combined classical lines with realism. Born in Florence, he received his early artistic training with a goldsmith and then worked briefly in the studio of Lorenzo Ghiberti, where he assisted with the creation of the bronze doors of Florence's Baptistry. From 1404, he spent three years in Rome with the architect and sculptor Filippo Brunelleschi, excavating and studying ancient Roman artefacts.

Donatello was inspired by the naturalism he saw in these great works of antiquity—and by the humanist movement that had started in Florence—and began creating statues that appeared to have a life of their own and individual personalities. This was a radical departure from the decorative Gothic style that he had been trained in.

He became accomplished in working with marble, bronze, wood, terracotta, and stucco and developed his own style of basso relievo, or low relief, which became known as schiacciato ("flattened out"). This technique involved extremely shallow carving to create dramatic images that reflected light and shadow. No one had created such images before and the naturalism and range of emotions Donatello portrayed in his work had a huge impact on both his contemporaries and the generations of artists that followed. Diverse, diligent, resourceful,

and original, he was more interested in depicting emotions than in the finish of his sculptures and reliefs. A prolific worker, he soon became so famous and in such demand that he had to turn down many commissions across northern Italy.

David

1408 BRONZE
HEIGHT 62 IN
(157.5 CM)
BARGELLO,
FLORENCE, ITALY

This was the first life-sized nude statue since classical times and provides a link between ancient and modern. In the Bible story, David, who is destined to become the second king of Israel, kills the giant Goliath. Donatello's statue symbolized the conflict between Milan (Goliath) and Florence (David).

KEY WORKS

St. John 1408–15, MUSEO DELL'OPERA DEL DUOMO, FLORENCE, ITALY
Statue of Habacuc (also known as Zuccone) 1411–13, MUSEO DELL'OPERA DEL DUOMO, FLORENCE, ITALY
Feast of Herod *c.*1425, BAPTISTRY, SIENA, ITALY
Equestrian monument of Gattamelata 1444–53, PIAZZA DEL SANTO, PADUA, ITALY
The Penitent Magdalene *c.*1453–5, MUSEO DELL'OPERA DEL DUOMO, FLORENCE, ITALY

Fra Angelico

*c.*1387–1455 • RENAISSANCE

This Dominican friar began as a manuscript illuminator. Later he became known as the "Blessed Angelico," as both his gentle personality and his art were held in the highest esteem.

Born in the countryside northeast of Florence, Guido di Pietro joined the Dominican monastic order with his brother Benedetto. Taking the name Fra Giovanni, he became the preeminent painter of altarpieces and other religious works in Tuscany for nearly 30 years. Because of his quiet piety and his delicate paintings, he was nicknamed "pictor angelicus" or "Angelic Painter," which after his death was translated into Fra Angelico.

At first, he and his brother decorated manuscripts, but they soon moved onto paint frescoes on the monastery walls. Most of the frescoes were in the friars' cells and designed to encourage meditation, so they were delicately colored, economical in line, and serenely composed. As he was not part of a closed order, Fra Angelico could meet and talk to others and he was soon promoted to managing a busy workshop. He became prominent among a new generation of Florentine artists, including Fra Filippo Lippi (1406–69) and Andrea del Castagno (*c.*1418–57).

In 1436, Fra Angelico's order took over the convent of San Marco in Florence and he was commissioned to decorate the friars' cells there. With the help of his brother and other assistants, he painted approximately 50 frescoes on the walls of the cloister, the cells, the common rooms, and the corridors. Rather than factually document biblical stories, the paintings encouraged a feeling of spirituality that was intended to stimulate prayer. In later life, Fra Angelico traveled widely for prestigious commissions—he worked in Orvieto, Perugia, and Rome, where he decorated the private chapel of Pope Nicholas V in the Vatican.

KEY WORKS

Eighteen Blessed of the Dominican Order *c.*1420–4, NATIONAL GALLERY, LONDON, UK

The Nativity *c.*1429–30, PINACOTECA CIVICA, FORLÌ, ITALY

Annunciation *c.*1432–4, MUSEO DIOCESANO, CORTONA, ITALY

The Virgin of Humility *c.*1436–8, RIJKSMUSEUM, AMSTERDAM, NETHERLANDS

The Adoration of the Magi *c.*1435–40, NATIONAL GALLERY, LONDON, UK

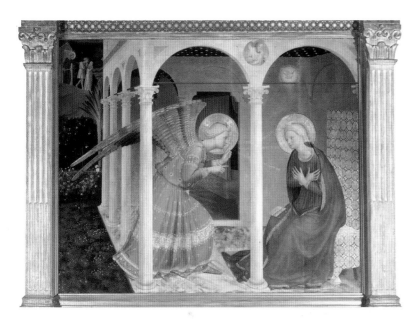

The Annunciation

1433–4 TEMPERA ON WOOD

68 X 70 IN (175 X 180 CM)

MUSEO DIOCESANO, CORTONA, ITALY

Created for the main altar of the church of San Domenico in Cortona, this was designed to promote contemplation and the new humanist ideas that were developing in northern Italy. Drawn with careful precision, it shows an understanding of depth and space.

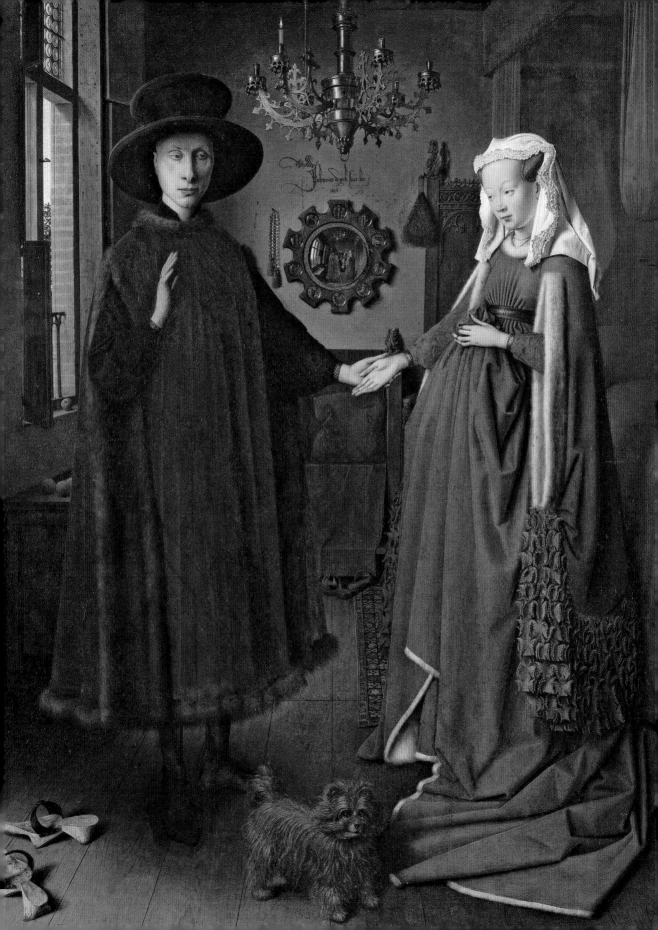

van Eyck

*c.*1390–1441 • NORTHERN RENAISSANCE

During the 14th century, the Belgian city of Bruges became one of the chief artistic centers of Europe, full of wealthy merchants who commissioned paintings to celebrate their achievements. Like Fra Angelico in Italy, it is likely that Jan van Eyck trained as a manuscript illuminator, but soon came to prominence as a painter.

Jan van Eyck was probably born near Maastricht in the Netherlands. He was one of the first Flemish artists to sign his work and his rich and detailed images reflect the prosperity of the cities of northern Europe, such as Ghent and Bruges. First documented as working in The Hague for the Count of Holland in about 1422, he was next at Bruges and Lille as court painter to Philip the Good, Duke of Burgundy in 1425. Three years later, he received a prestigious commission to paint Philip's future wife, Isabella of Portugal. After his return from Portugal, he bought a house in Bruges and remained in Philip's employment for the rest of his life.

For a long time, van Eyck was credited with the invention of oil paints and although this has now been refuted, he certainly perfected and exploited a medium of pigment, oil, and varnish that has allowed his rich colors to survive almost unchanged in nearly 600 years. Oil paints enabled him to combine a keen attention to detail and close observation of nature with complex symbolism. In the scale, breadth of vision, realism, and techniques of his work, he helped to establish a new style of painting that shaped northern European art for centuries and also made a great

impact on Italian Renaissance art. Admired for his accuracy, clarity of color, and sharpness of observation, he was commissioned to paint for private clients as well as his work at court.

As with many of the artists who attained fame during this period, there are uncertainties about some of van Eyck's work. In 1432, he completed the great altarpiece in Ghent Cathedral, the *Adoration of the Lamb* (also called the *Ghent Altarpiece*). An inscription on the frame states that the painting was started by "the painter Hubert van Eyck, than whom none was greater" and completed by "Jan, second in art." It is believed that Hubert was Jan's elder brother and that he died during the production of the *Ghent Altarpiece*. The question is: how much did Hubert do? There are no obvious differences in style.

Van Eyck's style was fresh and new in its detailed and faithful observation of nature. Aided by the smoothness and slow-drying qualities of oil paints, he was particularly skilled at rendering textiles and in depicting light and space. Considering that the representation of linear perspective was relatively new in Italy at this time, van Eyck was remarkably accomplished at it.

The Arnolfini Portrait

1434 OIL ON WOOD

32¼ x 23½ IN (81.8 x 59.7 CM)

NATIONAL GALLERY, LONDON, UK

Although not a wedding portrait as was once thought, this portrait of Giovanni and Giovanna Arnolfini in a richly furnished room is replete with symbolism. Fidelity, fertility, and work-related success are all suggested. A mirror ornamented with scenes from the Passion of Christ reflects two figures. Above it an inscription reads "Jan van Eyck was here 1434."

KEY WORKS

The Crucifixion 1425–30, METROPOLITAN MUSEUM OF ART, NEW YORK, US

The Ghent Altarpiece 1432, ST. BAVON, GHENT, BELGIUM

Portrait of a Man (Self-portrait?) 1433, NATIONAL GALLERY, LONDON, UK

The Madonna of Canon van der Paele 1436, MUSÉE COMMUNAL DES BEAUX-ARTS, BRUGES, BELGIUM

Virgin and Child with Saints and Donor 1441, THE FRICK COLLECTION, NEW YORK, US

Uccello

1397–1475 • RENAISSANCE

The paintings of Paolo Uccello were unique, not just for their pioneering use of linear perspective, but also for their storytelling qualities and overall design. An extremely versatile painter, Uccello mixed Gothic traditions with Renaissance investigations, but lost popularity toward the end of his life and was only rediscovered in the 20th century.

At the age of ten, Florentine Paolo di Dono—who became known by his nickname of Uccello ("the bird")—was apprenticed to the sculptor and goldsmith Lorenzo Ghiberti. In 1414, Uccello entered the painters' guild, Compagnia di San Luca, and a year later he joined another painters' guild, Arte dei Medici e degli Speziali. He worked on a variety of media: wood panels, canvas, and even mosaic for a while and also designed stained glass and frescoes for Florence's Duomo.

During the 1430s, influenced by his contemporary Masaccio, Uccello became engrossed with developing linear perspective in painting. His compositions became intricate mathematical designs, focusing on vanishing points and converging lines. He also became influenced by Donatello's lifelike gestures and tried to incorporate similar expression into his work. He chose colors not for their naturalism, but to create patterns, and he built up networks of shapes and lines across his paintings. Although he used perspective to try to create a feeling of depth and to portray the illusion of another world, his paintings are detailed, decorative, and complex.

Uccello's best-known work is a series of three paintings depicting the Battle of San Romano, which took place in 1432. In each of these, he took care to represent an assortment of armor littering the ground, all converging at a vanishing point. No foreshortened figure had ever been painted, so a fallen warrior within the battle must have caused quite a reaction, even though it is inaccurately small and out of proportion. Even the broken lances lying on the ground were arranged to point toward a common vanishing point.

Uccello's mathematical arrangements created strange and unnatural appearances, but realism was not his aim. He retained the ornate costumes and accessories of the Gothic style and embellished all his paintings with intricate details. His concern was not as much with light, as with spatial problems. Although his experiments with perspective did not quite work, his illusions of depth on two-dimensional surfaces influenced many younger artists. His work, however did not have lasting popularity. and commissions dwindled as tastes changed and people looked for sophistication and elegance in art.

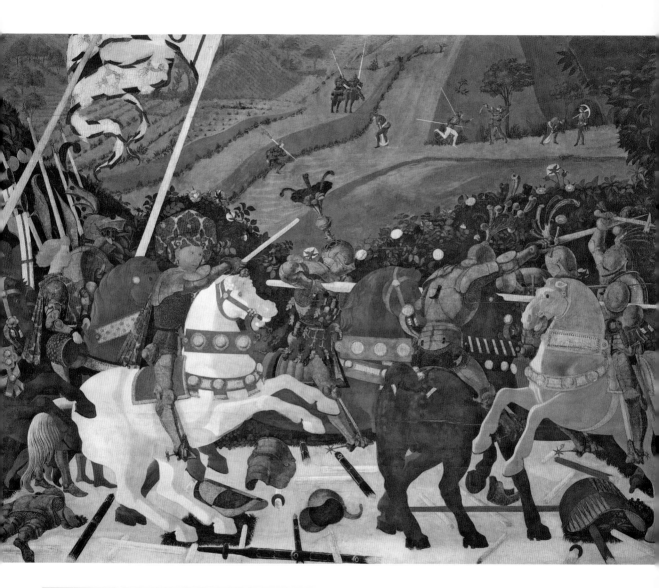

KEY WORKS

Funerary Monument to Sir John Hawkwood 1436,
 DUOMO, FLORENCE, ITALY
The Deluge 1939–40, SANTA MARIA NOVELLA, CHIOSTRO
 VERDE, FLORENCE, ITALY
The Hunt in the Forest 1460s, ASHMOLEAN MUSEUM,
 OXFORD, UK
St. George and the Dragon c.1470, NATIONAL GALLERY,
 LONDON, UK

The Battle of San Romano

c.1438–40 EGG TEMPERA WITH WALNUT OIL

AND LINSEED OIL ON POPLAR

71 X 126 IN (182 X 320 CM)

NATIONAL GALLERY, LONDON, UK

Depicting part of the Battle of San Romano fought between Florence
and Siena in 1432, this painting shows the leader of the triumphant
Florentine army, Niccolò da Mauruzi da Tolentino, on a white horse in a
flamboyant turban. The network of broken lances in curiously disciplined
rows, angled lances held by soldiers, and tiny distant figures show
Uccello's preoccupation with linear perspective and foreshortening.

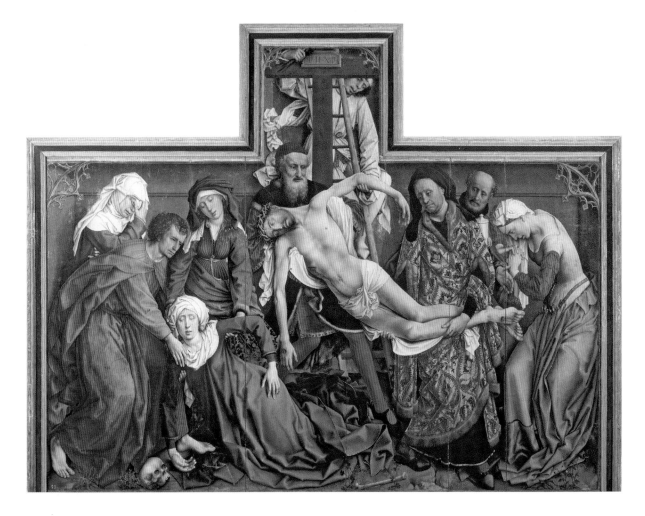

The Descent from the Cross / The Deposition

*c.*1435–8 OIL ON OAK PANEL

7 FT 2 IN X 8 FT 7 IN (220 X 262 CM)

MUSEO DEL PRADO, MADRID, SPAIN

The lifelike intensity here is poignant and precise. Rejecting a
background, van der Weyden has combined detailed observation
of Gothic miniature painting with the expressive gestures of Gothic
sculpture. The crucified Christ is lowered from the Cross by Joseph of
Arimathea and Nicodemus. Mary's swoon echoes her son's position
and the entire scene seems like a stage set. The nine grieving figures
that surround Christ's body are linked physically and emotionally in a
flowing rhythm across the work.

van der Weyden

1399–1464 • NORTHERN RENAISSANCE

One of the most influential painters of the 15th century, Rogier van der Weyden acquired wealth and international acclaim through civic commissions. He became renowned for his detailed and naturalistic paintings, attracting prestigious foreign patrons, including Philip the Good, Duke of Burgundy, and he was imitated by other artists for decades. After his death, his name faded from view, but his reputation was restored in the 20th century.

In the Netherlands, the beginning of the 14th century saw the emergence of a generation of painters with exceptional skills in depicting detail, which had a huge influence on the rest of Western painting. Rogier van der Weyden was one of the greatest of these painters, although he did not sign or date any of his works so their legitimacy and chronology have had to be determined through written records and the comparison of works by other artists.

It seems that van der Weyden became an apprentice relatively late in life, as he entered the workshop of the celebrated artist Robert Campin (c.1375–1444) in his home town of Tournai at the age of 27. By 1432, he had developed even greater skills than his master and by 1436, he was appointed official painter to the city of Brussels. At that point he changed his name from the French "de le Pasture" to its Flemish equivalent, "van der Weyden." His work showed an influence of van Eyck, but also many differences. Van Eyck used rich, sumptuous colors, while van der Weyden used a lighter, but still dazzling palette. Van Eyck's figures were restrained, but van der Weyden's expressed powerful emotions. Van der Weyden produced some secular paintings, but his only surviving works are either religious pictures or portraits. Most significant are his altarpieces of the Passion of Christ and his three-quarter portraits, which created a particularly convincing three-dimensional appearance.

Although he lived in Brussels in Belgium for most of his life, van der Weyden traveled around Europe to complete many commissions. He produced paintings for Chancellor Rolin of Burgundy in France, for the powerful Medici family in Florence, and for the d'Este family in Ferrara, Italy. While in Italy, he is believed to have taught Italian artists to paint with oils, as this was a medium used frequently at the time by Flemish painters, but rarely by Italians. He also seems to have been inspired by the art he saw in Italy, in particular the work of Gentile da Fabriano (c.1370–1427) and Fra Angelico.

In creating unusual compositions and in depicting feelings and sensations, van der Weyden was exceptionally resourceful and proficient. One of his innovations was the rendering of immaculate finish and detail in figures and objects, which he set against gold backgrounds, almost as if his figures are in relief. By pushing figures into the foreground in this way, he emphasized them, giving the impression that the religious event was actually happening and in isolation within a small space. Through his large and busy workshop, which exported copies of his paintings to Italy, France, and Spain, his influence extended across Europe.

KEY WORKS

St. Luke Drawing the Virgin c.1435–40, THE MUSEUM OF FINE ARTS, BOSTON, MA, US

Miraflores Altarpiece c.1440, GEMÄLDEGALERIE, BERLIN, GERMANY

Madonna in Red c.1440, MUSEO DEL PRADO, MADRID, SPAIN

Crucifixion Triptych c.1445, KUNSTHISTORISCHES MUSEUM, VIENNA, AUSTRIA

St. Columba Altarpiece c.1455, ALTE PINAKOTHEK, MUNICH, GERMANY

Masaccio

1401–1428 • RENAISSANCE

"Masaccio," a nickname meaning "clumsy Tom" that was given to him when he joined a Florentine craft guild as a child, is often called the first Renaissance master. During his tragically short life, he became renowned for creating dramatic effects with his revolutionary use of perspective and his confident handling of anatomy.

Maso di Ser Giovanni di Mone Cassai, who became known as Masaccio, was the first painter to use perspective systematically and effectively which, despite his brief career, profoundly influenced 14th-century painting. Very little is known about his early training in Florence, but as well as accurate linear perspective, he was the first painter to use the effects of light and tone strongly to make objects appear more solid.

Abandoning the accepted Gothic style and elaborate adornment completely, Masaccio took a naturalistic approach, stimulated by the pioneering work of Giotto, Donatello, and Nanni di Banco (c.1384–1421). He also integrated the linear perspective calculations of the architect Filippo Brunelleschi (1377–1446). His new techniques created a realistic illusion of perspective on flat surfaces and he also painted human bodies as he observed them—vulnerable and imperfect. His work stunned viewers because his figures seemed so real and because they were set in typical and convincing Italian locations. In 1422, Masaccio enrolled in the Florentine painters' guild, the Arte dei Medici e Speziali. From 1424 he worked with his older colleague Masolino (c.1383–1447) on the decoration of the Brancacci Chapel in the church of Santa Maria del Carmine in Florence

and the following year on an altarpiece in Santa Maria Maggiore in Rome.

Many works of art of this period were commissioned by those engaged in usury (the charging of interest on loans), which was considered a sin by the Church. Money-lending made men rich and powerful and in return, they financed great art to glorify churches. These donors liked to be portrayed kneeling at Mary's feet or standing near Jesus, believing that in this way their worldly sins would be forgiven and they would win a place in heaven.

In 1427, with Brunelleschi's help, Masaccio won a prestigious commission to produce a "Holy Trinity" for the church of Santa Maria Novella in Florence. In 1428 he unveiled the work, which featured the Virgin, St. John, and two donors. Viewers thought he had knocked a hole in the church's wall because the painting appeared to have such depth. This fresco marks the first use of methodical and accurate linear perspective in painting, probably devised by Masaccio and Brunelleschi together. Masaccio died that same year at the age of about 27. According to legend, he was poisoned by a jealous rival painter. In spite of his short career, his extensive influence on other artists directed the path of painting for the next 500 years.

KEY WORKS

St. Giovenale Triptych 1422, PARISH CHURCH OF ST. PIETRO, CASCIA DI RAGGELLO, FLORENCE, ITALY

Portrait of a Young Man c.1425, THE NATIONAL GALLERY OF ART, WASHINGTON, DC, US

The Tribute Money 1425, BRANCACCI CHAPEL, SANTA MARIA DEL CARMINE, FLORENCE, ITALY

Madonna Enthroned 1426–7, NATIONAL GALLERY, LONDON, UK

The Beheading of St. John the Baptist 1426, STAATLICHE MUSEEN ZU BERLIN, GEMÄLDEGALERIE, BERLIN, GERMANY

The Holy Trinity with the Virgin, St. John, and Two Donors

1426–8 FRESCO

263 x 125 IN (667 x 317 CM)

SANTA MARIA NOVELLA, FLORENCE, ITALY

This demonstrates Masaccio's confident handling of anatomy, light, and space, and his new system of linear perspective. When he painted it, barrel-vault ceilings had not been constructed since Roman times. God supports Jesus on the Cross, Mary, and St. John stand on each side and the two patrons observe like spectators.

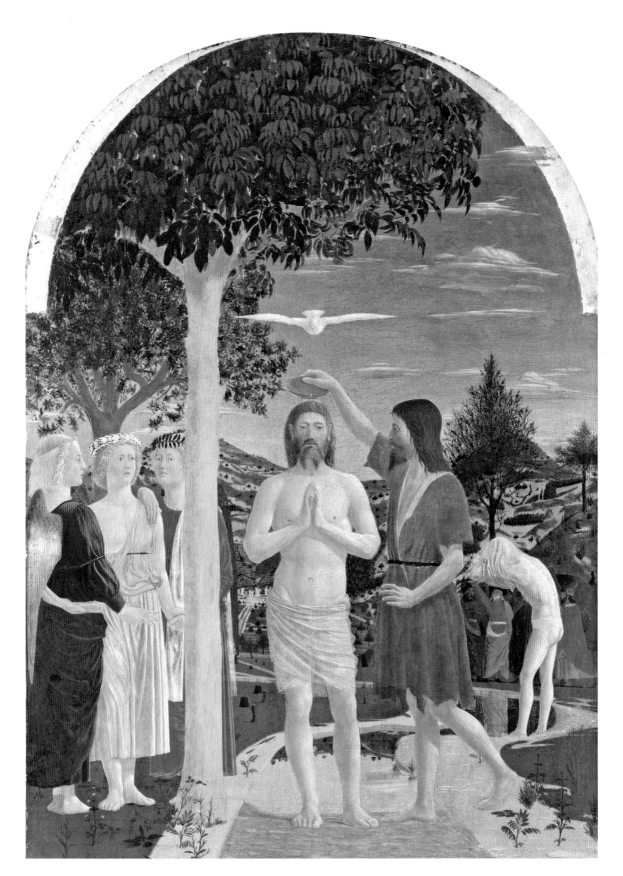

della Francesca

*c.*1415–1492 • RENAISSANCE

Embodying most of the intellectual discoveries and interests of Italian Renaissance artists, Piero della Francesca demonstrated an absolute command of linear perspective in his paintings. His religious works are marked by their simplicity, serenity, and clarity and he devoted his last years to writing treatises on mathematics and perspective.

It is not certain when exactly Piero was born, but it has been estimated at somewhere between 1410 and 1420, in the Tuscan town of Sansepolcro. His father was an affluent tanner and shoemaker and Piero was well educated. He probably studied painting with one of several skilled artists of the Sienese School who lived in Sansepolcro. By 1439 he was working with the artist Domenico Veneziano (*c.*1410–61) on frescoes for the hospital of Santa Maria Nuova in Florence. There, he saw the works of artists and architects such as Donatello, Uccello, Brunelleschi, Masaccio, and Fra Angelico, which had a profound influence on his style.

Piero's first documented work, a polyptych called the *Madonna della Misericordia*, was commissioned in 1445 and completed much later. It demonstrates how much inspiration he derived from those Florentine artists. As well as Florence, Piero also worked in other parts of Italy, including Rimini, Arezzo, Ferrara, and Rome, although he maintained his ties with Sansepolcro throughout his life. Much of Piero's work has been lost and his career has been poorly documented, but the work that survives demonstrates his harmonious style of painting, with pale colors, clear light, large airy spaces, and precise use of perspective. In 1452 he painted a cycle of frescoes, *The Story of the True Cross*, for the choir of the church of San Francesco in Arezzo, which he depicted in an original way in his tranquil style. The frescoes show his advanced knowledge of perspective and understanding of color and composition. A slow worker, he often hung wet cloths on his frescoes in the evening so that he could work on the same section again the next day—something that had not been done in fresco painting before.

Piero was extremely popular in his own lifetime— he worked for several eminent patrons and much of his later career was spent working at the humanist court of Federico da Montefeltro, who ruled Urbino. His work displays his interest in humanism and the rediscovery of classical antiquity, and exemplifies the objectives of early Renaissance painters. He is also known for his careful rendering of background landscapes—a new innovation in Italian art at the time—and his portrayal of light to create the illusion of depth. These, along with his representation of linear perspective, marked the beginnings of the depiction of aerial or atmospheric perspective, where warm colors in the foreground change to paler colors in the background, adding to the sense of distance.

The Baptism of Christ

1450S TEMPERA ON POPLAR

65¾ X 45½ IN (167 X 116 CM)

NATIONAL GALLERY, LONDON, UK

As part of an altarpiece for the priory church of St. John the Baptist in Sansepolcro, this symmetrical composition is created with a balance of verticals and horizontals. From the nave of the church, viewers' eyes would have been drawn to the central figure of Christ with the dove above his head, symbolizing the Holy Spirit.

KEY WORKS

Madonna della Misericordia 1445, PINACOTECA
 COMUNALE, SANSEPOLCRO, ITALY
The Story of the True Cross *c.*1452–7, SAN FRANCESCO,
 AREZZO, ITALY
Resurrection of Christ *c.*1453, PINACOTECA COMUNALE,
 SANSEPOLCRO, ITALY
The Flagellation of Christ *c.*1455–60, GALLERIA
 NAZIONALE DELLE MARCHE, URBINO, ITALY
Federigo da Montefeltro and Battista Sforza 1472,
 GALLERIA DEGLI UFFIZI, FLORENCE, ITALY

Bellini

*c.*1430–1516 • RENAISSANCE, VENETIAN SCHOOL

During the Renaissance, Venice was a stable, powerful, and prosperous city, independent from Rome. Giovanni Bellini was credited with bringing the Renaissance to Venice with his sumptuous coloring and fluent, atmospheric landscapes.

Like his brother Gentile, Giovanni Bellini began his career as an assistant in their father Jacopo Bellini's studio in Venice. When their sister married Andrea Mantegna in 1453, close relations between Venice and Padua were established. Venice's geographical location made it less susceptible to outside influences and allowed for a more relaxed attitude toward subject matter, which contributed to its unique artistic style. Giovanni responded to the influences around him: his family, Flemish art, the sculptures of Donatello, which he saw in Padua, and the paintings of Antonello da Messina (*c.*1430–79), who visited Venice in 1475. His paintings became distinctive for their mellow light, clear, and vivid colors, sculptural approaches to composition, and smooth, almost velvety brushstrokes. Looking at them today, they appear astonishingly modern.

Bellini's early work was in tempera, but later he became one of the first experts in oil painting techniques, creating deep, rich tints and detailed shadings, moving Venetian painting toward a more sensuous and coloristic style. As he matured, his colors gained in luminosity and depth; tonal inflections became even more delicate and precise and light filled every painting. He became known for his sensitive portraits, devotional paintings, architectural compositions, and remarkable landscapes, which revolutionized Venetian art. His ability to endow his figures with an expression of quiet contemplation, while conveying movement and accurate human anatomy, attracted many talented apprentices to his workshop, including Giorgione (*c.*1477–1510) and Titian, and he was recognized as the leading painter of the period.

KEY WORKS

Madonna and Child c.1468, PINACOTECA DI BRERA, MILAN, ITALY

St. Francis in the Wilderness c.1480, THE FRICK COLLECTION, NEW YORK, US

The Doge Leonardo Loredan c.1501–4, NATIONAL GALLERY, LONDON, UK

Sacra Conversazione (Madonna and Child with Saints)

c.1490–1500 TEMPERA ON PANEL

29½ x 33 IN (75 x 84 CM)

GALLERIA DELL'ACCADEMIA, VENICE, ITALY

Sacra Conversazione refers to paintings of Mary and Jesus within a group of saints. By the Renaissance period, the Byzantine style had been forgotten as artists depicted the figures in realistic-looking spaces. Rich colors convey the soft light of Venice.

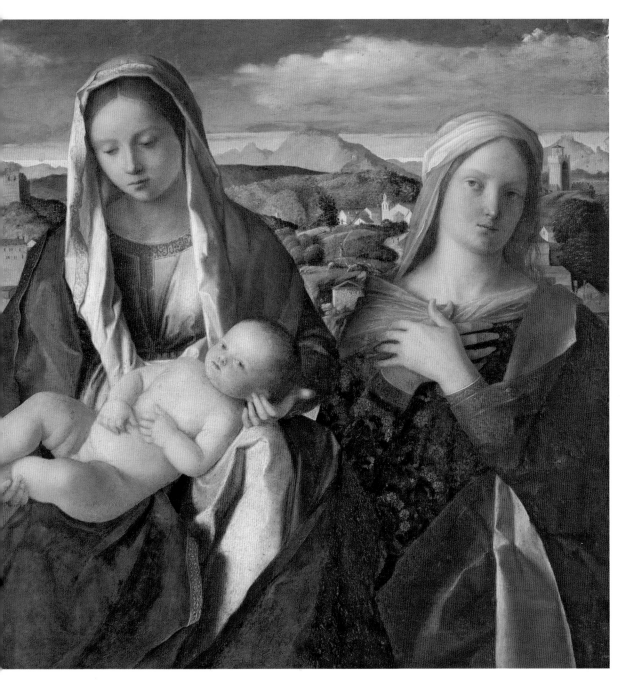

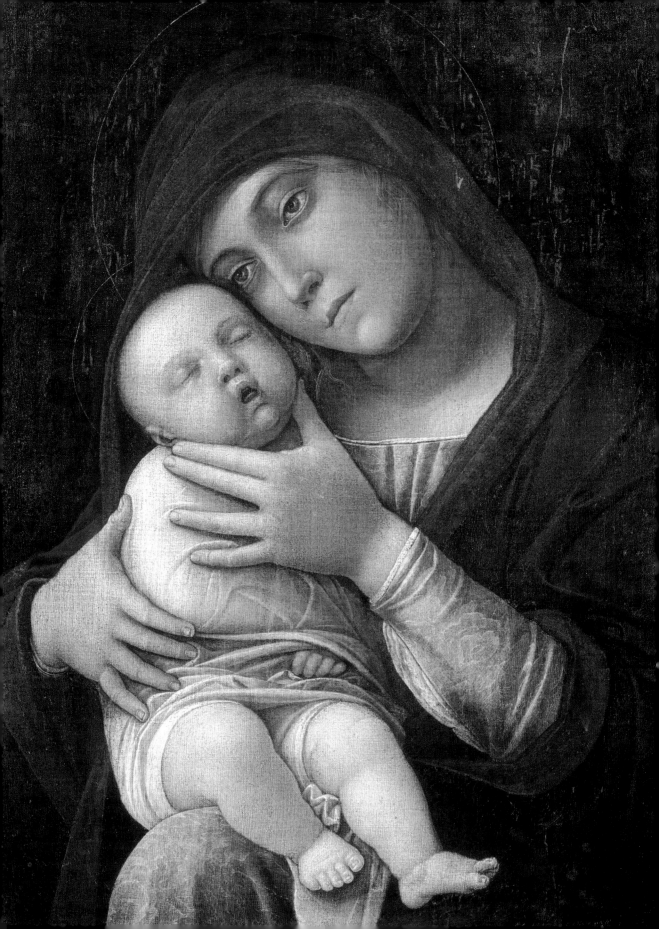

Mantegna

*c.*1431–1506 • RENAISSANCE

For about 50 years, Andrea Mantegna was probably the most influential painter in northern Italy. Featuring clarity of line and an accomplished use of perspective, his paintings astonished contemporary eyes.

Mantegna was born in Isola di Carturo in Italy, close to Padua, then part of the Republic of Venice. The second son of a carpenter, at the age of ten he was apprenticed to the painter Francesco Squarcione (1394–1468) whose workshop was renowned across Italy. Within a year, Squarcione had entered him in the guild of painters; an extraordinary attainment at such a young age, but by the time he was 17, he left his apprenticeship to set up his own workshop. There was great interest in classical antiquities in and around Padua at the time and, distinctively, Mantegna made specific use of archaeological accuracy in his paintings, while also experimenting with perspective.

From 1443, Donatello was in Padua creating the high altar for the church of San Antonio and from him, Mantegna learned how to produce anatomically correct figures and to represent "sculptural" figures and drapery. As he took on more commissions, he became recognized for his sophisticated perspective and unusual viewpoints. In 1453, he married Nicolosia Bellini, daughter of the artist Jacopo Bellini and sister of the celebrated artists Giovanni and Gentile Bellini. Squarcione and the Bellinis were rivals, so from that time, he and Mantegna became alienated from each other. Giovanni Bellini and Mantegna worked on several commissions together, and all three younger artists influenced each other. From Mantegna, the Bellini brothers gained greater understanding of perspective, while Mantegna became more skilled at selecting and using color and in depicting light. In 1460, he was appointed court painter to the Gonzaga family, the powerful rulers of Mantua. From then on, he only left Mantua for occasional trips to Tuscany and Rome.

Until that time, his work had been predominantly religious, but in Mantua he began producing more secular and allegorical subjects. Mantua was one of the leading centers of humanist culture in Europe and Mantegna's work celebrated this, as he produced some of his finest works for the Gonzaga court, including his famous frescoes in the Camera degli Sposi (Wedding Chamber) at the Palazzo Ducale. These included paintings in one room, featuring a sky on the ceiling with men and women looking down from above using complex foreshortening. In 1484 he was knighted; a rare honor for an artist. From about 1490, he also began to produce engravings which helped spread his name beyond Italy.

The Virgin and Child

1490S TEMPERA ON CANVAS

17¾ X 14 IN (45.2 X 35.5 CM)

MUSEO POLDI PEZZOLI, MILAN, ITALY

In a tender moment, Mary holds her baby's face. Wrapped in a cloth, Jesus sleeps. Despite the warmth of the scene, it foretells Jesus' death and how Mary will be holding him, wrapped in a sheet after his crucifixion.

KEY WORKS

Adoration of the Magi 1462, GALLERIA DEGLI UFFIZI, FLORENCE, ITALY

Camera degli Sposi 1473, PALAZZO DUCALE, MANTUA, ITALY

The Lamentation over the Dead Christ *c.*1480, PINACOTECA DI BRERA, MILAN, ITALY

St. Sebastian 1480, MUSÉE DU LOUVRE, PARIS, FRANCE

Madonna with the Cherubim 1485, PINACOTECA DI BRERA, MILAN, ITALY

Botticelli

1445–1510 • RENAISSANCE

Under the patronage of Lorenzo de' Medici, Alessandro di Mariano di Vanni Filipepi, better known as Sandro Botticelli, became the foremost painter in Florence during the late 14th century. His graceful contours and spirituality combine the decorative Gothic style with the emotion of humanism and the spatial illusions of Florentine art.

Florentine-born Botticelli was apprenticed to a goldsmith at 14 and by the age of 17 he was training in the workshop of the artist Fra Filippo Lippi (1406–69). It is possible that he traveled to Hungary for a short time to work on a fresco ordered in Lippi's workshop. On completion of his training, he painted frescoes in local churches and cathedrals with the painter and engraver Antonio del Pollaiuolo (1429/33–98), from whom he learned the art of creating an illusion of dynamism. He was also influenced by Masaccio's spatial management and the fine modeling of Andrea del Verrocchio (c.1435–88), while from Lippi himself, he had learned decorative techniques and an understanding of form. By 1470, Botticelli had his own workshop and his sinuous, rhythmic style and soft colors soon attracted some of the greatest patrons of the day, including the Roman Catholic Church and wealthy Florentine families, in particular the Medici.

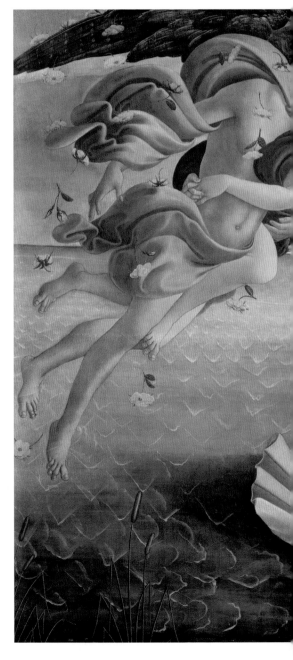

Integrating classical and humanist notions with Christianity, Botticelli produced life-sized mythological and religious paintings, altarpieces, and graceful Madonnas. In 1481, Pope Sixtus IV summoned him to Rome to paint frescoes for the Sistine Chapel. Back in Florence the following year, he painted *Primavera* for Lorenzo de' Medici's wedding. He also painted portraits, which were becoming popular because the new merchant class wanted to be immortalized as themselves, and not just depicted as extras in religious scenes.

The golden years of Medici power in Florence ended in a revolution in 1491. The fanatical Dominican monk, Girolamo Savonarola, dominated Florence, preaching against spiritual corruption. Instituting the "Bonfires of the Vanities," Savonarola encouraged Florentines to burn their possessions and save their souls. The emotion in Botticelli's late religious paintings, and the symbolism he employs, suggest that he was involved in the upheavals. He began painting only religious subjects and was soon replaced by a new generation of artists, including Leonardo and Michelangelo. Lost in obscurity for centuries, it was only in the 19th century, when the Pre-Raphaelites rediscovered his works, that he became appreciated once more.

KEY WORKS

Primavera or The Allegory of Spring *c.*1482, GALLERIA
 DEGLI UFFIZI, FLORENCE, ITALY
Venus and Mars 1483, NATIONAL GALLERY, LONDON, UK
Madonna Adoring the Child with Five Angels 1485–90,
 BALTIMORE MUSEUM OF ART, BALTIMORE, MD, US
The Cestello Annunciation *c.*1489, GALLERIA DEGLI
 UFFIZI, FLORENCE, ITALY

The Birth of Venus

*c.*1485 TEMPERA ON CANVAS

67¾ x 112¼ IN (172 x 285 CM)

GALLERIA DEGLI UFFIZI, FLORENCE, ITALY

This was the first large-scale Renaissance painting of a mythological subject and believed to be the first Renaissance nude painting in Europe. Venus, the Roman goddess of love and beauty, has emerged from the sea and is being wafted ashore by Zephyr, the West Wind and his bride, Flora. A nymph, symbolizing rebirth, greets her with a cloak; the anemone between her feet heralds the arrival of spring. The model for Venus was Simonetta Vespucci, mistress of Guiliano de' Medici, who died before Botticelli painted her. She stands in the Venus Pudica pose, which is modest and chaste, framed by her flowing, golden hair, while her elegant fingers delicately cover her modesty.

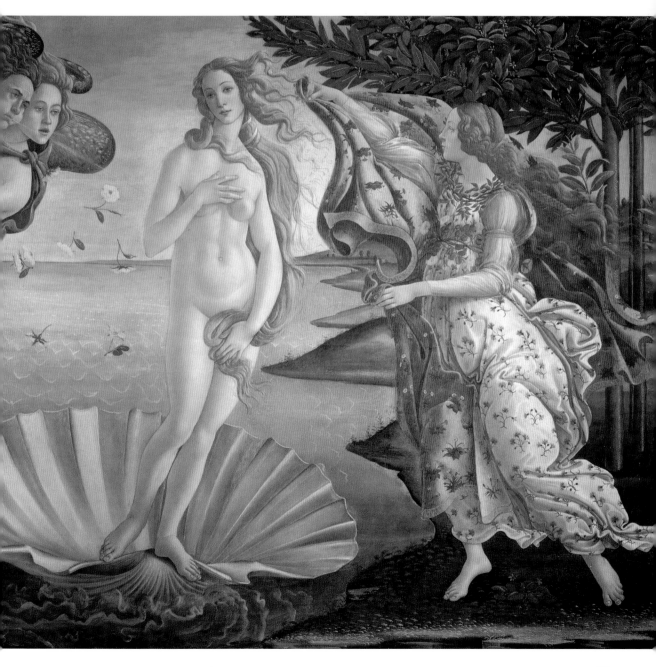

Ghirlandaio

1449–1494 • RENAISSANCE

A highly successful Florentine painter, Domenico di Tommaso Curradi di Doffo Bigordi, nicknamed Ghirlandaio, is renowned for training Michelangelo in fresco techniques. Ghirlandaio became known for his descriptive frescoes.

The nickname "Il Ghirlandaio" (garland-maker) derived from his goldsmith father, who made garland necklaces that were popular with Florentine women. The eldest of eight children, Ghirlandaio was initially apprenticed to his father. While training, he drew portraits, so his apprenticeship was transferred to the painter Alessio Baldovinetti (1425–99) to study painting and mosaic. It is probable that he also trained for a while with the painter and sculptor Andrea del Verrocchio (1435–88).

Compared to some of his prominent contemporaries, Ghirlandaio was rather conservative. He rarely used oils, preferring fresco and tempera, and he consolidated ideas and techniques rather than advancing them. Inspired by Masaccio and the Flemish painters, he ended up running one of the most successful workshops in Florence with his younger brothers. His frescoes were particularly popular as they often included portraits of his patrons. In 1481, he was commissioned to produce frescoes for the library of Pope Sixtus IV in Rome and part of the Sistine Chapel.

In 1486, the wealthy banker Giovanni Tornabuoni commissioned him to paint frescoes in the choir of Santa Maria Novella, illustrating scenes from the lives of the Virgin and St. John the Baptist. Ghirlandaio and his assistants depicted the story as if it had occurred in a contemporary gentleman's home. Reading like a sophisticated cartoon strip, his compositions were complex, the colors soft and subtle, and the inclusion of Tornabuoni and his family made the work extremely popular. Members of the Florentine upper class were impressed by his realism and attention to detail, and he remained busy and highly esteemed throughout his life.

The Visitation

1491

TEMPERA ON WOOD

67½ x 65 IN

(172 x 167 CM)

MUSÉE DU LOUVRE, PARIS, FRANCE

This unusually lifelike scene of Mary visiting her cousin Elizabeth includes Mary Salome praying, while Mary Jacobi looks out of the picture. Cut off at the edges, the two figures create an impression of dynamism, while the central figures are positioned against a light-filled landscape.

KEY WORKS

Old Man with a Young Boy c.1480, LOUVRE, PARIS, FRANCE
Last Supper 1480, CONVENT OF SAN MARCO, REFECTORY, FLORENCE, ITALY
St. Jerome 1480, OGNISSANTI, FLORENCE, ITALY
The Calling of St. Peter 1482, SISTINE CHAPEL, VATICAN
The Birth of Mary c.1485–90, SANTA MARIA NOVELLA, FLORENCE, ITALY

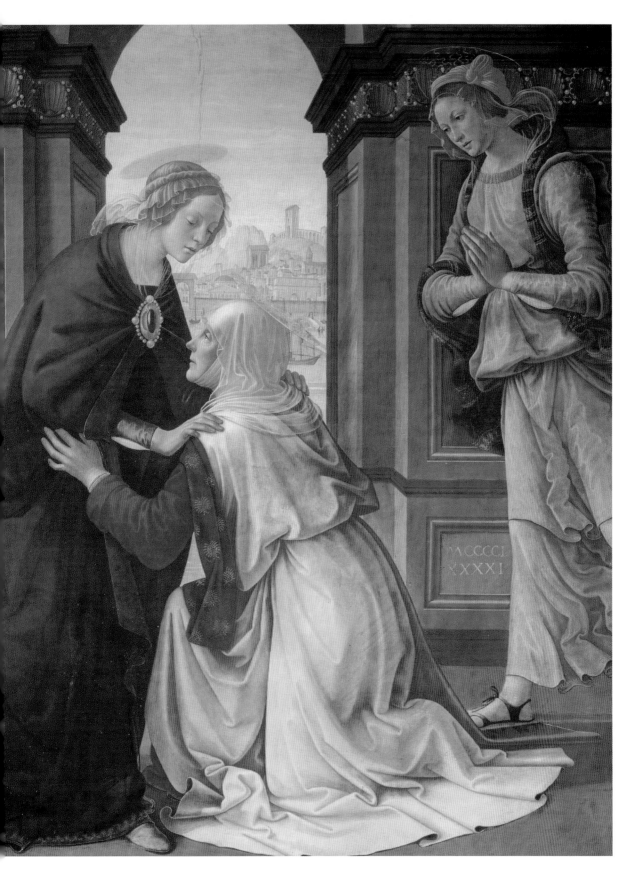

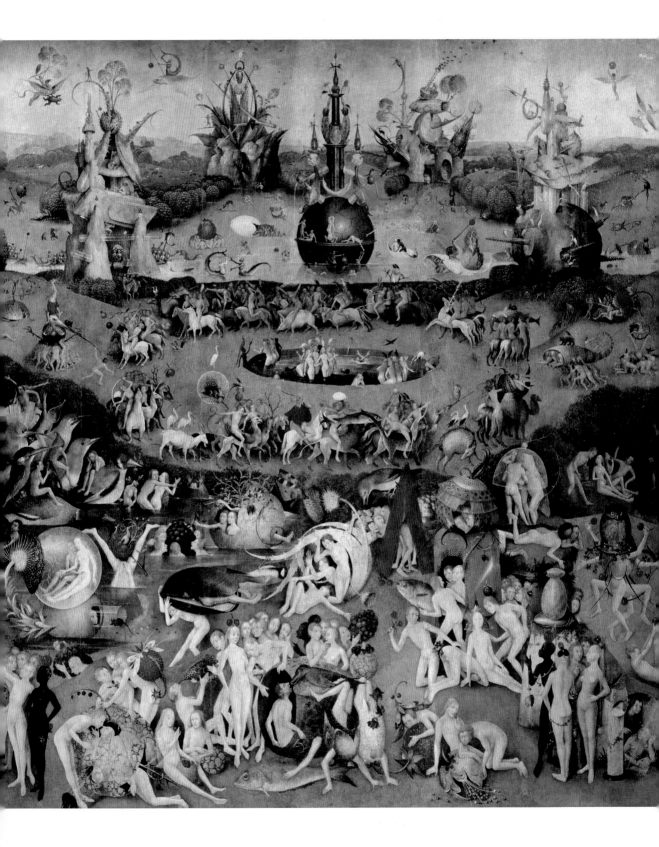

Bosch

*c.*1450–1516 • LATE GOTHIC, NORTHERN RENAISSANCE

Hieronymus Bosch became extremely popular for his large landscapes featuring fantastic, unearthly beasts and nightmarish visions representing the sins of the human race and the torments of hell.

Little is known about the life of Jeroen van Aken, who adopted the name Hieronymus Bosch after his home town of Hertogenbosch in the Netherlands, an urbanized and industrial location, known for its manufacture of textiles and its extensive trade with northern Europe and Italy.

Bosch's grandfather, father, three of his uncles, and one of his two brothers were artists, and taught him to paint. The new prosperity of northern European cities and the growth of capitalism initiated an interest in religious reform, while Bosch's lifetime was marked by numerous momentous discoveries and events. It was also a time of violence, ignorance, superstition, and pessimism. In response to all this, although his early work was fairly traditional, he soon abandoned such expected imagery and departed from the established conventions of painting, creating a fantasy world of passion and damnation. During 1480 or 1481, he married Alety Goyaerts van den Meervenne, an older woman from a wealthy family, which gave him a comfortable lifestyle and an improved social status. As a Catholic, in 1486 he joined the Brotherhood of Our Lady, a large local religious organization. Some of his first commissions came through the Brotherhood,

although none of those works has survived.

Bosch rarely traveled far from home, but it is believed that he painted an altarpiece for the Archduke Philip of Austria in 1504. His paintings summarized the prevalent fears of his times, particularly those related to sin and human conscience, as well as the political upheavals of the day, and his moralistic, direful images urged viewers to avoid wrongdoing. Full of symbolism, these paintings cautioned against corruption and sinfulness in imagery that was understood by all, including the illiterate lower classes. Unique, vivid, terrifying, often pessimistic, and meticulously detailed, they incorporate fantastic, strange creatures and situations. Pictures like this had never been seen before and soon the most important individuals of the time commissioned work from him. Although many are signed, none of his pictures is dated, which has caused confusion and numerous works have been attributed to him, but only about 30 have been verified as his.

By the time of his death, Bosch was celebrated as an unconventional painter of religious visions who focused on the consequences of a sinful life. His work became a major inspiration, not only for contemporary artists, but also for the Surrealists over 400 years later.

The Garden of Earthly Delights, (detail—central panel)

*c.*1510 OIL ON WOOD

CENTRAL PANEL 86½ x 76¾ IN (220 x 195 CM)

WINGS OF TRIPTYCH 86½ x 38 IN (220 x 97 CM)

MUSEO DEL PRADO, MADRID, SPAIN

This large triptych is an account of life, death, and the seven deadly sins. The garden in the central panel is filled with nudes, animals, and giant fruit, representing the avarice and gluttony of life during Bosch's time. The adjoining panel shows the consequential horrors of hell.

KEY WORKS

Christ Carrying the Cross 1485–90, KUNSTHISTORISCHES MUSEUM, VIENNA, AUSTRIA

Haywain (Triptych) 1485–90, MUSEO DEL PRADO, MADRID, SPAIN

Ecce Homo 1490, STÄDELSCHES KUNSTINSTITUT MIT STÄDTISCHER GALERIA, FRANKFURT, GERMANY

Christ Carrying the Cross 1490, MUSÉE DES BEAUX-ARTS, GHENT, BELGIUM

Flight and Failure of St. Anthony 1500, MUSEU NACIONAL DE ARTE ANTIGA, LISBON, PORTUGAL

High Renaissance to Mannerism
*c.*1500–1600

As European artists consciously rejected the Medieval past and initiated a rebirth of styles that looked to classical antiquity for its inspiration, their work became more diverse, idealistic, and dexterous. The artistic revolution matured with a massive outpouring of creativity that resulted in what has become known as the High Renaissance and Mannerism.

Intellectual curiosity

Although artists were conscious of their remarkable developments during this time, they did not label themselves—as history has done for them. So there is no clear-cut change from Early to High Renaissance. The development to what has since been categorized as the High Renaissance is generally accepted as occurring at the turn of the 16th century, when Leonardo da Vinci was establishing the idea of the artist as "genius." The great 16th-century artists benefited from a distinction and respect during their lifetimes that they have never lost.

The High Renaissance essentially describes the culmination of the artistic developments of the Early Renaissance and a great upsurge of exceptional creative

brilliance. Through his total command of artistic skills, his intellectual curiosity, and his enquiries into the physical world, Leonardo da Vinci initiated the idea of a universal man: one who was skilled in fields as diverse as art, music, and scientific endeavor—the polymath. Intellectual skills in the arts, which included astronomy, geometry, music, poetry, sculpture, painting, and architecture, were seen as prerequisites for an artist to attract fame, status, and financial success. During the period, painting and sculpture reached a peak of technical competence, expression, and proportion. Painters managed forms, colors, tonal effects, perspective, proportion, composition, and anatomy with control and outstanding skill. Similarly, sculptors

1501–03
David,
Michelangelo
(1475–1564)

1509–11
The School of Athens,
Raphael
(1483–1520)

1528
Visitation,
Jacobo Pontormo
(1494–1557)

1533
The Ambassadors,
Holbein
(1497–1543)

1475

1525

1498
Self-Portrait,
Dürer (1471–1528)

1503–06
Mona Lisa,
da Vinci
(1452–1519)

1520–23
Bacchus and
Ariadne,
Titian
(1488–1576)

1530
The Dead Christ
between the Virgin
and Mary Magdalene,
Bronzino (1503–72)

1535
Madonna with the
Long Neck,
Parmigianino
(1503–40)

favored balance, proportion, accurate anatomical details, idealism, and beauty. Both painting and sculpture were usually commissioned to decorate or embellish the distinguished High Renaissance architecture that was being built for the glory of God or for rich and powerful men.

Confidence and extravagance

Most of these new creative inventions and developments had been concentrated in the city of Florence, but in the 16th century, Rome became another important cultural center. As the Popes began their extravagant project of rebuilding St. Peter's Basilica in Rome, they also introduced the assured and immense paintings of Michelangelo and Raphael in the Sistine Chapel. Leonardo brought attention to Milan through his work there from 1481 and, following on from the precedent set by Bellini (c.1430–1516), the artists Titian, Tintoretto, and Veronese highlighted Venice as another worthy cultural center of the High Renaissance. Nevertheless, the grandeur and harmony of Florence and Rome contrasted greatly with the lively explosions of color being painted in Venice.

One of the significant developments of the period was the changes in the materials artists used. At the start of the Renaissance, most painting was either fresco or tempera (quick-drying powdered pigment mixed with egg) on wooden panels. As the use of oil paint spread from northern Europe, artists found that they could blend tones, incorporate intricate details in their work, and correct mistakes easily that had not been possible before.

Increasing exaggeration

Until about 1520, the High Renaissance thrived confidently. Then Martin Luther's Protestant Reformation tore central Europe apart, the Ottoman Empire of Turkey advanced on Vienna, and the plague recurred repeatedly, changing Europe forever. Reacting to the unrest, several artists began abandoning some of the harmonious ideals of the Renaissance in favor of a more emotional approach. They imitated Michelangelo's mature, gestural painterly style featuring graceful and expressive contrapposto ("counterpoise") figures, distorting or elongating them and placing them in unrealistic settings. In the 20th century, the style was labeled retrospectively as "Mannerism" after the Italian maniera ("style" or "stylishness"). Mannerism focused on exaggerated figures, colors, and compositions that expressed the new religious doubts and questionings.

The adventurous steps that had first been taken by Cimabue, Duccio, and Giotto ended up in a scale and depth of artistic endeavor that could not possibly have been anticipated. At its peak, the High Renaissance produced a generation of unique artists; at the end, it introduced a new attitude toward nature, the mysteries of the cosmos, and life itself.

1551–53
Construction of the Villa Cornaro, Piombino Dese, near Padua, Italy, *Palladio* (*c.*1508–80)

1567–69
Building of the Villa Rotunda, *Palladio* (*c.*1508–80)

1590–91
The Last Supper, *Tintoretto* (1518–94)

1565 1660

1546–64
Construction of the Dome of St. Peter's, Vatican City. *Michelangelo* (1475–1564)

1562–63
The Wedding Feast at Cana, *Veronese* (1528–88)

***c.*1568**
The Peasant Wedding *Bruegel the Elder* (*c.*1525–69)

da Vinci

1452–1519 • HIGH RENAISSANCE

Regarded by many as one of the greatest painters in history, Leonardo di ser Piero da Vinci was an artist, scientist, architect, engineer, mathematician, philosopher, botanist, inventor, musician, and writer. With an insatiable curiosity and thirst for knowledge, this extraordinary genius made many discoveries and inventions years ahead of their time.

Born in Vinci near Florence, Leonardo was the illegitimate son of Piero da Vinci, a public notary, and a peasant woman called Caterina. He lived with his mother until the age of four and then moved into the home of his father and stepmother. He developed an enduring fascination with nature, and with animals in particular, and became a vegetarian at a time when the morality of eating animals was rarely questioned. Piero soon noticed his son's exceptional artistic talent and enrolled him at the studio of the painter and sculptor Verrocchio (who had taught Botticelli and Ghirlandaio) when he was 15.

Within a short time, the young Leonardo outshone his master and he joined Florence's distinguished Guild of St. Luke, an association named after the patron saint of painters. By the late 1470s, he was working as an independent painter, architect, and engineer in Florence. His notebooks from this time are full of meticulous architectural and engineering details, but it is not known how he acquired his knowledge of these disciplines.

Although he began to attract wealthy patrons, Leonardo also gained a reputation for being unreliable, often failing to complete paintings. This might have been why Pope Sixtus IV did not call on him when he commissioned the most celebrated Tuscan artists to decorate the Sistine Chapel in Rome. Instead, Leonardo spent 18 years in Milan working for the powerful Duke Ludovico Sforza as musician, painter, designer, architect, engineer, sculptor, scientist, and even magician. In 1499, however, the French invaded Milan and captured Sforza. Leonardo returned to Florence and although 25-year-old Michelangelo was well established as the greatest artist in the city, Leonardo regained his popularity almost instantly. Between 1502 and 1503, Cesare Borgia, Duke of Romagna, briefly employed him as a military architect and engineer. In 1506, he was summoned to Milan to act as architectural consultant for the French governor there, and a year later, King Louis XII appointed him court painter and engineer. He served Pope Leo X in Rome in 1513, but because of instability in Italy, he spent his last years in France, working for the French king, François I.

There are perhaps 15 surviving paintings by Leonardo, and each has become iconic for its delicacy, realism, dynamism, expression, and glowing light effects. The many innovations and inventions that he explored in mirror writing, and in drawings and diagrams in countless notebooks, greatly advanced understanding in the fields of anatomy, civil engineering, optics, and hydrodynamics. The ultimate Renaissance man, Leonardo's brilliance remains as enigmatic as his most famous work of art.

KEY WORKS

The Annunciation c.1472–5, GALLERIA DEGLI UFFIZI, FLORENCE, ITALY
Madonna Benois c.1475–8, STATE HERMITAGE, ST. PETERSBURG, RUSSIA
Madonna of the Rocks 1482–6, MUSÉE DU LOUVRE, PARIS, FRANCE
The Last Supper c.1495–8, SANTA MARIA DELLE GRAZIE, REFECTORY, MILAN, ITALY
The Virgin of the Rocks 1506–8, NATIONAL GALLERY, LONDON, UK

The Mona Lisa

1503–6 OIL ON WOOD

30¼ X 20¾ IN (77 X 53 CM)

MUSÉE DU LOUVRE, PARIS, FRANCE

Famed for the mystery of the sitter's smile, few works of art have been the subject of so much analysis and reproduction. Set in a landscape inspired by the Arno Valley in Italy, it took five years to paint. The atmospheric sfumato (smoky) technique that Leonardo pioneered, and the mystery that shrouds the subject, continue to captivate and inspire.

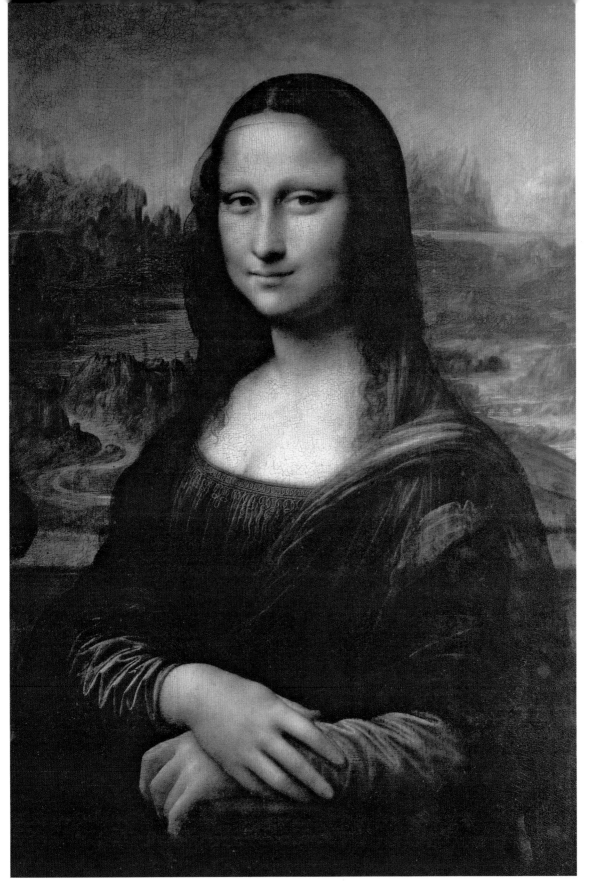

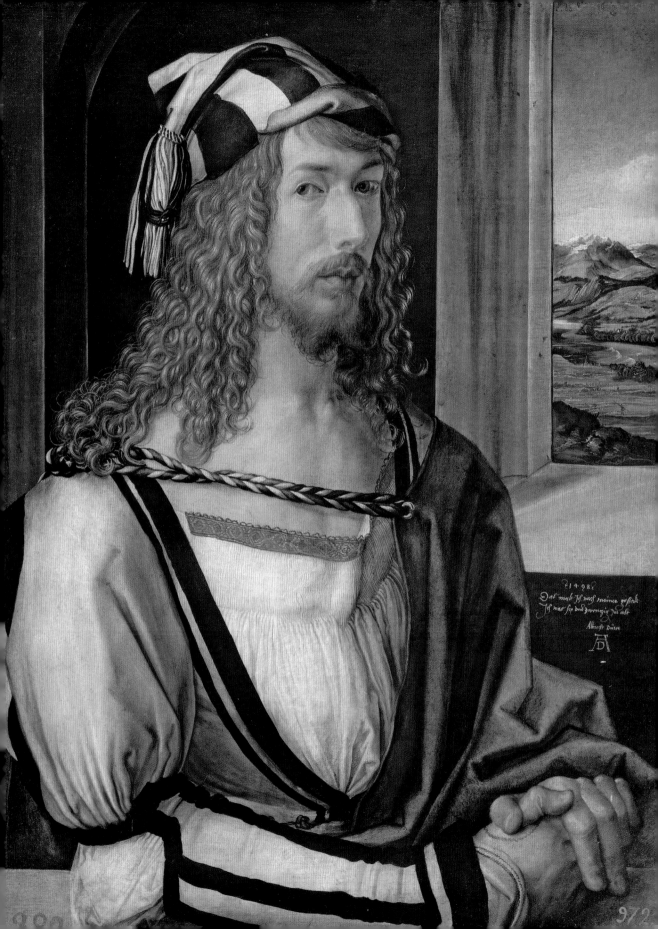

Dürer

1471–1528 • (NORTHERN) HIGH RENAISSANCE

The most significant German artist of the Renaissance, and possibly of all time, Albrecht Dürer was one of the first artists to experiment with etching. He raised woodcut and engraving techniques to new levels of artistic expression and established the practice of artists visiting Rome and Florence as a fundamental part of their creative education.

Dürer was born in Nuremberg, Germany, the son of a prosperous goldsmith. His early training was in his father's workshop and a self-portrait, drawn when he was 13, reveals his precocious talent. By the age of 15, he was an apprentice in the workshop of Michael Wolgemut (1434–1519), the leading painter and printmaker in Nuremberg at the time. In 1490, he left Nuremberg to travel, visiting Cologne and then the Netherlands. Four years later, he went to Italy, where he met Bellini in Venice and also saw the work of Mantegna and Antonio del Pollaiuolo (c.1432–98). Fascinated by the Italian styles and techniques, when he returned to Germany he established his own workshop and infused his northern Renaissance style (nonidealized, highly realistic, and detailed) with the sophisticated and fluid handling of color and application of perspective he had seen.

Inspired by the prestige bestowed on Italian artists, Dürer became one of the first artists of northern Europe to publicize himself—and as an intellectual more than a craftsman. Mixing with the scholars of the day more than other artisans, he intensified his studies of geometry and mathematics and began marketing himself through his prints, which often featured strong expression, powerful emotion, and busy compositions. No artist before him had achieved such fluidity in printed images. By 1497, through his woodcuts and engravings, he was employing someone to deal with the sale of his prints outside Germany and within a few years he was famed across Europe. The Holy Roman Emperor Maximilian I appointed Dürer as his artistic advisor, although Dürer's shrewd and unprecedented business dealings meant that he did not have to rely on wealthy patrons.

Dürer also painted landscapes, portraits, altarpieces, religious works, and scenes from daily life, all of which showed his fascination with the spirit and style of Italian humanism. Around 1500, he began to experiment with the problem of combining mathematically calculated proportions and accurate perspective with ideal beauty. Although his work incorporated many of the elements that he had admired in Italy, in turn his work eventually influenced the art of the Italian Renaissance.

In 1498, Dürer published a book of woodcuts called the *Apocalypse*. The first book to be printed entirely by an artist, it was a bestseller. In later life, he became a follower of the Protestant reformer Martin Luther, which can be sensed in the austerity of style and subjects in his religious works after 1520. His last years were mainly devoted to theoretical and scientific writings and illustrations.

Self-Portrait

1498 OIL ON CANVAS

20½ X 16½ IN (52 X 41 CM)

MUSEO DEL PRADO, MADRID, SPAIN

Elegantly dressed as a gentleman, Dürer intentionally positions himself away from the humble artisan and toward the ideals of the Renaissance. His facial features are recorded with objective precision and the landscape seen through a window in the background is reminiscent of contemporary Venetian and Florentine paintings. At the age of 26, Dürer seems assured of his own genius.

KEY WORKS

The Seven Sorrows of the Virgin c.1496 ALTE PINAKOTHEK, MUNICH, GERMANY
Self-Portrait at 28 1500, ALTE PINAKOTHEK, MUNICH, GERMANY
The Altarpiece of the Rose Garlands 1506, NARODNI GALERIE, PRAGUE, CZECH REPUBLIC
Portrait of Dürer's Mother 1514, KUPFERSTICHKABINETT, BERLIN, GERMANY
St. Jerome 1521, MUSEU NACIONAL DE ARTE ANTIGA, LISBON, PORTUGAL

Michelangelo

1475–1564 • HIGH RENAISSANCE

Possibly the most influential artist in history, Michelangelo di Lodovico Buonarroti Simoni, commonly known as Michelangelo, was a contemporary of Leonardo da Vinci with a career that lasted for more than 70 years. A prolific sculptor, painter, and architect, he was notoriously resolute and devoted to his art and his genius was praised consistently from the start of his unequaled career.

Raised in Florence, at the age of 13 Michelangelo entered the workshop of Domenico Ghirlandaio where, for three years, he learned fresco painting techniques. He also made studies of frescoes by Giotto and Masaccio and of sculptures by Donatello. Within a year, he became a guest of Lorenzo the Magnificent, the powerful ruler of Florence, in the Medici palace. There he mixed with some of the greatest scholars of the day, learning from sculptor Bertoldo di Giovanni (c.1434/40–91) and from the Medici collection of antique sculpture.

With the death of Lorenzo de' Medici in 1492, and unrest in Florence, Michelangelo left for Bologna and then Rome, where newly unearthed classical statues and ancient ruins inspired his first large-scale sculptures. One of these was *Pietà*, created for St. Peter's in Rome. A tragically expressive statue of a full-grown Christ lying dead in his mother's lap, it secured Michelangelo's reputation. He returned to Florence, commissioned to work on an old block of marble that a previous sculptor had abandoned, to create a symbol of the new Republic of Florence. The result was a gigantic naked statue of the biblical character David, which demonstrated a new understanding of anatomy. *David* was put outside the Palazzo Vecchio, the Florentine seat of government, and Michelangelo was nicknamed "Il Divino" or "The Divine One."

In 1505, Michelangelo was summoned to Rome by Pope Julius II to make his tomb. For over a year, he designed the monument and selected and transported marble from the quarries. Suddenly, the Pope stopped him working on the tomb in favor of painting the ceiling of the Sistine Chapel. Reluctantly, Michelangelo took up the project. Working largely on his own for four years, he covered the vast barrel-vaulted ceiling with nearly 350 life-sized figures, including prophets and sibyls, decorative medallions, slaves—or what Michelangelo called ignudi (nude figures)—and biblical scenes. Later, he painted *The Last Judgment*, a fresco on the altar wall of the chapel.

Just after the ceiling frescoes were completed, in 1513, Pope Julius died, his tomb barely started. For many years, Michelangelo worked intermittently on it, frustrated by delays and disagreements. Finally, he completed a pared-down version of the original tomb in 1545. For the rest of his life, he worked for successive popes and other powerful patrons, producing extraordinary works that reflected his spiritual beliefs, classical influences, and brilliant imagination. In addition to sculpture and painting, from 1546 he was appointed chief architect by the Pope to complete the rebuilding of St. Peter's in Rome. He designed the vast building, including the cathedral's great dome, which remained unfinished when he died.

KEY WORKS

Pietà 1499, ST. PETER'S, VATICAN CITY

David 1501–4, GALLERIA DELL'ACCADEMIA, FLORENCE, ITALY

Doni Tondo—The Holy Family with St. John the Baptist *c.*1504–6, GALLERIA DEGLI UFFIZI, FLORENCE, ITALY

Tomb of Lorenzo de' Medici 1526–31, MEDICI CHAPEL, SAN LORENZO, FLORENCE, ITALY

The Last Judgment 1534–41, SISTINE CHAPEL, VATICAN CITY

The Expulsion from Paradise (detail of Sistine Chapel ceiling)

1509–10 FRESCO

APPROXIMATELY 110¼ X 224½ IN (280 X 570 CM)

SISTINE CHAPEL, VATICAN CITY

Michelangelo completed the Sistine Chapel ceiling over four years, painting practically single-handedly in an awkward position for hours each day. The central theme is stories from the Book of Genesis, and this shows Adam and Eve being expelled from the Garden of Eden. Adam shields his eyes from the disgrace, while Eve seemingly hides her face in shame. Preferring sculpture to painting, Michelangelo created the figures with strong tonal modeling.

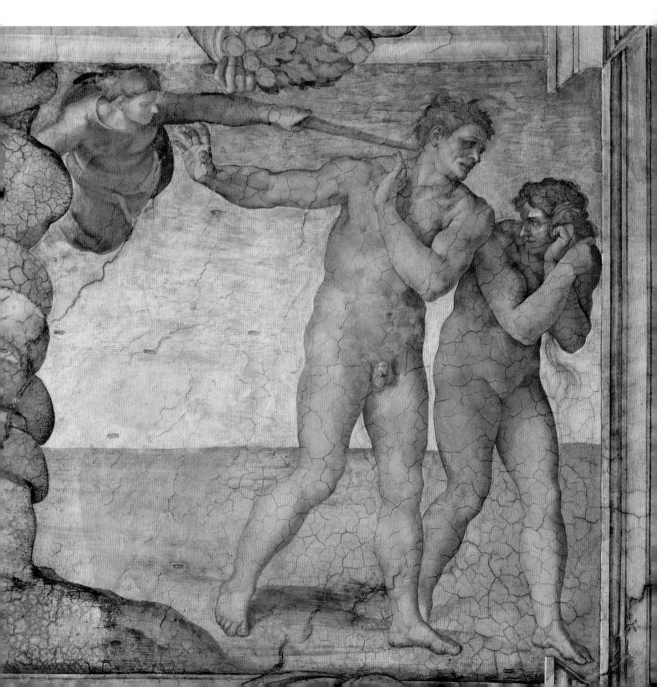

The School of Athens

1509–11 FRESCO

16½ X 25 FT (500 X 770 CM)

APOSTOLIC PALACE, VATICAN CITY

Assembling within a classical architectural background are the greatest ancient Greek philosophers. The two men in the center, on the top of the steps, are Plato and his student Aristotle. Plato is said to be a portrait of Leonardo. Seated on the steps, leaning on his hand, is a portrait of Michelangelo as Heraclites and looking out of the group on the right is a self-portrait of Raphael himself.

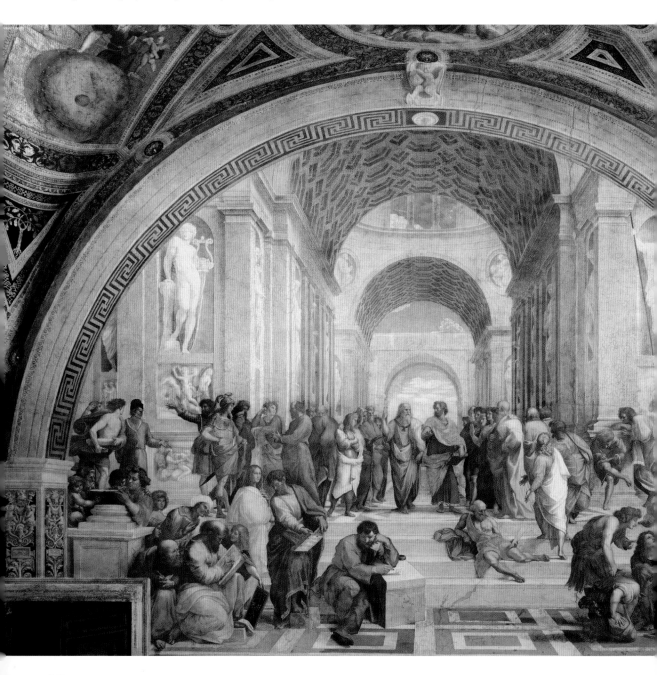

Raphael

1483–1520 • HIGH RENAISSANCE

Although he lived for just 37 years, Raphael is recognized as one of the three most revered Italian Renaissance masters. Although he was not a great inventor like Leonardo and Michelangelo, he is known for the grace, beauty, emotional depth, and sensitive expression that permeate his art.

Raphael was born Raffaello Sanzio. His father worked as a painter at the court of the Duke of Urbino, so he was aptly placed to give his son his first lessons in painting. By the time he was 11, however, both Raphael's parents had died and he had to rely on his precocious artistic talents to survive. His early life and apprenticeships are uncertain, but it is accepted that he worked in Perugia as an assistant to the master Perugino (c.1445–1523) from around 1500.

By 1501, Raphael was a master in his own right and soon settled in Florence, where Leonardo and Michelangelo were dominating the art world. He remained in Florence for four years, becoming known for his paintings of serene and natural-looking young Madonnas in idealized landscape backgrounds. As well as his outstanding drawing and painting skills, he became recognized for his handsome appearance, good manners, and courteous behavior. Leonardo and Michelangelo complained that he copied them, but Raphael denied this. However, he admitted that he had learned from the artists' understanding of anatomy, perspective, composition, and softly blended shadows. From this he developed his own unique and sophisticated understanding of color, line, and subtle textures.

In 1508, Pope Julius II summoned Raphael to Rome to paint some large frescoes in four rooms in the Vatican Palace. It was an extremely momentous commission for the 26-year-old artist, who had no experience of painting figures on such a large scale. Secretly, next door, the illustrious Michelangelo was painting the Sistine Chapel ceiling and Raphael had the chance to see the work before it was completed. Enthused, he produced hundreds of detailed preliminary drawings and then painted imposing scenes personifying Theology, Philosophy, Poetry, and Justice—one on each wall. Each work demonstrated Raphael's versatility, subtlety, and understanding of color and composition and earned him the reputation of being able to replicate textures, natural poses, and sensuous flesh. Apart from these monumental works, he also executed easel paintings, including religious works and portraits. His reputation lived on unsurpassed and his style set a precedent for Western art for the next 400 years.

KEY WORKS

The Sistine Madonna 1513, GEMÄLDEGALERIE, DRESDEN, GERMANY

Madonna of the Pinks c.1506–7, NATIONAL GALLERY, LONDON, UK

Galatea 1513, VILLA FARNESINA, ITALY

Portrait of Pope Leo X 1518–19, GALLERIA DEGLI UFFIZI, FLORENCE, ITALY

Titian

1488–1576 • (VENETIAN) HIGH RENAISSANCE

At the beginning of the 16th century, Venice was one of the wealthiest and most powerful city-states in Europe. The supreme Venetian artist of this period was Tiziano Vecellio, known as Titian. His work integrated all the Renaissance ideals, infusing them with new life, and the eminence he achieved during his own lifetime has endured for over 400 years.

For a little over 20 years, from 1538 to 1562, Florence was ruled by Cosimo de' Medici and his Spanish wife, Eleonora di Toledo. A pious woman, Eleonora discouraged art that seemed overtly sexual. In contrast, the young Titian, growing up in Venice, had none of these restrictions. The early 16th century was a time of abundant experimentation in Venetian painting and Titian, without Leonardo's fascination with science or Michelangelo's interest in religion and poetry, was simply an artist who developed innovative painting methods.

Titian was born in the Italian Alps and from the age of about ten, was sent with his elder brother to Venice to train with the mosaicist Sebastiano Zuccato. He soon moved to the painting workshop of the brothers Gentile and Giovanni Bellini and later joined the studio of Giorgione (c.1477–1510) as painter's assistant. The two became close friends and remained so until Giorgione's untimely death in his early 30s. The following year, Titian received a commission for three frescoes in Padua. Further commissions followed for the Italian courts of Ferrara, Mantua, and Urbino and his fame spread internationally.

In 1516, Giovanni Bellini died and Titian was appointed official painter of the Venetian Republic. His first public commission was the *Assumption of the Virgin* for the high altarpiece of the church of Santa Maria Gloriosa dei Frari. An outstanding example of his mastery with color, this established him securely as the greatest living Venetian artist. From then on, he gained many patrons, including François I of France, Philip II of Spain, the Holy Roman Emperor Charles V, and Pope Paul III.

For the rest of his life, Titian continued painting, displaying his versatility and imagination. His works feature dramatic expression, unconventional dynamic compositions, tonal drama, and sumptuous colors. He helped to establish oil paints as the most accepted medium, realizing that their fluid, slow-drying properties made them perfect for depicting textures, capturing the effects of light and atmosphere and blending gleaming colors inspired by the Venetian light itself.

Titian also realized that canvas was better suited to his painting techniques. Using freer brushstrokes than many Renaissance artists, and sometimes smoothing on paint with his fingers, he applied his rich and glowing colors rapidly and confidently. His reinterpretation of traditional themes, sometimes with asymmetrical compositions and often with figures interacting with each other, was entirely new. He strongly influenced his Venetian contemporaries and many later painters, including Poussin, Rubens, van Dyck, Velazquez, and Delacroix. For over five centuries, he has been classed as the greatest colorist of them all.

KEY WORKS

Assumption of the Virgin 1516–18, SANTA MARIA
 GLORIOSA DEI FRARI, VENICE, ITALY
Venus of Urbino 1538, GALLERIA DEGLI UFFIZI, FLORENCE,
 ITALY
Emperor Charles V at Muhlberg 1548, MUSEO DEL PRADO,
 MADRID, SPAIN
Diana and Actaeon 1556–9, NATIONAL GALLERY OF
 SCOTLAND, EDINBURGH, UK
Annunciation c.1559–64, SAN SALVADOR, VENICE, ITALY

Bacchus and Ariadne

1520–3 OIL ON CANVAS

69½ X 75 IN (176.5 X 191 CM)

NATIONAL GALLERY, LONDON, UK

Lavishly painted with an animated composition, Bacchus, the god of
wine, is gamboling along with his followers when he sees Ariadne. He
instantly falls in love with Ariadne and leaps from his chariot to speak
to her. Ariadne, abandoned by her former lover, Theseus (seen on
the ship in the distance), is initially afraid of Bacchus. She succumbs
to his advances when he offers to raise her to heaven, which is
indicated by the constellation in the sky.

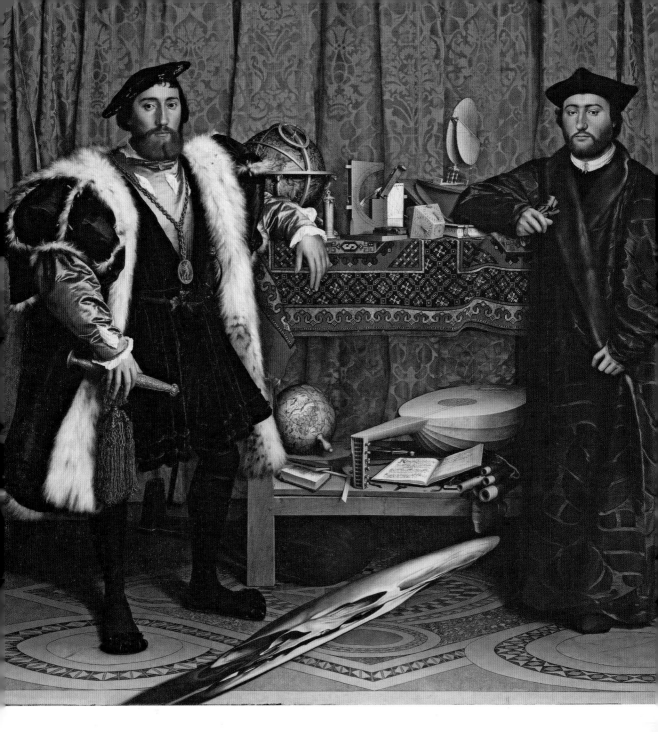

The Ambassadors

1533 OIL ON OAK

81 x 82 IN (207 x 209.5 CM)

NATIONAL GALLERY, LONDON, UK

This life-sized double portrait features various symbols that tell of the lives of the subjects. Jean de Dinteville on the left, aged 29, was French ambassador to England. His friend, Georges de Selve, aged 25, was bishop of Lavaur. Between them, they represent the secular and the spiritual. Two globes, a sundial, an Asian carpet, a lute with a broken string, flutes, books in the background, and a distorted skull in the foreground signify their lives and that death is never far away.

Holbein

1497–1543 • (NORTHERN) HIGH RENAISSANCE

Regarded as one of the greatest portraitists of all time, Hans Holbein the Younger moved to England from Germany when he was in his 20s, effectively taking Renaissance art to Britain. The work he produced as the court artist for King Henry VIII is vivid evidence of the glamor and dangers of court life in Tudor England.

Son of the successful painter Hans Holbein the Elder, Holbein was born in Augsberg, Germany. He and his elder brother Ambrosius received professional training with their father in jewelry design, printmaking, and painting. In 1516, the brothers traveled to Basel in Switzerland, where they entered the workshop of the foremost Swiss painter, Hans Herbster. Both brothers were gifted artists and in Basel they took on many small commissions for religious paintings and portraits, as well as book design and illustration. For two years from 1517, they lived and worked alongside their father in Lucerne, Switzerland, but after the premature death of Ambrosius in 1519, Hans returned to Basel. There he worked in a print and publishing workshop that was a meeting place for local intellectuals, and he made friends with the humanist scholar, Desiderius Erasmus.

Holbein soon earned a name for himself as a talented portraitist, painting the mayor of Basel and his wife and three portraits of the great Renaissance scholar Erasmus. But he did not restrict himself to portraiture and his output was extremely productive and varied, comprising murals, woodcuts (including illustrations of Martin Luther's Old and New Testaments), religious works (including frescoes and panel paintings), altarpieces, and designs for stained glass and jewelry. His observant, expressive, sharply detailed, and tonal style earned him the reputation of leading artist in Basel and he was awarded citizenship of the town.

Despite this success, as the Protestant Reformation spread throughout northern Europe, Basel became a difficult place for an artist to work and earn money. In 1526, carrying a letter of introduction from Erasmus, Holbein went to London. He was made welcome by Sir Thomas More, King Henry VIII's treasurer, and with his mix of northern and Italian Renaissance styles, rapidly established himself, proving himself to be an artist of remarkable skill. With his dexterous realism, he introduced the Renaissance to Britain and was soon accepted as the principal artist at the English court. As well as being employed by Henry VIII in a wide range of commissions, including designing court costumes, silverware, jewelry, and triumphal arches, to painting portraits of Henry's family, his future brides, queens, and important members of his court, he was also commissioned to paint portraits of numerous courtiers, landowners, and merchants.

Although he returned to Basel briefly, he was in Britain again in 1532. Employed as the King's Painter on an annual salary of thirty pounds, he continued painting portraits of significant figures and then the King himself. A gifted draftsman, Holbein always made preparatory portraits of his sitters, and these were exact, precise, and quickly rendered. Then he transferred each study to a panel using geometrical instruments, and creating the finished work with oil or tempera or a mixture of both. His work was unique and original, and his meticulous attention to detail, clear and lifelike representations, almost imperceptible brushstrokes, and close observation made him immensely popular, not least for the symbolism that he integrated into his portraits.

KEY WORKS

The Body of the Dead Christ in the Tomb 1521, KUNSTMUSEUM BASEL, BASEL, SWITZERLAND

Portrait of Erasmus 1523, MUSÉE DU LOUVRE, PARIS, FRANCE

Portrait of Georg Gisze of Danzig 1532, STAATLICHE MUSEEN ZU BERLIN, GEMÄLDEGALERIE, BERLIN, GERMANY

Portrait of Anne of Cleves c.1539, MUSÉE DU LOUVRE, PARIS, FRANCE

Portrait of Henry VIII 1540, GALLERIA NAZIONALE D'ARTE ANTICA, ROME, ITALY

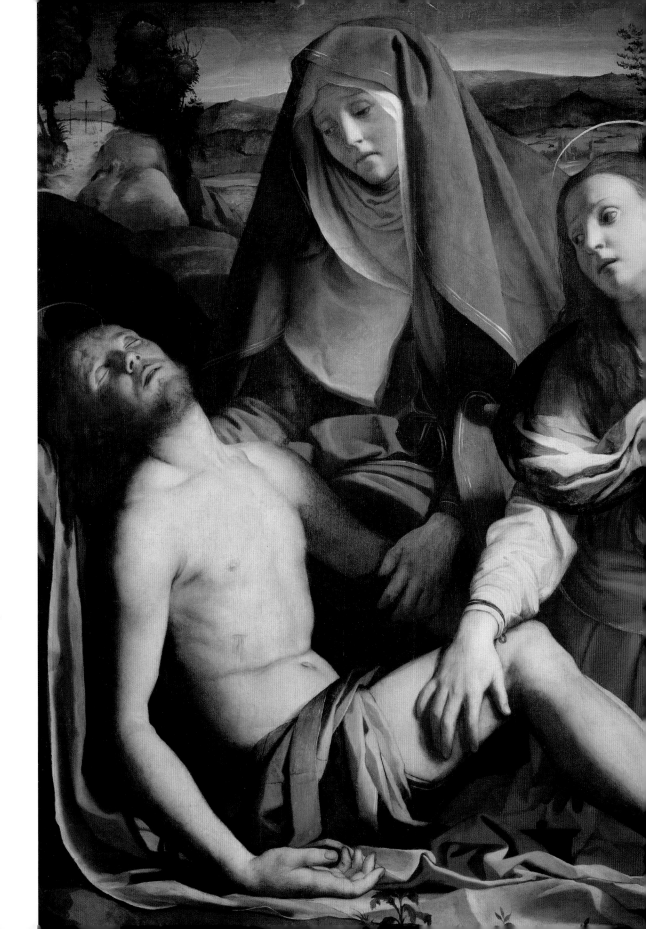

Bronzino

1503–1572 • MANNERISM

With his crisp and stylized approach, Agnolo di Cosimo, known as Bronzino, spent much of his life as court painter to the powerful Medici family in Florence.

As a pupil and adopted son of the Mannerist painter Pontormo, Bronzino (whose nickname probably arose from his dark complexion) developed a style that was heavily indebted to his master, but more detached. He excelled at portrait painting more than religious works because he infused them with refinement, assurance, and impartiality. His tapestry designs were also successful, thanks to his understanding of color and composition.

From 1539, when he was in his 30s, Bronzino began working for Duke Cosimo de' Medici. He spent almost his entire career in his service, and became the leading painter in Florence. Mannerism absorbed the ideals of the High Renaissance but stylized it and Bronzino's specific painting style influenced European court portraiture for a century. His elegant portraits of aristocratic figures seemed real but aloof, calm, and flawless, with tightly controlled coloristic effects.

Bronzino's style was cultivated from the later paintings of Michelangelo: composed and dignified, with elongated proportions subtly suffused with bright or deep colors and textural details, and cool, smooth, alabaster-like skin tones portrayed with assurance and sophistication. An exceptionally skillful draftsman, Bronzino conveyed the confidence and pride of his noble sitters, creating pearlescent skin and sumptuous clothes and jewelry—grandeur and perfection were favored over naturalism and imperfections. His religious and mythological paintings often feature elongated and contorted poses, inspired by Michelangelo and Raphael. Also a poet, Bronzino's most subjective portraits are those of other literary figures, including Dante and Petrach. In 1563, he became a founder member of the Accademia delle Arti del Disegno—the first academy of drawing in Europe.

The Dead Christ between the Virgin and Mary Magdalene

*c.*1530 OIL ON PANEL

39 X 41 IN

(100 X 105 CM)

GALLERIA DEGLI UFFIZI,

FLORENCE, ITALY

Filled with the three figures, this composition shows Bronzino's confident handling of color, tone, drapery, and textures. Strong light falls on the tragic group, highlighting the desolation. Although the story is unmistakable, the figures are remote and viewers can observe it with detachment.

KEY WORKS

Venus, Cupid, Folly, and Time 1540–5, NATIONAL GALLERY, LONDON, UK

Portrait of Bia de' Medici c.1542, GALLERIA DEGLI UFFIZI, FLORENCE, ITALY

Eleonora of Toledo 1544–5, GALLERIA DEGLI UFFIZI, FLORENCE, ITALY

Portrait of a Man holding a Statuette 1550, MUSÉE DU LOUVRE, PARIS, FRANCE

Martyrdom of Saint Lawrence 1565–9, SAN LORENZO, FLORENCE, ITALY

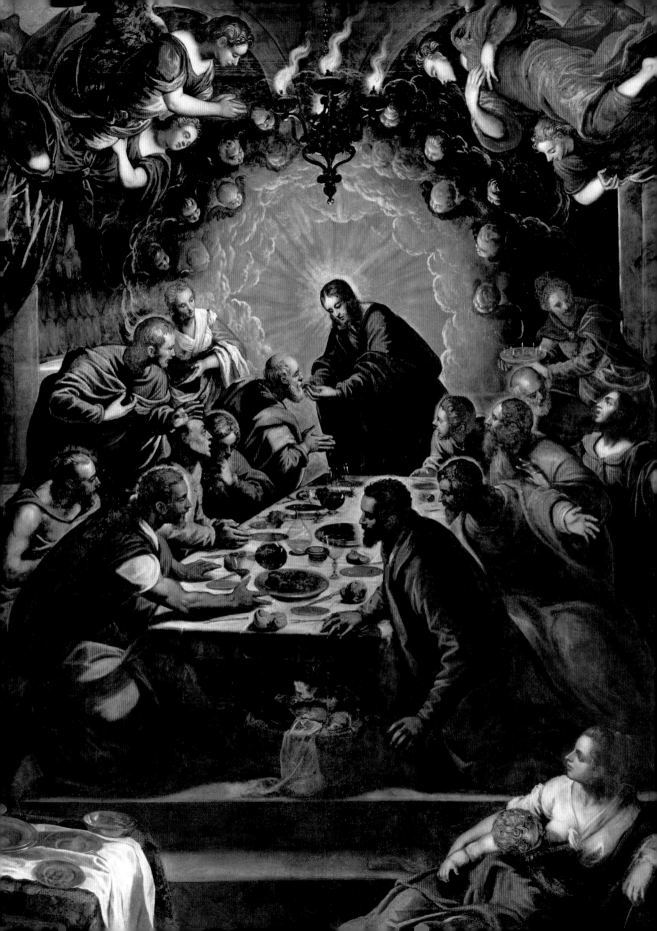

Tintoretto

1518–1594 • MANNERISM

Jacopo Comin, or Jacopo Robusti, who became known as Tintoretto (meaning "little dyer" after his father's trade), was one of the most successful Venetian painters in the generation after Titian.

Although a well-respected and prolific painter, little is known of Tintoretto's life. Born in Venice, the eldest of 21 children, his early years were often spent in his father's dyeing store. There, he allegedly drew charcoal drawings on the walls, coloring them with his father's dyes, which is how he earned his nickname. Another name he gained later was "Il Furioso," for the fury and speed with which he painted. Working extremely quickly, he used his imagination more than careful planning.

Legend has it that when he was 15, he was apprenticed to Titian, then in his 50s, but was dismissed within days because of rivalry. Other interpretations suggest that the notoriously difficult Tintoretto walked out on Titian after a row; still others say that he had only been in the studio for ten days when Titian sent him home—for disobedience, or because of Titian's jealousy of the boy's precocious talents. When he opened his own workshop just a few years later, he expressed his intention to synthesize "Michelangelo's design and Titian's color" in an inscription on the wall. However, his plan to reproduce the brilliant compositional methods of Michelangelo and the bold coloring of Titian was never achieved; instead his experimentation with dynamic perspectives and special lighting effects resulted in energetic and powerfully rhythmic and lyrical large paintings.

Through his creation in 1548 of *Saint Mark Rescuing a Slave*, a large, crowded composition that captures a moment in time and incorporates bold foreshortening and vivid color, his reputation was made. His paintings convey a more intense, exaggerated style than any other contemporary Venetian artists and he became known for his lively compositions and portrayals of figures in motion. He worked exclusively in Venice, and after two fires in the Doge's Palace in 1574 and 1577, he and Veronese were the main artists commissioned to renew the interior. He painted a huge work, *Paradise,* for the main hall. To aid his figure drawings, he used wax models of statues from the Medici family tombs, even working with them at night by candlelight to achieve his dramatic and unusual depictions of light. As his popularity and commissions increased (mainly for the state or local churches), he employed a large number of assistants, including his sons, Domenico and Marco, and his daughter, Marietta. His extravagant compositions formed what has been called Venetian Mannerism.

The Last Supper

1590–1 OIL ON CANVAS

137¾ x 92½ IN (350 X 235 CM)

DUOMO DI SAN MARTINO, LUCCA, ITALY

Mannerist paintings frequently place the focus deep into the composition. Here Tintoretto has adhered to that concept, with Jesus at the end of a foreshortened table, surrounded by apostles and angels. The light, composition, and dramatic perspective are striking and the colors spectacular.

KEY WORKS

The Maundy Thursday (Christ Washing the Feet of His Disciples) 1547, MUSEO DEL PRADO, MADRID, SPAIN

Saint George and the Dragon c.1560, NATIONAL GALLERY, LONDON, UK

Leda and the Swan c.1560, GALLERIA DEGLI UFFIZI, FLORENCE, ITALY

The Baptism of Christ c.1570, MUSEO DEL PRADO, MADRID, SPAIN

The Origin of the Milky Way c.1575, NATIONAL GALLERY, LONDON, UK

Bruegel

*c.*1525–1569 • (NORTHERN) HIGH RENAISSANCE

The last, and one of the greatest, of the 16th-century artists from northern Europe, Pieter Bruegel the Elder was a painter and printmaker known for his landscapes and satirical peasant scenes. Although he was nicknamed "Peasant Bruegel" because of his subject matter, he was a highly educated man with a broad knowledge of myth and legend.

As with many artists of this period, there is little documentation for Bruegel's early life. He was probably born in Breda, now in the Netherlands, and until 1559, spelt his name "Brueghel." Apprenticed to Pieter Coecke van Aelst (1502–50), a leading artist, sculptor, architect, and designer of tapestry and stained glass, in 1551 Bruegel was accepted as a master in the Antwerp Painters' Guild. The following year, he traveled to France, Italy, and Switzerland, visiting Palermo, Naples, Rome, and the Alps and producing several drawings and paintings, mostly of landscapes, while there. His prints and paintings were detailed, atmospheric, and spacious—clearly inspired by the places he had seen, rather than by the Italian artists, as they are different from anything produced in Italy at that time.

By 1555, Bruegel was back in Antwerp, designing engravings; between 1555 and 1563, he designed more than 40, taking advantage of the popularity of Bosch's style. He also began producing scenes of peasant life in the moralistic manner of Bosch, but without the fantasy, emphasizing the ridiculous and the vulgar through lively, witty, and compassionate compositions. The peasants he painted working, feasting, and merrymaking became vehicles through which he could highlight human failings and follies. In 1563, Bruegel married and moved to Brussels. At that point, his career changed direction. Although he continued to design engravings, he began working primarily as a painter.

In 1565, he was commissioned by his friend and patron, Nicolaes Jonghelinck, a wealthy merchant, to produce a series of paintings entitled *The Months*. Only five of the 12 works survive: *Hunters in the Snow* (January), *The Gloomy Day* (February), *Haymaking* (July), *The Corn Harvest* (August), and *The Return of the Herd* (November). With his colorful and descriptive style, Bruegel developed an original and invigorating style of storytelling. In the 1560s, he was influenced by Italian Renaissance art and simplified his work, including fewer and larger figures and situating them closer to the viewer. After his death, his sons became artists, although neither achieved their father's greatness.

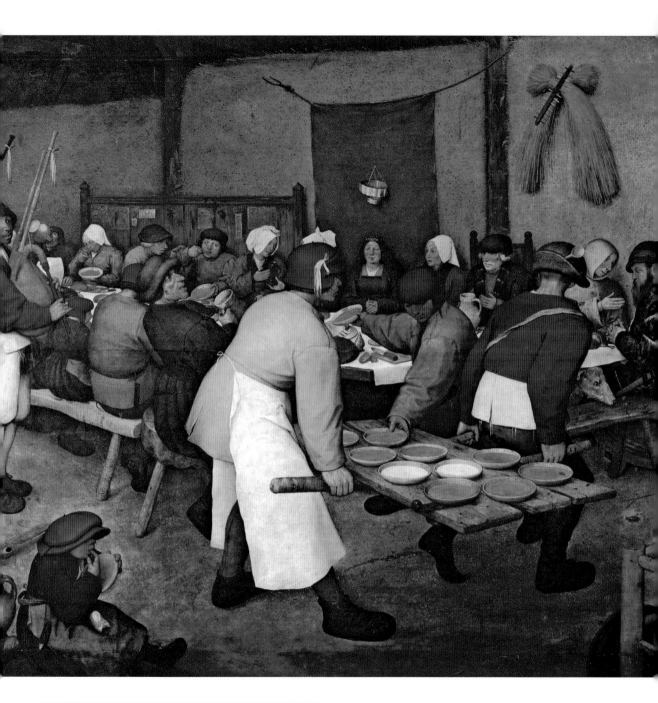

KEY WORKS

Landscape with the Fall of Icarus *c.*1558, MUSÉES ROYAUX DES BEAUX-ARTS DE BELGIQUE, BRUSSELS, BELGIUM

Netherlandish Proverbs 1559, STAATLICHES MUSEUM, BERLIN, GERMANY

The Fight between Carnival and Lent 1559, KUNSTHISTORISCHES MUSEUM, VIENNA, AUSTRIA

The Hunters in the Snow 1565, KUNSTHISTORISCHES MUSEUM, VIENNA, AUSTRIA

The Peasant Wedding

*c.*1568 OIL ON WOOD

45 x 64½ IN (114 x 164 CM)

KUNSTHISTORISCHES MUSEUM, VIENNA, AUSTRIA

In a barn, sitting under a canopy, the bride grins foolishly while the man who is probably the groom is intent on gobbling his food. One man pours beer and two others carry bowls of broth on a makeshift tray. At the back, gatecrashers try to enter, a musician looks hungry, and a child in an over-sized hat licks a plate. Yet in all the activity, Bruegel's composition does not seem congested.

The Wedding Feast at Cana

1562–3 OIL ON CANVAS

266½ x 391¼ IN (677 x 994 CM)

MUSÉE DU LOUVRE, PARIS, FRANCE

In the Bible, Jesus' first public miracle was turning water into wine at
a wedding feast at Cana. In this immense painting, intended for the
Benedictine Convent on San Maggiore, the feast takes place against
a monumental Venetian architectural backdrop inspired by Palladio.
In each of the 130 figures, every face is different and colors glow like
jewels. Veronese has included a self-portrait in white playing the viola;
beside him are Titian and Tintoretto.

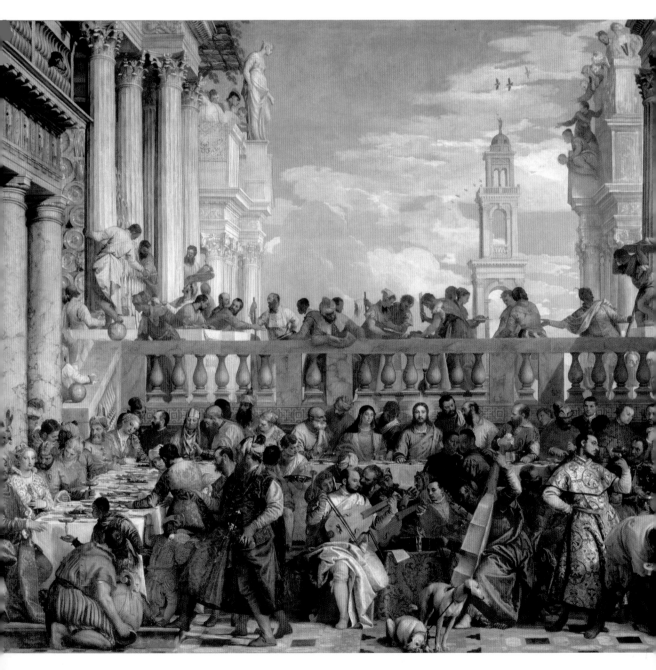

Veronese

1528–1588 • (VENETIAN) HIGH RENAISSANCE, MANNERISM

Besides Titian, there were two other great Venetian painters in the 16th century. One was Tintoretto, the other was Paolo Caliari, known as Veronese. Recognized for his imposing narrative paintings, with their dramatic and magnificent settings, Veronese's Mannerist style and handling of color and texture were sumptuous and powerful.

Veronese (nicknamed after his birthplace, Verona) was apprenticed at the age of 14 to the local master Antonio Badile (c.1518–60) and possibly also with Giovanni Francesco Caroto (1480–1555/8), from whom he learned local styles and traditions, including strong colors and contrasts. He moved briefly to Mantua in 1548 before arriving—and remaining—in Venice in 1553. For his first commissions, he articulately combined Veronese painting traditions with High Renaissance finishes and unusual Mannerist viewpoints and dramatic figures. He quickly attracted major commissions, both religious and secular, and his paintings for the church of San Sebastiano, the Doge's Palace, and the Marciana Library established him as a major force among Venetian artists, classed as high as Titian and Tintoretto. With his perspective effects, his decorative sense, and his distinctive radiant palette, he could make a crowded composition seem harmonious.

Veronese delighted in painting huge spectacles that displayed the majesty of 16th-century Venice. Marble columns, costumes of velvet and satin, and glittering jewels are major elements. He painted many religious, mythological, and allegorical works, as well as portraits; his religious scenes were particularly stunning to viewers as he set them in contemporary Venetian locations, dressing saints in expensive garments and jewels. Veronese's decorative narrative paintings massaged many Venetian nobles' egos, as they compared themselves with characters from the Bible and classical myth. Many of his works reveal his fascination with architecture, incorporating exacting architectural details and features that complement the stories. Veronese's early compositions often contained dramatically steep perspectives; later they became more classical, but featured dazzling light and color harmonies. From about 1583, he began introducing the soft light of dusk, as well as his usual brilliant daylight. Some of his finest works were frescoes, produced outside Venice. Because he had such a highly organized studio and his output was so large, there are difficulties in distinguishing his own work. After his death, his workshop was continued by his brother and his sons.

KEY WORKS

The Supper at Emmaus c.1559–60, MUSÉE DU LOUVRE, PARIS, FRANCE

The Finding of Moses c.1570–5, KUNSTHISTORISCHES MUSEUM, VIENNA, AUSTRIA

The Feast in the House of Levi 1573, GALLERIA DELL'ACCADEMIA, VENICE, ITALY

The Four Allegories of Love 1575, THE NATIONAL GALLERY, LONDON, UK

Pietà 1576, STATE HERMITAGE, ST. PETERSBURG, RUSSIA

Baroque

c.1600–1700

A term used to describe a style of art that succeeded Mannerism, Baroque is probably derived from "barocco," the Portuguese word for a misshapen pearl. The definition was introduced retrospectively to describe art that infused emotion, dynamism, and drama with strong tonal contrasts. Baroque developed as a consequence of the religious tensions in Europe and was intended to strengthen the image of Catholicism.

The Council of Trent

In reaction to the rejection of Catholic doctrines by the Protestant Christian movement in the early 1500s, bishops of the Catholic Church convened at the Council of Trent in Italy between 1545 and 1563. Over the course of 25 sessions. their purpose was to discuss and settle matters of Church doctrine and practice. One of the decisions was that religious art must encourage piety, through directness, accuracy, realism, and logic. But it was not until over 30 years later with the Counter-Reformation—a period of Catholic revival—that a radical new style developed. The Baroque style emerged initially in Italy, later spreading to France, Germany, Netherlands, Spain, and Britain. The new type of art

was intended to be visually and emotionally appealing and to focus clearly on the Catholic doctrine in order to influence and educate. The style evolved when the Roman Catholic Church had to make a strong stand against the many revolutionary cultural movements that were producing new religious ideas. It gave the Catholic Church an official and commanding form of expression to show the reformers the superiority of the Catholic religion—but it did not remain exclusively associated with religious art.

Stylistic interpretations

As with the Renaissance and Mannerism, Baroque artists included certain common styles, techniques, or

1601
Supper at Emmaus, *Caravaggio* (c.1573–1610)

1609–10
Samson and Delilah, *Rubens (1577–1640)*

c.1612–21
Judith Slaying Holofernes, *Gentileschi* (1593–1652)

1633
Charles I, *van Dyck* (1599–1641)

1600

1610

1600
Christ Driving the Traders from the Temple, *El Greco* (1541–1614)

1601
St. Cecilia, *Stefano Maderno* (1576–1636)

1624–33
Baldacchino, *Bernini* (1598–1680)

1634–37
San Carlino (San Carlo alle Quattro Fontane), *Francesco Borromini* (1599–1667)

approaches, but also introduced their own individuality. They all understood that their task was to interpret stories clearly and realistically, but from this starting point they diversified. All the work is exuberant and intense, with solid, believable figures and telling human dramas. From Mannerism, the style inherited movement and intense emotion, while it took solidity, perspective, and classical lines from the Renaissance. Two of the most significant aspects of Baroque art were in the portrayal of vivid contrasts of highlight and deep shadow and in the close observation of textures and details. Going against the Renaissance approach of idealizing figures and subjects, many Baroque artists portrayed realistic figures and situations, often using ordinary people as models. Relaxing harmonies were abandoned in favor of energetic and complex compositions. It was a direct, dramatic art, intended to tell stories with no chance of misinterpretation.

At the same time, architects began creating impressive structures and interiors that expressed pride, power, and influence. Baroque architecture features grand entrances and staircases, opulent courts and rooms, and a wide range of dramatic styles and use of light and shadow.

The spread of Baroque

In contrast to the Renaissance, when Florence and Venice were the main artistic centers, Rome was the starting point during the Baroque period. The new style soon spread through the other Catholic countries of Europe. Caravaggio's highly dramatic work was admired, although some rejected it as too realistic. The leading Baroque sculptor, Gian Lorenzo Bernini (1598–1680), had a profound effect on generations of artists with his expressive and energetic interpretations of biblical and mythological stories. In Flanders, Rubens produced religious and secular works in loosely applied paint, while in France, Poussin's crisp, clear style and Claude's classical landscapes contrasted with Rubens's passionate paintings. Meanwhile, in Spain art reached new heights with the rapid, dazzling brushwork of Velázquez. In Belgium and England, with his lively and elegant portraits and luxurious fabrics, van Dyck spread the styles of the Baroque even further north. Nonetheless, it took a while—Baroque was resisted in Protestant countries such as Holland and Britain for as long as possible. The Baroque art that did develop in northern Europe tended to emphasize realism in daily life, moving away from the emotional impact that the Catholic countries preferred.

The style had the greatest impact and lasted longest in Catholic countries. During the 18th century, it became increasingly ornate and ultimately receded in favor of the lighter, more decorative Rococo style.

c.1638–40
Et in Arcadia
Ego, *Poussin*
(1594–1665)

1648
The Embarkation of the
Queen of Sheba,
Claude (1600–82)

c.1650–55
Madonna with
the Rosary,
Murillo (1612–82)

1661–74
Château de
Versailles, *Jules
Hardouin-Mansart*
(1646–1708)

1666–79
San Lorenzo,
Turin, *Guarini*
(1624–83)

1650

1700

c.1640
Adoration of the
Shepherds, *Guido Reni*
(1575–1642)

1656
Las Meninas,
Velázquez
(1599–1660)

1665
Alexander in
Babylon,
Charles Le Brun
(1619–90)

El Greco

1541–1614 • MANNERISM, EARLY BAROQUE

Regarded as the first great genius of the Spanish School, Doménikos Theotokópoulos was a Cretan-born painter, sculptor, and architect. He settled in Spain when he was in his mid-30s, and produced dramatic paintings demonstrating spiritual energy and intensity. His work projected a visionary quality and was a blend of Mannerism and the Venetian Renaissance, with some stylized and personal distortions.

Known as El Griego (the Greek), which became El Greco after his death, Theotokópoulos signed his work with his full name in Greek letters throughout his life. Little is known about his youth, but in 1563 he was referred to as a master painter, so he must have been running his own workshop. As a native of Crete, he would have trained in icon painting, which was influenced by Byzantine art. By 1570, he had traveled to Venice and Rome and was described as a disciple of Titian, which could mean that he was trained by Titian, that he worked in the artist's workshop, or simply that he was influenced by him.

El Greco's art illustrates the strict piety that abounded during the Counter-Reformation in Europe. In Rome, he began painting new interpretations of traditional religious subjects, but he did not receive any public commissions and worked mainly on a small scale. His rejection of Michelangelo's techniques and his unconventional approach attracted enmity, so in 1576 he moved to Spain, briefly staying in Madrid before settling in Toledo, the religious capital of Spain at the time, where he spent the rest of his life. His individual style became extremely popular in Toledo and he gained major commissions, starting with a picture for the cathedral in 1577.

By elongating his figures, he aimed for graceful lines, dramatic compositions, and arresting color. His palette is reminiscent of Titian's but his distortions seem to derive from Tintoretto. He believed that color was more important than form and applied light colors over dark underpainting. Many works seem violent and stormy, which is probably a reflection of his intense religious beliefs (it is debated whether he was Catholic or Greek Orthodox). In several paintings, he seems to blend form and space—so for instance, skies and air can look just as powerful and dominant as figures and solid objects.

In assimilating ideas of the Renaissance and late Mannerism, he created dramatic illusions, portraying stories in fantastic, almost hallucinatory ways. Figures twist and stretch like flames; apocalyptic skies represent the anger of God; angels sit on stormy clouds looming over contemporary figures; and dramatic light and tone pull everything together. Although he painted fewer portraits than religious works, they include similar characteristics and he was also highly esteemed as a sculptor. But, largely because his methods did not fit in with any major style, he had no real followers, although much later, Goya and then Picasso revived his popularity.

KEY WORKS

The Holy Trinity 1577, MUSEO DEL PRADO, MADRID, SPAIN

El Espolio (The Spoliation, Christ Stripped of His Garments) 1577–9, SACRISTY OF TOLEDO CATHEDRAL, TOLEDO, SPAIN

The Adoration of the Shepherds 1612–14, MUSEO DEL PRADO, MADRID, SPAIN

The Opening of the Fifth Seal of the Apocalypse c.1608–14, METROPOLITAN MUSEUM OF ART, NEW YORK, US

Baptism of Christ 1608–14, HOSPITAL DE SAN JUAN BAUTISTA DE AFUERA, TOLEDO, SPAIN

Christ Driving the Traders from the Temple

*c.*1600 OIL ON CANVAS

41¾ X 51 IN (106.3 X 129.7 CM)

NATIONAL GALLERY, LONDON, UK

During Christ's lifetime, a market was held in the porch of the Temple in Jerusalem. Traders sold sacrificial animals and changed money. In a biblical story, a furious Jesus turned the traders away, claiming that God's house should be one of prayer. Here, Jesus dominates the canvas, ready to unleash his whip. The traders recoil on his left and his apostles stand on the right. El Greco painted this subject several times. The version shown here, with its intense colors and elongated forms, is believed to have been painted in Toledo in about 1600.

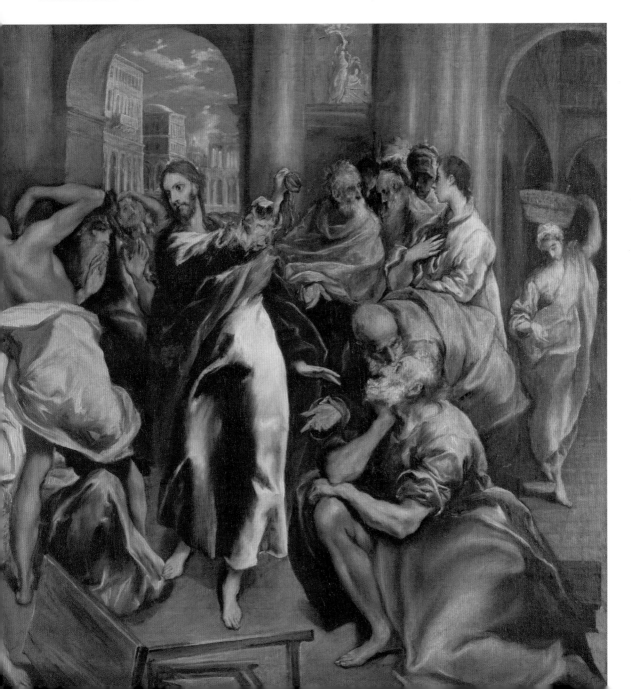

Supper at Emmaus

1601 OIL AND TEMPERA ON CANVAS

55½ X 77 IN (141 X 196.2 CM)

NATIONAL GALLERY, LONDON, UK

Caravaggio's portrayal of holy figures as low-class people was considered by many to be blasphemous. This is after the Crucifixion when two of Jesus' apostles are supping with a stranger they met on the road. Suddenly they realize it is Jesus. The vivid realism, dramatic lighting, and the apostles' shock involve viewers in the event.

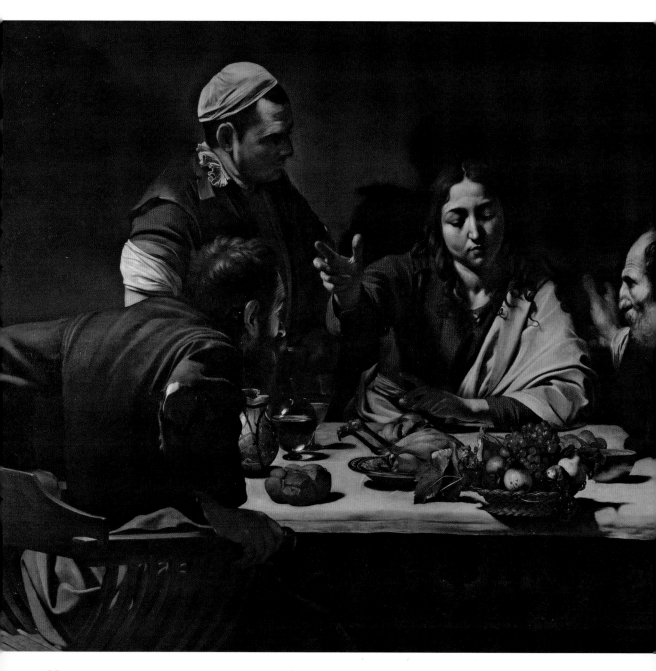

Caravaggio

c.1573–1610 • BAROQUE

Despite the controversies that dogged his short and troubled life, Michelangelo Merisi, known as Caravaggio, was one of the most influential artists of the late 16th and early 17th centuries. Often classed as the first Baroque painter, he introduced a completely new concept in art—that simple reality is more important than idealism.

Michelangelo Merisi da Caravaggio was born in Milan but moved to Caravaggio in Lombardy soon after and later trained there. By the time he was 13, both his parents had died, so he returned to Milan to continue training with one of Titian's pupils, Simone Peterzano (c.1540–96). In 1592, aged about 20, he traveled to Rome, which was being modernized and where the cultural environment embraced humanist beliefs. He was introduced to Giuseppe Cesare d'Arpino (1568–1640), the most popular painter and art dealer there, and through him Caravaggio quickly gained recognition and was commissioned by several prominent patrons.

Tormented, aggressive, and often involved in fights, Caravaggio's personal life became a series of confrontations with the Church, the state, and those around him. He introduced elements of everyday reality into his art, abandoning the rules that had guided a century of artists before him. Rejecting the sketches, squared-up drawings, and lengthy canvas preparations that most artists employed, he worked in oils directly from the subject, creating a look of spontaneity and immediacy. Aiming to produce forceful paintings that showed the truth, he was critically condemned for featuring working-class figures in religious works. Whereas Renaissance artists had idealized the human and religious experience, he portrayed it in blunt reality—ordinary people looking remarkably lifelike in everyday surroundings.

Many were shocked by Caravaggio's work, believing it to be sacrilegious and irreverent, but it was also widely admired. Caravaggio became overwhelmed with commissions to produce more large-scale, powerfully expressive canvases, which featured his dramatic foreshortening and striking use of chiaroscuro—strong light contrasted with deep shadow. However, because of his violent disposition, he was persistently in trouble with the law. In 1606, he became involved in a murder and fled from Rome. He found refuge in various places, including Naples, Sicily, and Malta, always painting to earn a living. Eventually he heard of the Pope's pardon, but never reached Rome as he died from a fever on his eventful return journey.

> **KEY WORKS**
>
> **The Cardsharps** c.1594, KIMBELL ART MUSEUM, FORT WORTH, TX, US
>
> **The Crucifixion of Saint Peter** 1601, CERASI CHAPEL, SANTA MARIA DEL POPOLO, ROME, ITALY
>
> **Death of the Virgin** 1601–6, MUSÉE DU LOUVRE, PARIS, FRANCE
>
> **The Deposition** 1604, PINACOTECA VATICANA, ROME, ITALY

Rubens

1577–1640 • BAROQUE

Usually classed as the supreme Baroque painter of northern Europe, Peter Paul Rubens had great energy and many interests and was one of the era's most versatile, original, and prolific artists. Extremely successful—he and his large workshop in Antwerp produced a huge number of works—he also played an important diplomatic role in politics.

The son of a Flemish court official and lawyer, Rubens was born in Germany, but soon moved to Antwerp. He began training with local artists when he was about 14. In 1598 he graduated as an independent master from the Antwerp painters' guild and then traveled to Italy. Stunned by the works of Michelangelo and Titian, and the treasures of antiquity, his work immediately began to change. In 1603, he traveled to Spain on a diplomatic mission and saw Philip II's collections of Raphael and Titian. He returned to Italy in 1604 for four years.

Italy's impact on Rubens was profound. In 1608 he returned to Antwerp, where his reputation preceded him. In order to satisfy the huge demand for his work, he began his own workshop and the following year he was appointed court painter to the rulers of the Netherlands, the Archduke Albert and his wife Isabella. Rubens's intelligence, charm, linguistic skills, and shrewd business sense were noticed and he traveled on many diplomatic missions for his royal patrons. The greatest part of his work, however, was altarpieces; great undertakings featuring voluptuous figures, vigorous brushwork, and brilliant colors. He rose at four each morning and worked until five in the evening. While painting, he employed someone to read to him from classical literature. In 1622, Rubens was commissioned by Marie de' Medici, the widow of Henry IV of France. The monumental project required two galleries in the Luxembourg Palace in Paris to be decorated with two allegorical cycles celebrating the lives of the queen and her late husband. It was a difficult commission in many ways. Marie was unpredictable and her favorite, Cardinal Richelieu, saw Rubens as a political threat. Eventually, the project was abandoned half completed when Maria was banished from court by her son, Henry V. Yet the vast cycle of 24 paintings shows Rubens's fiery approach: a blend of portraits, history, and allegory on 13-foot (4-meter) high canvases, which the artist painted single-handedly.

The demand for Rubens's work was extraordinary, but with his energy, organizational skills, and speedy working methods, he completed countless paintings in his exuberant, fluid, and colorful style. Popular throughout Europe, he was knighted by both Philip IV of Spain (who commissioned over 80 paintings) and Charles I of England. He also produced book illustrations and designed sculpture and architectural details and tapestries. During his lifetime, he was described as a "prince of painters and painter of princes" and on his death he was mourned as one of the great men of his age.

KEY WORKS

The Raising of the Cross 1610–11, CATHEDRAL OF OUR LADY, ANTWERP, BELGIUM

The Descent from the Cross 1611–12, ANTWERP CATHEDRAL, ANTWERP, BELGIUM

Daniel in the Lion's Den c.1615, NATIONAL GALLERY OF ART, WASHINGTON, DC, US

The Arrival of Marie de' Medici at Marseilles 1622–5, MUSÉE DU LOUVRE, PARIS, FRANCE

The Three Graces MID-1630s, MUSEO DEL PRADO, MADRID, SPAIN

Samson and Delilah

c.1609–10 OIL ON WOOD

72 x 80¾ IN (185 x 205 CM)

NATIONAL GALLERY, LONDON, UK

Influenced by Caravaggio and Michelangelo, Rubens has depicted a candlelit interior in which the Jewish hero Samson lies asleep in the lap of his lover, the Philistine Delilah. Bribed by the Philistines, Delilah had discovered that Samson's strength came from his uncut hair. While Samson sleeps, one of the Philistines cuts his hair to drain him of his strength. More Philistines wait at the door, ready to capture Samson.

Gentileschi

1593–1652/3 • BAROQUE

One of the first female painters to gain recognition in the male-dominated world of 17th-century art, Artemisia Gentileschi's powerful and ambitious works reflect her own dramatic life history.

In an age when women artists were severely restricted in their study of art, in what subjects they depicted and in gaining commissions, Roman-born Gentileschi was the first female to paint major historical and religious scenes. Daughter of the artist Orazio Gentileschi (1563–c.1639), she learned to paint directly onto canvas in her father's workshop. Influenced by her father's Mannerist style, and the work of Bronzino (1503–72) and Pontormo (1494–1556), and especially Caravaggio, despite the difficulties she experienced in such a male-dominated world, she developed her own strong and distinctive Baroque style.

Regardless of her skills, as a female Gentileschi was not allowed to enter art academies, so her father hired the painter Agostino Tassi (1578–1644) to teach her privately. In 1611, Tassi raped her. Her father pressed charges, Tassi was arrested, tried publicly, and sentenced to a year's imprisonment, although he never served the time. During the trial, however, Gentileschi was both humiliated and tortured as the Roman courts tried to establish whether or not she was telling the truth. A month after the trauma of the trial, Orazio arranged for her to marry a Florentine artist, Pierantonio Stiattesi, and the couple moved to Florence. Her experiences impacted on her work and opposing conventions for female artists, she produced forceful and violent paintings featuring confident women from myth and the Bible who assert their strength in adversity. The dramatic realism and chiaroscuro of Caravaggio proved to be the most powerful influence on her style, and, like his, her images are full of passion and emotion. She achieved huge success, building up friendships with the most respected artists of the day and gaining the favors and protection of influential individuals, including Cosimo II de' Medici and his wife. Charles I of England was also one of her patrons.

As well as in Florence, she worked in Rome, Venice, Naples, and England. Frequently criticized for possessing what was viewed as a masculine talent, she eventually became the only female artist in 17th-century Italy to be taken seriously. She was welcomed as the first official female member of the Accademia del Disegno in Florence and enjoyed renown across Europe. After her death, however, she fell into obscurity, and her works were often attributed to her father or other artists. It was not until the late 20th century that interest in her developed once more.

Judith Slaying Holofernes

c.1612–21 OIL ON CANVAS

78 x 64 IN (199 x 162 CM)

GALLERIA DEGLI UFFIZI, FLORENCE, ITALY

This painting of the Jewish heroine, Judith, decapitating the Assyrian tyrant, Holofernes, for trying to rape her is a powerful expression of the artist's own distress. It is believed that the depiction was a way in which she could psychologically extract her revenge.

KEY WORKS

Madonna and Child c.1609, GALLERIA SPADA, ROME, ITALY
Susannah and the Elders 1610, COLLECTION GRAF VON SCHOENBORN, POMMERSFELDEN, GERMANY
Judith and her Maidservant c.1612–13, PITTI GALLERY, FLORENCE, ITALY
Saint Cecilia c.1620, GALLERIA SPADA, ROME, ITALY
Self-Portrait as the Allegory of Painting 1638/39, ROYAL COLLECTION, LONDON, UK

Poussin

1594–1665 • BAROQUE, CLASSICISM

Inspired by Titian and Raphael in turn, Nicolas Poussin is regarded as the most important and influential French painter of the 17th century and his many followers became known as "Poussinistes."

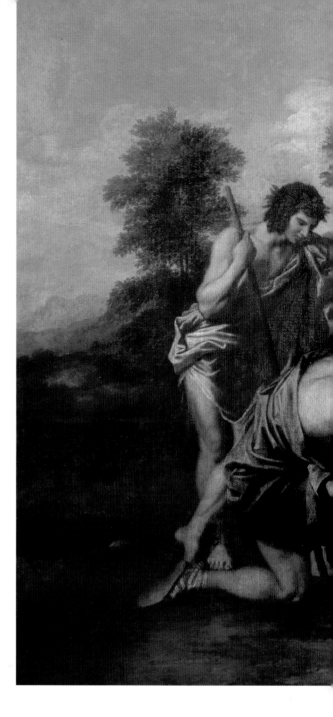

Except for a short period when he was ordered back to France to serve as First Painter to the king, Poussin spent most of his working life in Rome. Born in Normandy, at 18 he moved to Paris to train as an artist. There he became enthralled by classical and Renaissance art in the museums and galleries. In 1624, he went to Rome and remained there for 16 years, studying ancient sculpture and architecture and Renaissance art. During this period of learning and work, his reputation was established and he mixed with the scholars of the day, developing the attitude that art should appeal to the intellect and not just the eyes. His work displayed a blend of his belief in logic, harmony, and intellectual accuracy, which separated his painting from that of his Baroque contemporaries. Poussin's subjects were usually based on stories from classical literature and the Bible, often highlighting moral issues or thoughts about life and death.

In the second half of the 1630s, his reputation had spread and young artists in Paris were beginning to follow his style. Louis XIII demanded his return to France and for about two years he painted altarpieces and canvases and supervised decorative work in the Louvre, until the jealousy of others sent him rushing back to Rome, leaving the work unfinished. Nevertheless, his beliefs about order and the importance of drawing were adopted by the Académie Royale de Peinture et de Sculpture, which was established in Paris in 1648. Members of the Académie who emphasized classical design and the primacy of line became known as "Poussinistes," and he set the standard for a tradition of art that continued until the end of the 19th century.

KEY WORKS

St. Cecilia c.1627–8, MUSEO DEL PRADO, MADRID, SPAIN

Descent from the Cross c.1630, STATE HERMITAGE, ST. PETERSBURG, RUSSIA

Adoration of the Golden Calf c.1637, NATIONAL GALLERY, LONDON, UK

The Rape of the Sabine Women, Rome 1637–8, MUSÉE DU LOUVRE, PARIS, FRANCE

Assumption of the Virgin c.1638, NATIONAL GALLERY OF ART, WASHINGTON, DC, US

Et in Arcadia Ego

c.1638–40 OIL ON CANVAS

73 X 48 IN (185 X 121 CM)

MUSÉE DU LOUVRE, PARIS, FRANCE

In this earthly paradise, everyday cares do not exist, but a group of shepherds is reading the tomb inscription: "Et in Arcadia Ego." The words suggest the presence of death even in the most agreeable places. One shadow falls over a shepherd—a premonition of the future.

Velázquez

1599–1660 • BAROQUE

Considered by many to be the greatest European painter ever, Diego Rodríguez de Silva y Velázquez was a distinctive Baroque artist who painted various historical and cultural works and countless portraits. It is believed that he may have had a greater influence on European art than any other painter.

Born in Seville to a family of noble Portuguese stock, Velázquez served a six-year apprenticeship with Francisco Pacheco (1564–1644), a prominent artist whose workshop attracted poets, scholars, and artists. There, the lively discussions about art, humanism, and classical antiquity taught the young Velázquez a great deal, especially about Raphael, Michelangelo, Titian, and Caravaggio. In 1617, he was accepted into the painters' guild of St. Luke in Seville, which meant he could set up his own workshop. Although he was only 18, his work had already surpassed that of his teacher's, displaying precocious skill and provocative power. His use of strong chiaroscuro and naturalism was directly inspired by Caravaggio and his portraits were admired for the life they gave to his subjects.

For the following five years, as well as portraits and religious works, Velázquez produced bodegones— a popular genre of kitchen or tavern scenes featuring food and drink. The dignity and naturalism he brought to these works made him instantly popular. By 1622, he had traveled to Madrid, visiting Toledo on the way to view works by El Greco, and in 1623, he was summoned to the Spanish court to paint a portrait of Philip IV. The resulting work demonstrated his extraordinary talent for painting lifelike portraits. Philip appointed him court painter and declared that in future, he was the only artist allowed to paint the king. At 24, Velázquez was suddenly the country's most important painter and he maintained that position for the rest of his life, along with further appointments including marshal of the royal household and planner of ceremonies. The move to the royal court allowed him access to the royal collection and there he studied the Italian paintings, particularly those by Titian. His style and approach changed as a result. He became primarily a portraitist and abandoned bodegones, although he still occasionally painted historical, mythological, and religious works. His palette lightened and his brushwork became more fluid.

When Rubens arrived in Madrid on a diplomatic mission in 1628, the two artists became well acquainted and Rubens persuaded Velázquez to go to Italy. He made two trips, in 1629 and 1649, studying paintings at close hand. He also bought works for the king's collection, including some by Titian, Tintoretto, and Veronese. Already influenced by Rubens's painting style and Venetian palettes, the trip to Italy stimulated and strengthened these notions.

Velázquez died of a fever in 1660. For his incredible treatment of color, light, and space, he has been called a painter's painter, and artists have been influenced by him for centuries. Among the more prominent of these, were Goya, Manet, Whistler, and Picasso.

Coronation of the Virgin

1641–4 OIL ON CANVAS

69 X 48¾ IN (176 X 124 CM)

MUSEO DEL PRADO, MADRID, SPAIN

In a gold, silver, blue, violet, and crimson heart-shaped composition, little putti (cherubs) carry Mary up to heaven; Jesus and God hold a crown of roses over her head and the Holy Spirit hovers above her. Bathed in glowing light, and with a silky bloom on her skin, Mary points to her own heart.

KEY WORKS

The Waterseller of Seville 1623, WELLINGTON MUSEUM, LONDON, UK

Christ Crucified c.1632, MUSEO DEL PRADO, MADRID, SPAIN

The Toilet of Venus (the Rokeby Venus) 1647–51, NATIONAL GALLERY, LONDON, UK

Innocent X c.1650, GALLERIA DORIA-PAMPHILI, ROME, ITALY

Las Meninas (Maids of Honor) 1656–7, MUSEO DEL PRADO, MADRID, SPAIN

van Dyck

1599–1641 • BAROQUE

The most gifted pupil of the great Rubens, Anthony van Dyck became one of Europe's greatest portrait painters. His depictions of royal and aristocratic sitters characterized the Stuart era and influenced English portrait painting for the next 150 years.

After Rubens, van Dyck was the most important Flemish painter of the 17th century. As well as working in oils, he painted in watercolor and also produced engravings and etchings that publicized his work to a wider audience. Born in Antwerp to a wealthy family, by the age of about ten he was apprenticed to Hendrick van Balen (1575–1632), a skillful Flemish artist.

Showing significant early precocity, by the time he was 16 van Dyck set up his own studio with Jan Brueghel the Younger (1601–78). In 1618, he was admitted to the Antwerp painters' Guild of Saint Luke, the most renowned of artists' guilds, which meant that he could take on apprentices and sell paintings to the public. He was soon appointed chief assistant in the large workshop run by Rubens, who described him as "the best of my pupils." In 1620, he traveled to London and worked for King James I, and from 1621 to 1627 he stayed in Italy, painting portraits for the aristocracy.

A devout Catholic, his religious paintings were highly emotional, but on his return from Italy, he concentrated increasingly on portraiture, infusing these works with dignity and realism. By 1632 he was again in London, on the invitation of Charles I and Queen Henrietta-Maria, who gave him a house and studio, the position of principal painter to the king, and a knighthood. As First Court Painter, he executed numerous portraits of the king and his family, and overall, he portrayed Charles I as a relaxed, noble, and authoritative figure. Other members of the royal court wanted the same sort of refined representations of themselves and their families, and as his commissions increased, he extended his studio and organized his assistants with disciplined precision. Painting at least one portrait a week, he worked to a system: he painted the faces while his assistants painted the clothes, which they modeled on dummy figures. Finally, he added finishing touches to the work.

After Rubens, he most admired the work of Veronese and Titian, and, where possible, incorporated elements of their styles into his painting. While achieving good likenesses, his unique, formal yet relaxed approach flattered his subjects, and his elegant style profoundly influenced a generation of portrait painters after him, including notably Sir Peter Lely (1618–80) and Thomas Gainsborough (1727–88). He became the dominant influence on English portrait painting for the following 150 years.

KEY WORKS

Samson and Delilah 1620, DULWICH PICTURE GALLERY, LONDON, UK

Portrait of Charles V on Horseback 1620, GALLERIA DEGLI UFFIZI, FLORENCE, ITALY

Susanna and the Elders 1621–2, ALTE PINAKOTHEK, MUNICH, GERMANY

Portrait of a Man in Gilt Armor 1624, KUNSTHISTORISCHES MUSEUM, VIENNA, AUSTRIA

Portrait of Philadelphia and Elizabeth Wharton LATE 1630S, STATE HERMITAGE, ST. PETERSBURG, RUSSIA

Charles I at the Hunt

*c.*1635 OIL ON CANVAS

104¾ x 81½ IN (266 x 207 CM)

MUSÉE DU LOUVRE, PARIS, FRANCE

Set against a bright sky, his horse and servants blending into the foliage, this life-sized portrait of the king of England shows him confidently looking down on viewers. His shimmering silver satin jacket and the soft brushwork propel him to the fore.

Claude

1600–1682 • BAROQUE, LANDSCAPIST

In the 17th century, landscape became a subject in its own right. Claude, a painter, draftsman, and etcher, became the most celebrated landscapist of all.

Claude Gellée was often called Claude Lorrain after his place of birth, or, even more commonly, simply Claude, demonstrating his great fame and reputation. At the age of about 13, he moved to Rome, where he worked as studio assistant to Agostino Tassi (who raped Artemisia Gentileschi). By then, Tassi was a landscapist and the leading Italian painter of illusionistic frescoes—he instilled in Claude a fascination with perspective and landscape painting. Claude spent a short time studying in Naples and in 1625 he returned to Lorraine to work with the court painter Claude Dernet (1588–1660) on church frescoes in Nancy. Within two years, he was back in Rome, where he remained for the rest of his life. Establishing himself as one of the leading landscape painters in Rome, in 1633 he became a member of the highly respected Accademia di San Luca. His landscapes differed from the realism of traditional Dutch landscape paintings, as he created ideal scenes of nature that were more beautiful than reality. His nostalgic, melancholic, or dreamlike features are always bathed in ethereal light.

During the 17th century, many of the middle classes had new homes built, and Claude's popularity was fueled by the trend for interior decorations. His patrons were mainly wealthy French or Italian noblemen and he always worked on commission. Because his style was so popular, he never changed it. His work remained hugely influential for the following two centuries.

KEY WORKS

Port with Villa Medici 1637, GALLERIA DEGLI UFFIZI, FLORENCE, ITALY

Italian Coastal Landscape 1642, STAATLICHE MUSEEN, BERLIN, GERMANY

Mercury Stealing Apollo's Oxen 1645, GALLERIA DORIA-PAMPHILJ, ROME, ITALY

Port Scene with the Departure of Ulysses from the Land of the Feaci 1646, MUSÉE DU LOUVRE, PARIS, FRANCE

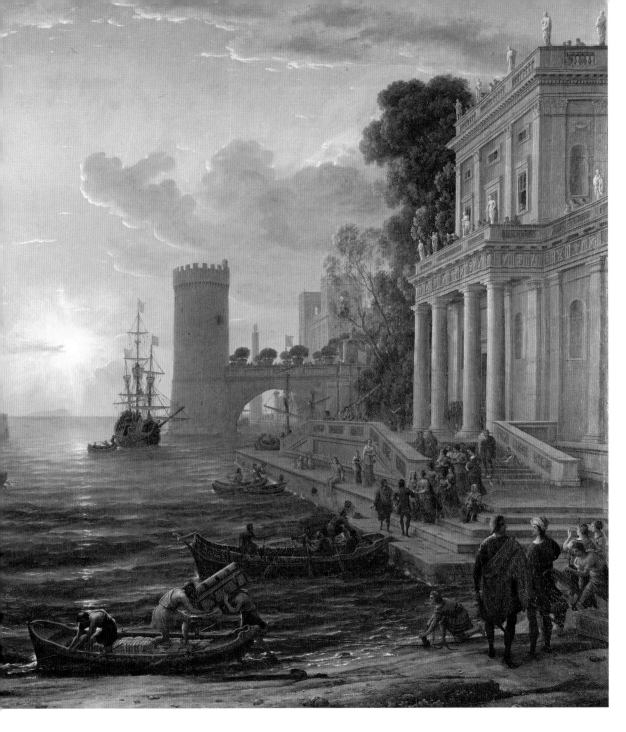

The Embarkation of the Queen of Sheba

1648 OIL ON CANVAS

58¾ x 77½ IN (149.1 x 196.7 CM)

NATIONAL GALLERY, LONDON, UK

Here, the Queen of Sheba is visiting King Solomon in Jerusalem and this imaginary seaport is bathed in glowing light. Antiquity is evoked by the ethereal, yet stately architecture. Perspective is carefully considered and becomes a foil for the luminous atmospherics.

Dutch Realism

c.1600–1700

During the 17th century, an extraordinarily realistic style emerged in the Netherlands. It occurred for many reasons, but mainly because of the Reformation—the establishment of Protestantism as a branch of Christianity—in the previous century. Religious and political unrest had divided the Low Countries into two nations. Flanders stayed Catholic and royalist, while the Netherlands became a republic and a center of Protestantism.

The Dutch Golden Age

The stripping of all Catholic large-scale religious art in the Netherlands left a space in the artistic sensibilities of the Dutch people. Growing trade and prosperity had initiated what became known as "the Dutch Golden Age" and resulted in an increased confidence and awareness of cultural identity. Yet the visual exuberance of the Baroque and its Catholic associations was totally different from the Protestant ethic of self-denial and sobriety. Apart from being commissioned for portraiture, artists had no real purpose and their professional status had become insecure.

For centuries, painting had been categorized into a strict hierarchy, with some subjects being regarded as more prestigious than others. History and religious painting were the most worthy; portraits came next, followed by genre, or scenes of everyday life, then landscapes, and finally still life. But now, Protestant painters had to reconsider. Gradually they began producing small-scale modest subjects for the homes of the new, wealthy merchant classes. They often painted genre or still life to emphasize the renewed interest in ordinary things. Everyday objects or daily life represented the virtues of honesty, hard work, and self-control. The philosophy was that although these things may seem insignificant or transitory, no aspect of God's creation is too trivial to be noticed, valued, or represented. Subjects drawn from the Bible, mythology,

1625
Vanitas,
Pieter Claesz
(1619–90)

1638
Carousing Peasants
in an Interior,
Adriaen van Ostade
(1610–85)

1642
The Night Watch,
Rembrandt
(1606–69)

1600 **1610**

1624
Laughing Cavalier,
Hals (1580–1666)

1632–48
building of the
Taj Mahal

1640
An Allegory of the
Vanities of Human
Life, *Steenwyck*
(1612–59)

1646
Construction of the
Royal Palace,
Amsterdam.
Jacob van Campen
(1596–1657)

and ancient history were also depicted in similarly realistic ways, to moralize or to establish parallels between the Dutch and great historical, cultural, or political events of the past. These artists developed a style that highlighted clarity, definition, and spatial relationships.

Portrait painting

Commissioned portraiture was a reliable way for an artist to earn a living. Many portraits were commissioned by wealthy individuals or committees. Successful Dutch merchants wanted portraits of themselves, their families, homes, and possessions to show others how they were thriving. Members of local committees wanted to celebrate their importance in a material form that would decorate public rooms and impress future generations. During the first half of the century, portraits were formal and rigid. Attention was paid to fine details in clothing and surroundings to show status in society or profession. Later, group subjects became livelier and colors brighter. Rembrandt, who became known as the greatest Dutch artist, transformed his subjects with his technical mastery. Although working in Protestant Amsterdam, he was inspired by the work of Caravaggio, which prompted him to experiment with dramatically lit scenes full of action.

Still life and interiors

By 1640, the new genre of still life had been established in Holland as a subject in its own right and not just as part of a grander picture. With the middle classes now the primary patrons of art, still life paintings appealed for their realism, color, and size. Contrasts of texture and lifelike details fascinated owners of the paintings and their guests. Paintings that also incorporated symbolic reminders, such as a skull, globe, or rotting fruit—representing the transitory nature of life—were even more popular. These works were known as "vanitas" after the Biblical quotation from the Old Testament book of Ecclesiastes (1:2): "Vanitas vanitatum ... et omnia vanitas," meaning "Vanity of vanities ... all is vanity." They were reminders of the perils of vanity and the certainty of death.

Other intimate subjects such as small-scale interiors of buildings were successful with middle-class patrons. The ideology behind this was that art can be revealed in everyday experiences—all subjects are worthy if the artist is skilled enough. In contrast to most art at the time, these artists usually produced their works speculatively for the art market rather than for direct commissions. Most became experts in one kind of picture, working in a limited style, building up their reputations, and establishing markets for their work.

c.1653
Still life with Drinking Horn, *Willem Kalf* (1629–93)

1657
View of Deventer Seen from the North-West, *Salomon van Ruisdael* (1602–70)

c.1665
Girl with the Pearl Earring, *Vermeer* (1632–75)

1689
The Avenue, Middleharnis, *Hobbema* (1638–1709)

1660 1700

1653
Blenheim Castle, *Jacob van Ruisdael* (1628–82)

c.1663–65
Card Players in an Opulent Interior, *de Hooch* (1629–84)

1675–1776
Construction of St. Paul's Cathedral, *Wren* (1632–1723)

Rembrandt

1606–1669 • DUTCH BAROQUE

Generally considered the foremost Dutch artist, and ranking with the greatest artists of all time, Rembrandt Harmenszoon van Rijn transformed his subjects with technical mastery, whether in painting, drawing, or etching. His dramatically lit scenes display action, drama, or disarming simplicity. Although he experienced personal tragedies, his work never suffered and his many self-portraits offer a visual autobiography of his eventful life.

Born in Leiden, the son of a miller, Rembrandt had a good education and at the age of 14 he was enrolled at the University of Leiden but soon left to study art. His most significant early tutor was the Amsterdam-based Catholic Pieter Lastman (1583–1633), a Baroque artist who inspired him to concentrate on dramatic lighting and dynamic compositions. After six months he returned to Leiden and took his first pupils, but it was not an easy climate in which to work and with no Church commissions he had to try to obtain work from private patrons.

In 1631, Rembrandt moved to Amsterdam, the most prosperous port in northern Europe at that time. It offered him far more opportunities than Leiden and his first portrait was of a wealthy merchant, Nicolaes Ruts. Featuring the dramatic contrasts in lighting and the rendering of varied textures that are characteristic of his early work, it established him as the leading portrait painter in the city. In 1634, his marriage to Saskia van Uylenburgh, the cousin of a successful art dealer, enhanced his career even further, bringing him into contact with ever more wealthy patrons. Success continued and by 1639, he had earned enough to buy a large house. However, following the deaths of his wife and mother in the 1640s, he became introspective and began painting more religious works. His mythological and religious paintings are imbued with a sense of mystery through his warm and subtle use of chiaroscuro—the employment of light and shadow—and his dramatic masterpieces made him hugely popular. His teaching skills also became renowned and pupils flocked to join his studio.

One of the first artists to paint directional brush-strokes—that is, marks that follow the directions of the objects being painted—Rembrandt's work was innovative simply because the viewer was able to see his brushmarks. His later paintings display even broader marks, some of which were applied with a palette knife. While his earlier pictures had a smooth finish, the later works are more vigorous and painterly in style.

In the 1650s, Amsterdam suffered a huge economic depression. Rembrandt's creditors began to chase him for money and in 1656 he successfully applied for a form of bankruptcy that avoided imprisonment. He spent the last 20 years of his life painting commissioned portraits, as well as self-portraits. Rembrandt's ability to capture with accuracy the outward appearance of those he painted also exposed their underlying character. This understanding of humanity, along with his skill in portraying it, is one of the key issues that has made him so revered.

KEY WORKS

Nicolaes Ruts 1631, THE FRICK COLLECTION, NEW YORK, US

The Blinding of Samson 1636, STÄDELSCHES KUNSTINSTITUT, FRANKFURT, GERMANY

Portrait of the Artist at His Easel 1660, MUSÉE DU LOUVRE, PARIS, FRANCE

The Militia Company of Captain Frans Banning Cocq (Night Watch) 1642, RIJKSMUSEUM, AMSTERDAM, NETHERLANDS

Susanna and the Elders 1647, GEMÄLDEGALERIE, BERLIN, GERMANY

Belshazzar's Feast

*c.*1636–8 OIL ON CANVAS

66 x 82¼ IN (167.6 x 209.2 CM)

NATIONAL GALLERY, LONDON, UK

Rembrandt intensified the drama of a moment with a focus of brilliant
light inspired by Caravaggio. From the Old Testament Book of Daniel,
Belshazzar—the king of Babylon—has been blasphemously serving wine
in the sacred vessels his father Nebuchadnezzar has looted from the
Temple in Jerusalem. This is the moment when a divine hand appears
and writes a warning on the wall that says: "God has numbered the
days of your kingdom and brought it to an end; you have been weighed
in the balances and found wanting; your kingdom is given to the Medes
and Persians."

Steenwyck

*c.*1612–1659 • DUTCH BAROQUE

From about 1620, vanitas, a type of still-life painting, became popular with artists in the Netherlands, centered on the university town of Leiden. Harmen Evertz Steenwyck was one of the foremost artists of the style.

Steenwyck's year of birth is not confirmed, but it is based on the appearance of his first paintings in 1628. He and his brother Pieter were sons of a spectacle and lens maker in Delft and both brothers became pupils of their uncle, David Bailly (1584–1657), who lived and worked in Leiden. Bailly has been credited with the invention of the vanitas genre. A vanitas painting contains collections of objects symbolic of the transitory nature of life, the vanity of wealth, and the inevitability of death. Viewers are asked to consider mortality and to repent. Steenwyck trained with his uncle from 1628 for five years. The errors of coveting worldly pleasures and possessions and the frailty of human life had often been symbolized in religious art, but with no large religious works being commissioned in the Protestant Dutch Republic, the vanitas still lifes appealed to the wealthy middle classes for their realism and chilling warning.

Steenwyck became the leading exponent of vanitas still lifes, painting in smooth, invisible brushmarks, with strong tonal contrasts and a warm, golden palette. He worked in a radiant and exceptionally realistic manner, usually painting intricately detailed fruit and flowers that illustrated the vanitas theme. The brothers returned to Delft in 1633 and they shared a successful studio. In 1636, Steenwyck joined the Guild of Saint Luke in Delft, which enabled him to take on pupils. He traveled to the Dutch East Indies for a year in 1654 and returned to work in Delft for the remaining few years of his life.

KEY WORKS

Vanitas *c.*1640, STEDELIJK MUSEUM DE LAKENHAL, LEIDEN, NETHERLANDS

Still life with skull, books, flute, and whistle *c.*1646, KUNSTMUSEUM BASEL, BASEL, SWITZERLAND

Still life with earthen jar, fish, and fruit 1652, RIJKSMUSEUM, AMSTERDAM, NETHERLANDS

Still life with fish in a colander, peaches, a bucket, berries, and a cucumber 1652, RIJKSMUSEUM, AMSTERDAM, NETHERLANDS

An Allegory of the Vanities of Human Life

*c.*1640 OIL ON OAK

15.4 X 20 IN (39.2 X 50.7 CM)

NATIONAL GALLERY, LONDON, UK

Embodying the vanitas themes, a skull forms the centerpiece. The shell and Japanese sword are rarities, symbolizing worldly possessions. The books represent knowledge; the musical instruments denote the pleasures of the senses; and the chronometer and snuffed-out lamp allude to the transience of life.

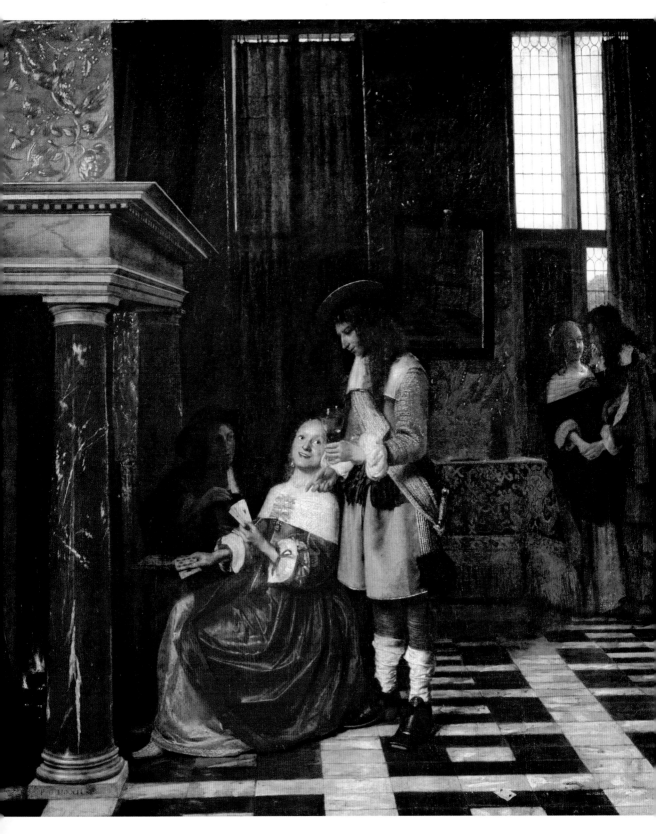

de Hooch

1629–1684 • DUTCH BAROQUE

A contemporary of Jan Vermeer and a genre painter from Delft, Pieter de Hooch was a master of painting delicately detailed interior scenes bathed in sparkling light.

The son of a Rotterdam bricklayer and a midwife, de Hooch received his early training under the landscape artist Nicolaes Berchem (*c.*1620–83) in Haarlem. From about 1650 he worked for a cloth merchant and art collector, Justus de la Grange, in Rotterdam, acting as painter and servant and accompanying his master on visits to Leiden, The Hague, and Delft. He eventually relocated to Delft and joined the painters' Guild of Saint Luke in 1655. He remained in Delft until 1661, when he moved to Amsterdam, staying there until the end of his life.

Small, meticulous genre scenes of domestic life exploited the pride the Dutch felt in their achievements and de Hooch's interiors, courtyards, and gardens convey their calm self-assurance. With his incisive observations, everything was treated equally, from the smallest brick to the main figures, and his clear, warm colors and precise details resemble intricate enamel work. His interest in accurate perspective and detail is a foil for the moralistic messages within the harmonious scenes. The family unit was central to an increasingly middle-class Dutch society, and de Hooch's main characters include friends, families, and maids. The worlds he depicts are snapshots of life seen discreetly through open doors and windows.

Once in Amsterdam, de Hooch experimented with new subjects. He gradually abandoned the homely scenes, moving onto the contrived luxury of the residences of the wealthy middle classes. But his technique gradually deteriorated and his work was never again quite as accomplished as it had been in Delft.

Card Players in an Opulent Interior

*c.*1663–5

OIL ON CANVAS

26 x 30 IN

66 x 77 CM

MUSÉE DU LOUVRE,

PARIS, FRANCE

A couple play cards by a marble fireplace. The woman has cheated and holds all the aces. A man colludes with her as a maid waits to serve him, and another couple snatch an intimate moment. The floor tiles lead viewers into the lavish interior.

KEY WORKS

A Man Offering a Glass of Wine to a Woman *c.*1654–5, STATE HERMITAGE MUSEUM, ST. PETERSBURG, RUSSIA

The Visit *c.*1657, METROPOLITAN MUSEUM OF ART, NEW YORK, US

The Courtyard of a House in Delft 1658, NATIONAL GALLERY, LONDON, UK

A Dutch Courtyard *c.*1659–60, NATIONAL GALLERY OF ART, WASHINGTON, DC, US

Vermeer

1632–1675 • DUTCH BAROQUE

With only about 36 works confirmed as his, Johannes Vermeer's domestic interior scenes of the bourgeoisie were nonetheless fairly successful during his lifetime. He was largely forgotten until the middle of the 19th century, when he was "discovered" by a French writer. Since then, he has been acknowledged as one of the greatest artists of the Dutch golden age.

Little is known for certain about Vermeer's life and career. Born in 1632 in Delft, his father was a silk-weaver, a part-time picture dealer and later, an innkeeper. It is thought that Johannes, or Jan, may have been apprenticed to Leonaert Bramer (1596–1674) or Carel Fabritius (1622–54), both respected artists in Delft. Fabritius had been one of Rembrandt's best pupils, but he died young.

Whoever taught him, in 1653, at the age of 21, Vermeer was admitted to the Guild of Saint Luke, which meant he had trained for the obligatory six years with a master recognized by the guild. His early works included history paintings inspired by Caravaggio's style (he probably saw work by the Italian master's followers in Utrecht). By the late 1650s, he was working on genre subjects, which were popular in Delft at the time. It is clear that Vermeer was influenced by Pieter de Hooch's light-filled, meticulous interior views.

During the 1660s, Vermeer became extremely successful locally and was elected as dean of his guild in 1662–3 and 1670–1. His style gradually became sharper and his ability to render natural light in carefully arranged compositions was unmatched. His work was similar to other Dutch painters' interiors, but far more delicate and lustrous. Vermeer worked painstakingly slowly and carefully, using bright colors and expensive pigments to create hushed, atmospheric scenes bathed in silvery light. Viewers are drawn into his pictures by the careful placing of objects and clearly defined architectural spaces. Many of his paintings seem to sparkle—a result of the tiny, spherical dots of thick, opaque paint that he placed across the canvases to suggest highlights. These are referred to as pointillés, and they were applied to create a convincing illusion of light, shade, and form, making the works incredibly lifelike. This treatment later became a great influence on the Impressionists.

He also used a camera obscura—a precursor to the camera—which projected images that artists could trace. Many artists used this technology to help them establish basic lines. They still had to arrange each composition and apply their painting skills to show their genius; the instrument was merely an aid in the early placement of elements. With such a small output of paintings, it is probable that Vermeer had other interests. It is thought that he inherited his father's picture-dealing business and possibly his inn as well. He seems never to have been particularly wealthy, and by 1672 he was in financial trouble. He died insolvent in 1675, at the age of only 43, leaving his wife and 11 surviving children in debt.

KEY WORKS

The Little Street *c.*1658–60, RIJKSMUSEUM, AMSTERDAM, THE NETHERLANDS

View of Delft *c.*1660–1, KONINKLIJK KABINET VAN SCHILDERIJEN MAURITSHUIS, THE HAGUE, THE NETHERLANDS

Young Woman with a Water Pitcher *c.*1664–5, METROPOLITAN MUSEUM OF ART, NEW YORK, US

The Lacemaker *c.*1669–70, MUSÉE DU LOUVRE, PARIS, FRANCE

The Art of Painting *c.*1666–73, KUNSTHISTORISCHES MUSEUM, VIENNA, AUSTRIA

Girl with a Pearl Earring

*c.*1665 OIL ON CANVAS

17.5 X 15.4 IN (44.5 X 39 CM)

MAURITSHUIS, THE HAGUE, THE NETHERLANDS

Tension is evoked by the body turning away and the head looking back. This is not a conventional portrait and might even be a "tronie"—a study of a facial expression. The sitter is a mystery. Tiny pointillés create shimmering effects on her earring, collar, lips, and eyes. As usual, Vermeer used only expensive pigments.

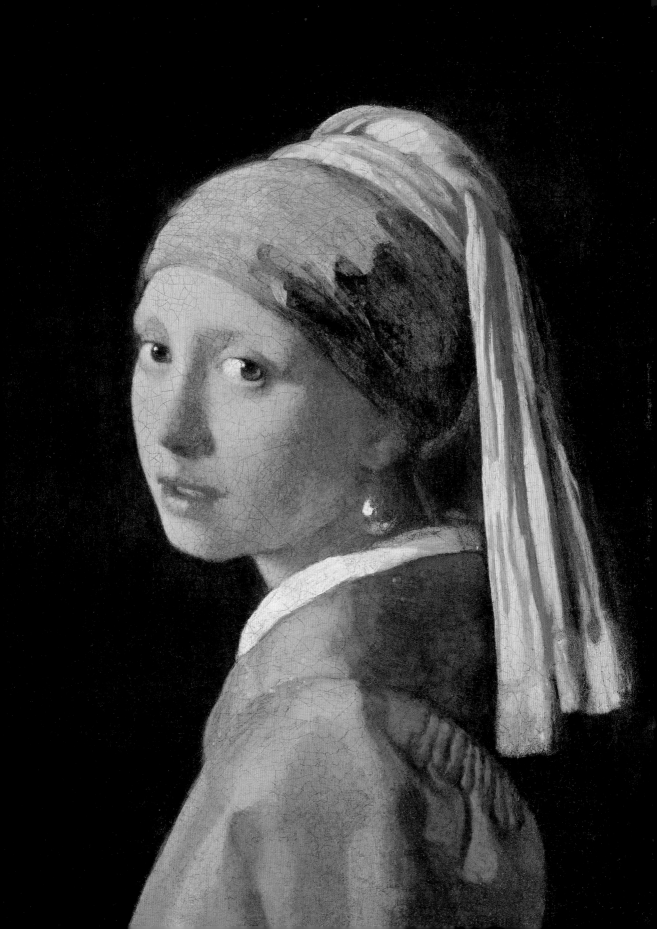

Rococo to Neoclassicism

c.1700–1800

At the dawn of the 18th century, both as a development from and a reaction to the Baroque style, another fashion of art and design emerged. Known as Rococo, this ornamental, elegant, and light style was eventually replaced at the end of the century by Neoclassicism—a movement that embraced order and restraint.

An era of elegance

In the 1700s, across Europe and many parts of America, traditional institutions, customs, and morals were challenged as philosophers championed the principles of personal freedom and democracy. Many of these ideas also swept through the arts. The Rococo style was the visual representation of the positivity the wealthy felt in response to these new philosophies, in particular in France. In 1682, Louis XIV, the Sun King, moved into his opulent palace at Versailles. By 1715, his heir, Louis XV, was on the French throne and his reign was marked by the introduction of similarly extravagant but lighter elements with more curves and delicate patterns. His most well-known mistress, Madame de Pompadour, exerted strong influence at the French court from 1745 to 1750 and her passion for art spread to the rest of Europe.

The flourishing Rococo style emphasized beauty and happiness, encapsulating the elegance of high society. The word "rococo" began to be used at the end of the century, derived from the word "rocaille," meaning "rock work" or "shell work," which was a favorite motif of the time. Like many art movements, it began as a derogatory term, implying tastelessness. Characterized by lightness, grace, and elegantly flowing shapes, Rococo was initially expressed in interior decoration with light and delicate ornamentation. Rococo-style architecture followed and then painting and sculpture, which spread firstly to Italy and subsequently to other parts of Europe and America.

c.1737
Fury of Achilles,
*Charles-Antoine
Coypel (1696–1752)*

c.1740
Venice: the Upper
Reaches of the Grand
Canal with San
Simeone Piccolo,
Canaletto (1697–1768)

1750–53
Würzburg Ceiling,
*Tiepolo
(1696–1770)*

1755
Portrait of Madame
de Pompadour,
*Maurice Quentin de la
Tour (1704–88)*

1700

1745

c.1717–18
The Dance,
*Watteau
(1684–1721)*

c.1739
Soap Bubbles,
*Chardin
(1699–1779)*

1743
Marriage à la Mode,
*Hogarth
(1697–1764)*

1748–49
Mr and Mrs
Andrews,
*Gainsborough
(1727–88)*

1752
Reclining Girl,
*Boucher
(1703–70)*

c.1759
Portrait of Madame
Lalive d'Épinay,
*Jean-Étienne
Liotard (1702–89)*

Rococo painting

In France, the death of Louis XIV in 1715 resulted in the Regency—the heir was only five years old and reigned initially with the help of his great-uncle. The court life that surrounded the young Louis XV as he grew up was sensual and indulgent. Artists of the time include Watteau, Boucher, Fragonard, and Chardin. Apart from Chardin, who was more restrained, the aforementioned painters' work exemplified "joie de vivre" (the joy of living). In England, Rococo was thought of as "French taste" and it appeared in landscapes or in satirical images of society. In Italy, flowing or precise pictures were produced by artists such as Canaletto and Giambattista Tiepolo (1696–1770).

The Age of Enlightenment

Radical new developments continued throughout the century, in science, technology, and the arts. Many of the old ways, such as guild systems and religious authority, were being lost. Education was expanding for the middle classes and ordinary people were gaining more autonomy. Intellectual, social, and political reforms gave people hope for the future as scholars suggested that reason could be used to overcome oppression and ignorance and create a better world. They began talking about their time as "The Age of Reason." Later, during the 19th century, the period was referred to as "The Age of Enlightenment."

With all this intellectualizing, the taste for superficial aesthetics diminished. By the 1760s, Neoclassicism emerged—a conscious use of Greek and Roman elements, such as classical architecture or clean lines and perfect contours. The rebellious attitudes that instigated the American Revolutionary War (1775–83) and the French Revolution (1789–99) resulted in even firmer opinions that frothy, effervescent art was unnecessary. Instead, people looked to the republics of Greece and Rome, perceiving parallels between their own and the ancient societies.

Renaissance artists had been inspired by classical antiquities, but the discovery in Italy of the ruins of Pompeii and Herculaneum (excavations started in 1748) stimulated a more scientific interest. Neoclassicism had moral as well as artistic implications—its diverse styles were usually based on virtue and heroism. Precise drawing (or accuracy of representation) was favored over color. The greatest Neoclassicist painter was David, who celebrated history and civic pride in large formats. His best student, Ingres, became the quintessential Neoclassicist painter for the next generation.

1757
Ancient Rome,
Giovanni Paolo Panini
(1691–1765)

*c.***1770**
An Architectural Caprice,
Francesco Guardi
(1712–93)

1778
Construction of Apsley House,
Adam
(1728–92)

*c.***1785**
The Artist and her Daughter,
Vigée Le Brun
(1755–1842)

1793
The Death of Marat, *David*
(1748–1825)

1780 **1815**

1759
Portrait of Madame La Live d'Epinay,
Jean-Etienne Liotard
(1702–89)

1771–72
The Meeting,
Fragonard
(1732–1806)

1779
John Parker and his sister Theresa,
Reynolds
(1727–88)

*c.***1780**
Painting Color,
Kauffmann
(1741–1807)

1787–93
Cupid and Psyche,
Canova
(1757–1822)

1814
The Third of May, 1808, *Goya*
(1746–1828)

Gersaint's Shop Sign

1721 OIL ON CANVAS

64 X 121½ IN (163 X 308 CM)

CHARLOTTENBURG PALACE, BERLIN, GERMANY

Watteau's last work was intended to be a signboard for an art-dealing business run by his friend, E.F. Gersaint. It's a slice of life showing the interior of Gersaint's store, with whom Watteau was staying after his visit to a doctor in England. Painted lightly and rapidly, the colors are subtle, pearly, and soft; tones are warm and the airy composition creates a light and agreeable atmosphere. The figures are based on real figures, but their costumes and poses are those of actors—this is an escape from real life.

Watteau

1684–1721 • ROCOCO

The French Rococo blossomed through Jean-Antoine Watteau, whose charming and graceful paintings show his love for the theater. Best-known for his "fêtes galantes," a genre he invented of dreamlike and idealized scenes depicting elegant ladies and gentlemen relaxing or performing in imaginary outdoor settings, his short but meteoric career epitomized the new style.

Watteau was born in Valenciennes, a town near the Flemish border. He was the son of a literate, middle-class master roofer and carpenter. Although his three brothers joined the family business, at the age of 15, Watteau began training with a little-known local painter, Jacques-Albert Gérin. Three years later, he traveled to Paris, supporting himself by painting religious pictures and copying the works of popular Dutch artists. He became friendly with a printshop owner, Pierre II Mariette (1694–1774), who owned many prints of works by the great masters such as Rubens, Titian, and Bruegel. In reaction, Watteau's style became more fluid. From 1703, he began working with Claude Gillot (1673–1722), a stage-set designer. After helping Gillot decorate the Paris Opera House, Watteau developed a lifelong fascination with the Italian theater and the Commedia dell'Arte.

In 1708, Watteau began working with Claude Audran (1658–1734), the curator at the Luxembourg Palace. The palace's collection included Rubens' early 17th-century paintings from the life of Marie de' Medici. The works were a revelation to the young artist, and he began to change his own approach, creating completely unique illusions that reflected contemporary tastes. In addition, he helped to develop chinoiserie, a Chinese-inspired decorative style applied to panels, furniture, and porcelain. In his painting, he began producing dreamy, pastoral pictures, which became known as his "fêtes galantes." By portraying figures in seemingly mythological backgrounds, he was appealing to the French Academy's hierarchy of "appropriate" painting subjects, while remaining popular with buyers.

In 1663 an annual art competition began—the Prix de Rome. The winner was awarded a scholarship to study at the Palazzo Mancini in Rome. In 1709, Watteau entered, but did not win. Three years later, he competed once more; no prize was offered that year, but he was invited to apply to become a member of the Académie Royale de Peinture et de Sculpture—a prestigious accomplishment. Tragically, after suffering with consumption for most of his life, he died aged 37.

KEY WORKS

La Gamme d'Amour c.1712, NATIONAL GALLERY, LONDON, UK

Love in the Italian Theater 1716, GEMÄLDEGALERIE, BERLIN, GERMANY

Les Champs-Elysées c.1717, WALLACE COLLECTION, LONDON, UK

The Shepherds c.1717–19, STAATLICHE MUSEEN, SCHLOSS CHARLOTTENBURG, BERLIN, GERMANY

The Dance c.1719, GEMÄLDEGALERIE, BERLIN, GERMANY

Venice: the Upper Reaches of the Grand Canal with San Simeone Piccolo

c.1738 OIL ON CANVAS

49 X 80½ IN (124.5 X 204.6 CM)

NATIONAL GALLERY, LONDON, UK

The domed 18th-century church of San Simeone Piccolo softens the "x" shaped composition. The vertical lines of the buildings are also tempered by the activity on the water, as gondolas create a contrast. Canaletto's control of lighting is masterful, and the tiniest touches of fluid, thin paint have been applied with extremely small brushes to suggest glittering reflections. Canaletto made these grand views of Venice for the many wealthy visitors who flocked to see the city.

KEY WORKS

Grand Canal: Looking North-East from the Palazzo Corner-Spinelli to the Rialto Bridge *c.*1725, GEMÄLDEGALERIE ALTE MEISTER, DRESDEN, GERMANY

Grand Canal: The Stonemason's Yard; Santa Maria della Carità from the Campo San Vidal *c.*1728, NATIONAL GALLERY, LONDON, UK

Piazza San Marco: The Clock Tower *c.*1730, NELSON-ATKINS MUSEUM, KANSAS CITY, MO, US

The Reception of the French Ambassador in Venice 1740s, STATE HERMITAGE, ST. PETERSBURG, RUSSIA

A View of the Ducal Palace in Venice 1755, GALLERIA DEGLI UFFIZI, FLORENCE, ITALY

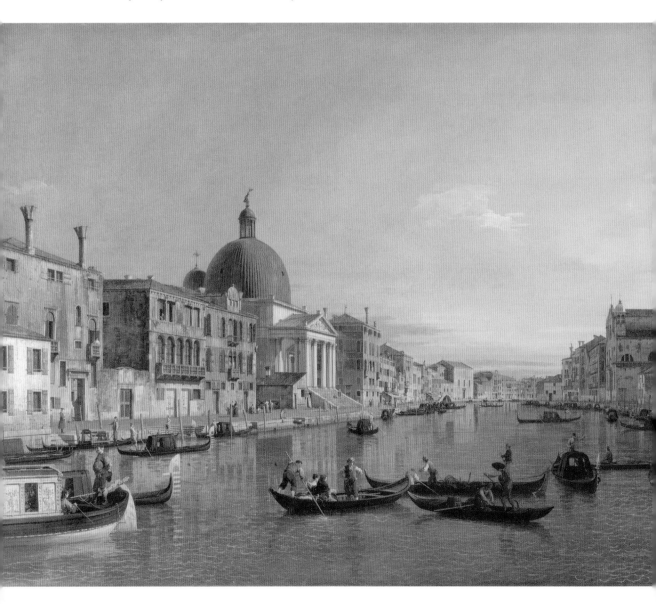

Canaletto

1697–1768 • ROCOCO PERIOD

For around 20 years, Canaletto was one of the most successful artists in Europe. His dramatic and picturesque views of Venice were extremely sought-after, particularly by the wealthy Englishmen who undertook Grand Tours of Europe. The paintings' clarity of light, precise perspective, and sharp tonal details evoked vivid memories of places visited.

Giovanni Antonio Canal was born in Venice, the son of a theatrical scene painter. He became known as Canaletto, probably to distinguish him from his father, with whom he worked as a scene painter. When he was 22, Canaletto visited Rome and became enthusiastic about the work of the vedute painters he saw there. Vedute paintings are extremely detailed and accurate pictures of cityscapes, or other panoramas, which originated in Flanders and the Netherlands during the 16th century. In Rome, Giovanni Paolo Panini (1691–1765) and some Dutch vedute painters inspired Canaletto. From them, he discovered an understanding of precise perspective and tonal contrasts and he made many architectural drawings. By 1720, he was back in Venice. He became a member of the painters' guild and abandoned theatrical scene painting, instead producing views of Venice in strong chiaroscuro.

Although these views were enchanting, he soon realized that they were not as exact as they could be. In rivalry with Luca Carlevaris (1665–1731), a painter, etcher, and architect in Venice who instigated the use of a camera obscura for greater accuracy, Canaletto began to produce views that were more dramatic, smoother, and topographically accurate than before. These included Venetian ceremonial and festival subjects, such as the *Regatta on the Grand Canal*.

Canaletto developed an outstanding talent for perfectly composed, evocative views of Venice, characterized by clear-cut realism, glass-like finishes, and bustling life. He became extremely influential and successful, famed for his skill, individual approach, and rendering of atmospheric light. As a perfectionist, he used the camera obscura to make sure that his basic outlines were accurate, but his overriding concerns were with creating engaging compositions and he produced numerous meticulous preparatory drawings for every painting he undertook. Canaletto's works were not symbolic or religious, but they were objective studies of the unique city built on canals and lagoons. His fluid, thinly spread paint and small brushmarks included tiny touches of color, creating sparkling, shimmering impressions of the people, architecture, ships, water, skies, and reflections.

The War of the Austrian Succession, which lasted from 1740 to 1748, led to a reduction in the number of visitors to Venice, severing Canaletto from his main patrons and badly affecting his lucrative business. In the early 1740s, he turned more to drawings and etching. Frequent visits to London in 1746 led to Canaletto painting views of London and his patrons' castles and homes for the next ten years. In 1763 he was at last elected to the Venetian Academy of Fine Arts and continued to paint until his death in 1768.

Hogarth

1697–1764 • MORALIZING PAINTINGS—ROCOCO PERIOD

William Hogarth considered himself to be a dramatist in paint. By satirizing contemporary society in his paintings and engravings, he created a new direction in art.

The fifth child of a schoolmaster, London-born William Hogarth was forced to earn money after his father's premature death in 1718. Five years previously, he had started his apprenticeship to a silver plate engraver, and by 1720 he had set up an independent business as an engraver, taking on commercial work including bookplates and etched cards. In his spare time, he also studied painting at St. Martin's Lane Academy. His first paintings were small portrait groups called "conversation pieces"—informal group portraits, popular in Britain at the time, where the sitters are sometimes involved in a conversation. He also painted lifelike, delicately colored, and sensitive portraits and large history paintings.

Deploring what he saw as the corrupt and sordid society of mid-18th-century England, Hogarth began producing paintings and prints that parodied all he disliked about it. These took shape as sequences of paintings that satirized contemporary politics, customs, and behavior. They were usually cautionary tales of vanity, dishonesty, and duplicity and were inspired by the new types of popular literature—novels. Hogarth's friendship with the novelist Henry Fielding (1707–54) is believed to have prompted this idea. Successful from the start, his first series, completed in 1731, was the six-scene *The Harlot's Progress*; this was immediately followed by *The Rake's Progress* and then *Marriage à la Mode*. These works made him widely known in Britain and abroad and his engravings of them were so plagiarized that he lobbied for the Copyright Act of 1735 as protection for writers and artists. In 1735, he opened his own academy in St. Martin's Lane, London.

KEY WORKS

A Scene from the Beggar's Opera *c.*1728, THE NATIONAL GALLERY OF ART, WASHINGTON, DC, US

The Tavern Scene (A Rake's Progress) 1732–4, SIR JOHN SOANE'S MUSEUM, LONDON, UK

A Rakes Progress 1732–5, THE SOANE MUSEUM, LONDON, UK

The Graham Children 1742, TATE BRITAIN, LONDON, UK

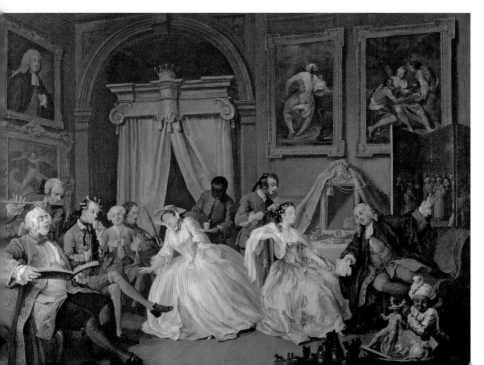

Marriage à la Mode: 4, The Toilette

*c.*1743 OIL ON CANVAS

27¾ x 35¾ IN

(70.5 x 90.8 CM)

NATIONAL GALLERY,

LONDON, UK

This was the first of Hogarth's sardonic series of paintings that mocked high society. The works gained wide recognition, as he made engravings from them. Each work tells an episode in one story, with clues about what has happened previously appearing around the picture.

Chardin

1699–1779 • ROCOCO PERIOD

One of the greatest painters of the 18th century, Jean-Baptiste Siméon Chardin documented the life of the Paris middle classes through his wholesome still lifes and domestic interiors.

A Parisian who rarely left the city, Chardin was largely self-taught and was influenced by artists such as de Hooch. Apprenticed for a short time to the history painters Pierre-Jacques Cazes (1676–1754) and Noël-Nicholas Coypel (1690–1734), when he was 25 he became a master in the Académie de Saint-Luc. In 1728, he was admitted to the Académie Royale de Peinture et de Sculpture and began to paint scenes of everyday life in bourgeois Paris, and still lifes using muted colors, seemingly tangible textures, and soft lighting. Chardin's humble subjects had not previously been considered worthy for painting and his work contrasted with the historical and Rococo paintings that characterized most French art at the time. Nevertheless, from 1737, Chardin regularly exhibited at the Paris Salon—the annual exhibition set up by the official Académie, where works displayed were selected by a jury. From the 18th and throughout the 19th centuries, the Paris Salon was held annually or biannually and was the greatest art event in Europe. Through this exposure, Chardin attracted patrons from the French aristocracy, including King Louis XV.

With paint applied in thick layers, thin glazes, and often fairly dry, Chardin rendered soft contours and textures with startling realism. He selected his subjects with great care and studied them closely and objectively. He later gained wider popularity when engraved copies of his works were produced. When his eyesight began to fail in later life, he turned to pastels, which he handled with sensitivity, balancing color, light, and composition.

KEY WORKS

The Silver Goblet 1728, MUSÉE DU LOUVRE, PARIS, FRANCE
The Young Schoolmistress 1735–6, NATIONAL GALLERY, LONDON, UK
Saying Grace c.1740, MUSÉE DU LOUVRE, PARIS, FRANCE
The Morning Toilet 1740, NATIONAL MUSEUM, STOCKHOLM, SWEDEN
Grapes and Pomegranates 1763, MUSÉE DU LOUVRE, PARIS, FRANCE

Soap Bubbles

c.1739 OIL ON CANVAS

24 X 24 IN

(61 X 63 CM)

METROPOLITAN MUSEUM

OF ART, NEW YORK, US

Admiring the Dutch artists of genre and still life, Chardin often included vanitas elements in his own works. This painting of a boy blowing a bubble from a pipe symbolized the fragility of life. Chardin's subject, palette, and composition have been selected with great care.

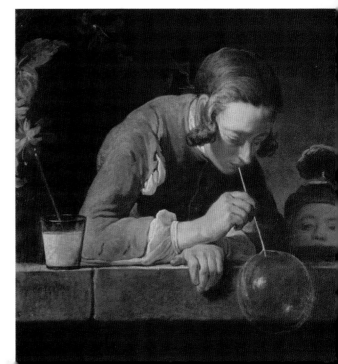

Reclining Girl

1752 OIL ON CANVAS

23¼ x 28¾ IN (59 x 73 CM)

ALTE PINAKOTHEK, MUNICH, GERMANY

The model is 15-year-old Louise O'Murphy. Small, delicately flushed, and rounded, she was one of Louis XV's many mistresses. This painting shows her childlike naivety but also emphasizes her voluptuous curves and provocative sensuality, exemplifying the atmosphere of the era.

KEY WORKS

The Rest on the Flight to Egypt 1737, STATE HERMITAGE MUSEUM, ST. PETERSBURG, RUSSIA
Diana Leaving her Bath 1742, MUSÉE DU LOUVRE, PARIS, FRANCE
The Toilet of Venus 1751, METROPOLITAN MUSEUM OF ART, NEW YORK, US
Madame de Pompadous 1759, WALLACE COLLECTION, LONDON, UK

Boucher

1703–1770 • ROCOCO

The favorite artist of Louis XV's mistress, Madame de Pompadour, François Boucher was known for his tranquil and graceful works on classical themes, decorative allegories, and portraits.

The son of a lace designer, Parisian-born Boucher studied with the painter François Lemoyne (1688–1737) but was particularly influenced by the work of Watteau, Tiepolo, and Rubens. When he was 20, he won the Prix de Rome and spent four years studying in Italy, where he was greatly inspired by Tiepolo and Veronese. He returned to Paris in 1731 and built up an extremely successful career, during which he received many honors.

Boucher first produced large-scale mythological and history paintings and became a member of the Académie Royale de Peinture et de Sculpture. Later he became a professor of the Académie and head of the royal Gobelins tapestry factory. As the protégé—and also the teacher—of Madame de Pompadour, mistress to Louis XV, in 1765 he became the king's official court painter and the director of the Académie. Immensely versatile, he designed fans, porcelain, slippers, interiors, theater sets, costumes, and tapestries. He produced book illustrations and decorative schemes for the royal palaces, resulting in many engravings and reproductions of his work onto porcelain and biscuit-ware at the Vincennes and Sèvres factories.

His early paintings celebrated innocence, but his later work became more amorous and erotic. His delicate, cheerful, and sometimes risqué depictions of women created a new genre and he became the most fashionable painter of his day. Toward the end of his career, as French taste began to favor Neoclassicism, he was criticized for his artificiality and for not painting from life. Yet his work was intended to please, not to instruct.

Reynolds

1723–1792 • ROCOCO PERIOD

One of the most significant figures in British art, Joshua Reynolds specialized in portraits and idealized images. He was one of the founders, and the first president of London's Royal Academy of Arts.

The son of a grammar school headmaster in England, Reynolds was well-educated, which was rare for an artist of the time. From an early age he aspired to be a painter and despite his family's poverty, at 17 he went to London to study with the portrait painter Thomas Hudson (1701–79), and began working as an independent, professional portrait painter two years later. In 1749, he traveled to the Mediterranean, visiting Lisbon, Cadiz, Algiers, and Minorca. From Minorca he went to Livorno in Italy, and then to Rome, where he spent two years studying the Old Masters, becoming inspired by the techniques of Michelangelo and Raphael, and fascinated by the antiquities of ancient Rome. In 1753, he settled in London and set up a portrait painting practice and by 1760 he was the most popular portrait painter in Britain.

Over his lifetime, Reynolds produced as many as 3,000 portraits, employing assistants to paint drapery and backgrounds. He became particularly renowned for his sensitive children's portraits and the inventiveness of his poses, while with all his sitters, he managed to capture the essence of their individuality. His style became known as the "grand manner" and he helped to make British portraiture the most respected and influential in the world.

Reynolds's success was achieved through intelligence, diligence, and a firm grasp of how to organize a business, as well as great skill and ambition. He worked extremely long hours, rarely taking a vacation and he became wealthy and accepted in the highest levels of society. Sociable and intelligent, through his association with literary and intellectual figures of the day, such as Dr Samuel Johnson (1709–84), Oliver Goldsmith (1728–74), Edmund Burke (1729–97), and David Garrick (1717–79), he raised the status of artists in Britain. He also helped to establish the Royal Academy of Arts, and in 1768 was made its first president. This was hugely significant because the Royal Academy became the principal institution for artists' exhibitions. From 1769 to 1790, he delivered annual lectures called Discourses to Royal Academy students. He claimed that the aim of art is moral improvement and that artists should seek inspiration in noble and high themes. His Discourses became the basis for academic art education for nearly 200 years. In 1769, he was knighted. Twenty years later, the loss of sight in his left eye finally forced him into retirement.

John Parker and his Sister Theresa

1779 OIL ON CANVAS

56 X 44 IN (142.2 X 111.8 CM)

SALTRAM HOUSE, DEVON, UK

This portrait of pink-cheeked siblings is appealing and informal without being sentimental. Clearly having a good rapport with the children, Reynolds worked directly onto the canvas, without preparatory drawings. The confidence of his style can be seen in the painting's warmth and vitality.

KEY WORKS

Anne Dashwood 1764, METROPOLITAN MUSEUM OF ART, NEW YORK, US

Miss Bowles 1775, WALLACE COLLECTION, LONDON, UK

Omai (Omiah) 1776, CASTLE HOWARD COLLECTION, YORKSHIRE, UK

Lady Taylor 1781–4, THE FRICK COLLECTION, NEW YORK, US

Georgiana, Duchess of Devonshire and her Daughter 1784, THE DEVONSHIRE COLLECTION, CHATSWORTH, DERBYSHIRE, UK

Gainsborough

1727–1788 • ROCOCO PERIOD, ROMANTICISM

As one of the most famous portrait and landscape painters of 18th-century Britain, Thomas Gainsborough contrasted with Reynolds in his easy-going, laid-back attitude. His light and rapid brushstrokes and delicate colors made him the favorite painter of the royal family and his approach made him influential with future landscape painters.

Thomas Gainsborough was born in Suffolk, eastern England, to a weaver in the wool trade and an artistic mother. Around the age of 13, he had impressed his family enough with his drawing skills for them to let him study art in London. He first trained under Hubert Gravelot (1699–1773), a London-based French designer and engraver, and later became associated with William Hogarth. He was also influenced by the painter and illustrator Francis Hayman (1708–76). In about 1752, Gainsborough set up as a portrait painter in Ipswich, Suffolk. Seven years later, he moved with his wife and children to Bath in southwest England, which, as a fashionable spa resort, attracted many clients for his portraits. Combining some of van Dyck's elegance with his own relaxed style, his work was instantly successful with the city's wealthy visitors.

In 1768, George III founded the Royal Academy of Arts, intending to raise the professional status of artists by establishing a system of training and exhibitions of quality contemporary works of art. It was also anticipated that the academy would encourage public appreciation and interest in art "of good taste." Thirty-four founder members were chosen, of which Gainsborough was one. He exhibited at the academy annually until 1784, when he retired after a dispute over the hanging of his works. In 1774 Gainsborough moved to London and continued to develop his own style, painting quickly, with soft colors and fluid marks, inspired, to a degree, by Rubens. He became the royal family's favorite painter—however, as president of the Royal Academy, George III was obliged to appoint Joshua Reynolds as the king's principal painter.

In addition to portraits, Gainsborough painted many landscapes. His rural scenes were painted in a manner that was usually reserved for historical or religious subjects and so demonstrated the legitimacy of everyday themes in art. His visions of rural life were intended to please and to provoke reflection. Contemporary debates about the changing agricultural economy—common land was being taken into private ownership and traditional ways of country life were becoming obsolete—made many nostalgic for the past. Gainsborough's picturesque landscapes were an elegiac lament for a vanishing world.

The feathery brushwork and rich sense of color in his mature work contribute to the enduring popularity of Gainsborough's portraits. All his sitters are portrayed informally in fashionable contemporary dress. In 1780, he painted portraits of George III and the queen. Further royal commissions followed, even though, in ignoring many of the traditional rules of painting, Gainsborough was classed as a rebel among painters.

KEY WORKS

Mr and Mrs Andrews c.1750, NATIONAL GALLERY, LONDON, UK
The Painter's Daughters, Margaret and Mary, Chasing Butterfly c.1756, NATIONAL GALLERY, LONDON, UK
The Blue Boy 1770, HENRY E. HUNTINGTON ART GALLERY, SAN MARINO, CA, US
Mrs "Perdita" Robinson 1781–2, WALLACE COLLECTION, LONDON, UK
The Mall 1783, THE FRICK COLLECTION, NEW YORK, US

The Painter's Daughters with a Cat

c.1760–1 OIL ON CANVAS

29¾ x 24¾ IN (75.6 x 62.9 CM)

NATIONAL GALLERY, LONDON, UK

Gainsborough's daughters, Mary and Margaret, were about ten and eight years old here. The painting is unfinished and the outlines of a cat snuggled against them can just be seen. Although he was more relaxed with his own daughters, Gainsborough always portrayed something elusive about his sitters' personalities.

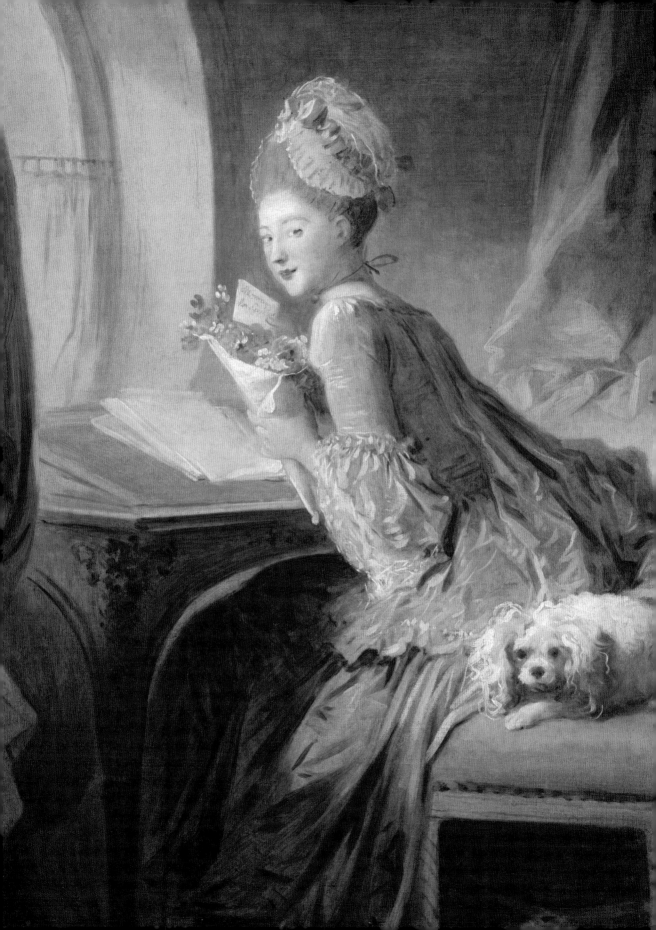

Fragonard

1732–1806 • ROCOCO

A prolific French painter and printmaker, whose energetic and playful style embodied the self-indulgence of the late Rococo period, Jean-Honoré Fragonard has been described as the "fragrant essence" of the 18th century. His delicate coloring, exuberant scenes and fluid brushwork encapsulate the attitudes of the preRevolutionary French aristocracy and bourgeoisie like no other.

Although born in Grasse, Fragonard moved to Paris with his family when he was five years old. He spent six months training with Chardin and then became apprenticed to Boucher. In 1752 he won the Prix de Rome, even though he was not officially eligible as he was not a student at the Académie. From 1756 to 1761, he lived in Rome, studying past artists and Tiepolo, who was still working. While in Italy, Fragonard produced small paintings for individual collectors living there and he made some careful drawings of the gardens of the Villa d'Este at Tivoli, where he stayed with the artist Hubert Robert (1733–1808).

Back in Paris in 1761, Fragonard's paintings were instantly popular. They blended elements of Italian Baroque painting and 17th-century Dutch landscapes, and in 1765 he became a member of the Académie after painting a mythological scene that was spectacularly received. Nevertheless, he soon abandoned grand history and mythological works and gravitated toward more pleasurable smaller scenes for private collectors, which featured love, happiness, flowing clothes, abundant foliage, and soft, spontaneous brushwork. He worked rapidly, barely blending his colors to create a look of artlessness in his pictures. Prolific and inventive, Fragonard's work constitutes an expansion of the Rococo style. Over the course of his career, he produced more than 550 paintings, plus drawings and etchings.

He decorated rooms for several of Louis XV's mistresses, among them Madame de Pompadour (who died in 1764) and his last official mistress, Madame du Barry. Fragonard's masterpiece of the period is the series of large panel paintings commissioned by Madame du Barry for the Château de Louveciennes, in the western suburbs of Paris. These four large canvases, called *The Progress of Love*, feature lovers in various stages of romantic attachment in luxuriant, dense gardens full of mythological statues, plants, and tumbling flowers. Unfortunately, Madame du Barry rejected the panels and Fragonard left for a second trip to Italy in 1773.

After his return to France, Fragonard tried to adapt to the newly popular Neoclassical style, with its less complex compositions and smooth application of paint, but he found it too alien to his approach and stopped painting in 1792. Because Fragonard had helped the young unknown artist, Jacques-Louis David, in turn David helped him after the French Revolution, finding him a job at the Louvre as curator. Fragonard finally fell from favor under Napoleon and died in relative obscurity in 1806.

The Love Letter

c.1769–70 OIL ON CANVAS

32¾ x 26 IN (83.2 x 67 CM)

METROPOLITAN MUSEUM OF ART, NEW YORK, US

A charming, exquisitely dressed young woman is looking coquettishly out of the canvas, while her little dog adds to the impression that we have interrupted her. She has written a love letter to a gentleman and is about to send it. Fragonard's great compositional skills, free, confident handling, and sense of color are apparent.

KEY WORKS

The Lost Wager c.1759, STATE HERMITAGE, ST. PETERSBURG, RUSSIA

The Swing 1767, WALLACE COLLECTION, LONDON, UK

The Loves of the Shepherds: Love Letters 1771–3, THE FRICK COLLECTION, NEW YORK, US

The Reader c.1770–2, NATIONAL GALLERY OF ART, WASHINGTON, DC, US

The Fountain of Love c.1785, WALLACE COLLECTION, LONDON, UK

Goya

1746–1828 • ROCOCO PERIOD, ROMANTICISM

The artistic career of the Spanish artist Francisco José de Goya y Lucientes was long and successful. Principal painter to Charles IV of Spain, he was the most powerful and original European artist of his time. Prodigiously gifted as a draftsman, printmaker, and painter, he is considered both the last old master and the first modern painter.

Apart from an excursion to Rome for a year from 1770 to 1771, Goya spent most of his life in Spain. Born near Saragossa, he began training at the age of 14. At 17, he went to Madrid and studied with Anton Raphael Mengs (1728–79), a painter who was popular with the Spanish royal family. Goya's style was influenced from then on by Mengs and by Tiepolo, who was working in Spain.

After spending time in Rome, Goya returned to Saragossa and painted frescoes for the local cathedral in the fashionable Rococo style. These established his reputation. From 1775 to 1792, he designed for the royal tapestry factory in Madrid, producing his first genre paintings of everyday life. Through these, he developed a keen eye for the nuances of human behavior and also became established as a portrait painter to the Spanish aristocracy. In 1786 he became painter to Charles III, and in 1789, to Charles IV.

In 1792, a serious illness left Goya permanently deaf and he became more introspective. His work increasingly featured fantasies from his imagination, blended with sardonic observations of human behavior, and he evolved a bold and quite savage style, satirizing human flaws. His portraits became insightful depictions of his subjects rather than flattering representations and his religious frescoes displayed a loose, uninhibited style and an unrefined application of paint that was unique in works featuring sacred subjects.

Goya served as director of painting at the Real Academia de Bellas Artes de San Fernando from 1795 to 1797 and was appointed first Spanish court painter in 1799. His study of the works of Velázquez in the royal collection resulted in a looser, more spontaneous painting technique and he also became influenced by Neoclassicism. During the Napoleonic invasion and the Spanish War of Independence from 1808 to 1814, he painted for the French court. When the Spanish monarchy was restored, he was pardoned for serving the French, but his work did not appeal to the new king. He moved outside Madrid and remained isolated from society. Free from court restrictions, he adopted an increasingly personal style, expressing his darkest, nightmarish visions. In 1824, after the failure of an attempt to restore liberal government, he moved to France, settling in Bordeaux and continuing to work there until his death in 1828. Goya produced more than 700 paintings during his lifetime. His versatile, imaginative, and expressive works, with their free and experimental handling, influenced many later artists, particularly Manet and Picasso.

KEY WORKS

The Holy Family c.1775–80, MUSEO DEL PRADO, MADRID, SPAIN

The Clothed Maja (La Maja Vestida) 1800–3, MUSEO DEL PRADO, MADRID, SPAIN

Senora Sabasa García c.1806–7, THE NATIONAL GALLERY OF ART, WASHINGTON, DC, US

The Second of May, 1808 at the Puerta del Sol 1814, MUSEO DEL PRADO, MADRID, SPAIN

Self-Portrait 1815, ROYAL ACADEMY OF SAN FERNANDO, MADRID, SPAIN

The Third of May 1808

1814 OIL ON CANVAS

104½ X 135¾ IN (266 X 345 CM)

MUSEO DEL PRADO, MADRID, SPAIN

Commemorating Spanish resistance to Napoleon's armies during
the occupation of 1808, Goya depicts the horrific public execution of
insurgents as French soldiers fail to suppress them. The painting was
revolutionary in its subject matter, composition, and handling. With its
expressive use of color and dramatic composition, this conveys the
suffering of his compatriots at the hands of the French. Most of the
victims have faces; the killers do not. The pose, white shirt, and dreadful
facial expression of the central figure are reminiscent of Jesus on the
Cross and serve to evoke viewers' compassion.

The Death of Marat

1793 OIL ON CANVAS

65 X 50 IN (165 X 128 CM)

MUSÉES ROYAUX DES BEAUX-ARTS, BRUSSELS, BELGIUM

Jean-Paul Marat was a popular revolutionary. He defended the rights of
the poor in a newspaper, *L'Ami du Peuple*, and the Royalists hated him.
A young woman called Charlotte Corday murdered him while he was
sitting in a bathtub to relieve a skin condition. Sympathizing with Marat,
David portrayed him as an admirable hero.

David

1748–1825 • NEOCLASSICISM

Considered the unrivaled painter of the era, Jacques-Louis David perfected the new Neoclassical style, influencing several generations of painters. A supporter of the French Revolution, his academic style of history painting instigated a shift in taste from the lighthearted Rococo style toward a more classical sobriety, which was more in keeping with the mood of the period.

Raised from the age of nine by two uncles, François Buron (1731–1818) and Jacques-François Desmaisons (*c*.1720–89), who were both architects and building contractors, the young David received a good education. His family wanted him to become an architect, but he insisted on being a painter and was sent to study with François Boucher, a distant relative and the leading painter of the day. As modern tastes were changing, Boucher decided that his Rococo style was not suitable for David and so he sent him to his friend Joseph-Marie Vien (1716–1809), a painter with a more modern approach who taught at the Académie Royale de Peinture et de Sculpture in Paris.

In 1774, David won the prestigious art scholarship, the Prix de Rome, which meant he was able to study for five years at the French Academy in Rome, from 1775 to 1780. By the time he returned to France, he had completely rejected the Rococo style and developed a more classical approach, influenced by his study of ancient works and, in particular, the paintings of Raphael he had seen in Rome. By 1781, a year after his return to Paris, David had been made an associate member of the Académie Royale and his status was growing rapidly. In France, the frivolous Rococo style was associated with court life and David's austere Neoclassical style was viewed as an expression of the new thinking and changes in French society. After the French Revolution in 1789, David actively participated in political life. In 1791, he was elected a deputy of the Convention from Paris. He voted for the death of Louis XVI in 1793, which is somewhat odd as the king had supported him so strongly, but nonetheless, he supported Robespierre and the left radicals' regime. He served on various committees and used his art as propaganda for the new republic. After Robespierre and his closest supporters were overthrown, David was arrested twice and narrowly escaped the guillotine. His political career ended, but his artistic career revived and his work was appreciated for its patriotism, clarity, and purity of style.

Once Napoleon had restored order to France, David became devoted to him. The Emperor commissioned many works, including portraits and large paintings glorifying his life. In 1803, Napoleon made David a knight (or chevalier) of his newly founded Legion of Honor. After the fall of Napoleon and the Bourbon restoration, although he was offered the position of court painter, David refused and fled to Brussels in 1816. Now approaching 70, he turned to mythological subjects and intimate portraiture, abandoning the large-scale historical works that had maintained his reputation through such turbulent times. David's legacy was far-reaching. He taught many great artists, including Gros, Gérard, and Ingres, and his descriptive, polished, and noble style continued to influence many other painters until the middle of the 19th century.

KEY WORKS

The Oath of Horatii 1784, MUSÉE DU LOUVRE, PARIS, FRANCE

The Death of Socrates 1787, METROPOLITAN MUSEUM OF ART, NEW YORK, US

The Intervention of the Sabine Women 1799, MUSÉE DU LOUVRE, PARIS, FRANCE

Bonaparte Crossing the St. Bernard Pass 1800, MUSÉE NATIONAL DE MALMAISON, RUEIL-MALMAISON, FRANCE

Consecration of the Emperor Napoleon I and Coronation of the Empress Josephine in the Cathedral of Notre-Dame de Paris on December 2 1804 1808, MUSÉE DU LOUVRE, PARIS, FRANCE

Romanticism to Realism

*c.*1800–1900

Romanticism in the arts developed partly in opposition to elitist, aristocratic social, and political attitudes during the Age of Enlightenment. Emphasizing the emotions, it also rejected the rigor of Neoclassicism and gained popularity during the upheaval of the Industrial Revolution. Two movements followed on closely—Academic art was an attempt to fuse Romanticism with Neoclassicism; Realism was a reaction against both styles.

Romanticism

Originating in the first two decades of the 19th century, Romanticism appeared in art, music, literature, and poetry across Europe and America. Artists including the poets Goethe, Wordsworth, and Keats; the composers Beethoven, Mozart, and Haydn; and the painters Delacroix, Géricault, Blake, Turner, and Friedrich demonstrate the diversity of the movement. Emphasizing the emotions, in many ways Romanticism was the antithesis of Neoclassicism, while in some ways the two movements overlapped. Romantic art featured swirling shapes, dramatic compositions, and bold colors. A reaction against rationalism and an age of great upheavals, it was

also a manifestation of the revolutionary spirit of America and France. Romantic artists prized intuition, passion, suffering, the power of nature, and individual heroics. The imagination was respected and established rules rejected; subjectivity and individuality took precedence over reason. Investigating human nature in adversity, the Romanticists' work was emotionally charged, aiming to elude many of the rapid social, technological, economic, and political changes that were taking place.

Academic art

Simply meaning "art of the Academy," Academic art came to mean skillfulness without individuality.

1803
Calais Pier,
Turner
(1775–1851)

1814–17
Three Graces,
Antonio Canova
(1757–1822)

1816–17
Flatford Mill,
Constable
(1776–1837)

1822
Moonrise
over the Sea,
Friedrich
(1774–1840)

c.1831
The Great Wave
off Kanagawa,
Hokusai
(1760–1849)

1790

1820

1794
The Ancient
of Days,
Blake
(1757–1827)

1812
Construction of
Park Crescent,
John Nash
(1752–1835)

1814
La Grande
Odalisque,
Ingres
(1780–1867)

1819
The Raft of
the Medusa,
Géricault
(1791–1824)

1827
The Death of
Sardanapalus,
Delacroix
(1798–1863)

During the 19th century, the art academies of Europe had supremacy over the art world. Most artists could not achieve success unless they were accepted at the main academy of their country. Those who ran these institutions became increasingly conservative and opposed to innovation. In 1816, the Parisian Académie Royale de Peinture et de Sculpture, founded in 1648, merged with the Académie de Musique and the Académie d'Architecture, to form the Académie des Beaux-Arts. It became the standard which all other academies followed and it insisted that all artists should aim for a fusion of Neoclassicism and Romanticism. Painters were taught to aim for clean lines, detailed and lifelike depictions, invisible brushwork, and subtly blended tones and colors. In addition, certain subjects took precedence over others. Of greatest prestige were paintings ennobling historical, biblical, or mythological topics, and portraiture.

Realism

With the invention of photography in 1839, debates arose about the nature and purpose of painting and both Neoclassicism and Romanticism soon seemed dated and contrived. Realism was a revolt against emotionalism, emphasizing "truth to nature." As new technologies developed, social and political changes took place, and many artists decided that ordinary people and their activities were worthy subjects for art and that the styles of Neoclassicism and Romanticism were too contrived and self-conscious. Courbet, Manet, and Millais were three Realist painters who individually stressed factual accuracy and avoided exaggeration. As with many art movements, Realism manifested itself in various ways in different places and at different times. From about 1800 to 1899 in France, Realists painted the modern life they saw around them objectively without embellishment or personal bias. Aligning with the Revolution of 1848 in France (which led to Louis Napoleon's election as President of the Second Republic), Realists were reacting as much against society's artificiality and materialism as against academic rules and ingrained artistic traditions.

Other groups had similar philosophies. For instance, during the 1840s and 1850s, some French artists painted in the Forest of Fontainebleau near the village of Barbizon, far away from the Parisian Académie. Following on from the traditions of 17th-century Dutch and early 19th-century English landscape painting, they painted directly from nature. Meanwhile in England, from 1848, a group of painters, poets, and critics formed the Pre-Raphaelite Brotherhood to paint only "truth to nature" rather than adhering to the academic traditions that insisted on following Raphael. The PRB believed that many artists before Raphael were more liberated and honest, and focused on achieving realism through accurate details and color.

1839–52
Building of the Palace of Westminster,
Barry (1795–1860) and *Pugin*
(1812–52)

1845
Restoration of Notre Dame Cathedral, Paris,
Viollet-le-Duc
(1814–79)

1851–52
Ophelia,
Millais
(1829–96)

***c*.1861–65**
Orpheus Lamenting Eurydice,
Corot
(1796–1875)

1874
Proserpine,
Rosetti
(1828–82)

1850 1900

1833–34
Rainstorm at Shinō,
Hiroshige
(1797–1858)

1849–50
A Burial at Ornans,
Courbet
(1819–77)

1857
The Gleaners,
Millet (1814–75)

1866
Orpheus,
Moreau
(1826–98)

Blake

1757–1827 • ROMANTICISM

An English poet, painter, and printmaker who was largely ignored during his lifetime, William Blake is now seen as an exceptionally important artist of the Romantic Age. His visionary poetry and atmospheric artworks have shaped our views of the times in which he lived and have influenced generations of artists and writers since.

As a child, William Blake claimed to have seen a tree filled with angels. He grew up to develop a uniquely personal approach to art and poetry, exploiting a range of literary, mythological, and biblical sources. Blake was born in London's Golden Square, the son of a successful businessman. At the age of ten, he went to a drawing school in Covent Garden and at 14, he was apprenticed to James Basire (1730–1802), an engraver to the London Society of Antiquaries. In August 1779, he was admitted to the Royal Academy. Paying his way by producing engravings for novels and catalogs, he learned to draw from casts, life models, and corpses, but his opinions clashed with several of his tutors. Three years later, he became a freelance engraver, initially working for the bookseller Joseph Johnson (1738–1809). In 1784, he opened a print shop, but the business was unsuccessful and within two years he was back working for Johnson.

When his younger brother Robert died, Blake claimed that his spirit came to him and revealed a secret technique for combining poem and picture on a single printing plate. In 1788, he began producing illuminated books using this method. This launched the most creative and productive period of his life. He used several other techniques, avoiding oil paints as he believed they did not give him enough clarity of line, but he often worked in tempera, woodcut, relief etching, monotype, and watercolor. Many of his works portray his feelings about human dishonesty and oppression.

After the political upheavals of the Revolution in France in 1789, Blake's work became even more radical. He began to adapt his printing to produce full-scale paintings and was commissioned to produce many engravings and watercolors. In 1800, the writer William Hayley (1745–1820) invited Blake to live on his estate in Sussex, in southern England. He moved there and was delighted by the natural beauty of the area, but by 1802, the situation had soured. Tired of the trivial commissions from Hayley and his society neighbors, Blake moved back to London in 1803.

However, success proved more elusive than ever. When he held an exhibition in his brother's hosiery store in 1809, he was mocked as "an unfortunate lunatic whose personal inoffensiveness secures him from confinement." By 1810, Blake was impoverished and estranged from his friends and patrons. He continued to work, however, believing Jerusalem, an epic about war, peace, and liberty focused on London, to be his finest work. As he turned 60, his work at last began to be admired by younger artists.

KEY WORKS

God Judging Adam 1795, TATE BRITAIN, LONDON, UK
Newton c.1805, TATE BRITAIN, LONDON, UK
Nebuchadnezzar c.1805, TATE BRITAIN, LONDON, UK
The Good and Evil Angels c.1805, TATE BRITAIN, LONDON, UK
The Body of Abel Found by Adam and Eve c.1826, TATE BRITAIN, LONDON, UK

The Ancient of Days

1794 WATERCOLOR, BLACK INK, AND GOLD PAINT, OVER A RELIEF ETCHED OUTLINE PAINTED IN YELLOW

9 X 6 IN (23.3 X 16.8 CM)

BRITISH MUSEUM, LONDON, UK

A religious man who disagreed with Church teachings, this is Blake's expression of God's perfection and omnipotence—"The Ancient of Days" is a name for God in Aramaic. The figure derives from 18th-century artists and Michelangelo. Compasses symbolizing the act of creation have been used in Medieval manuscripts and early Bibles.

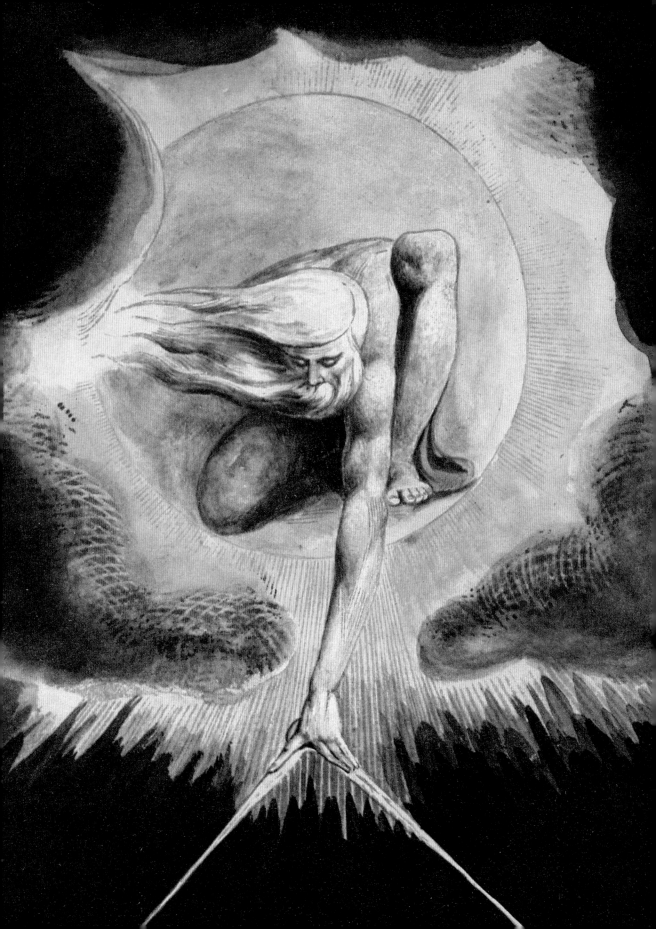

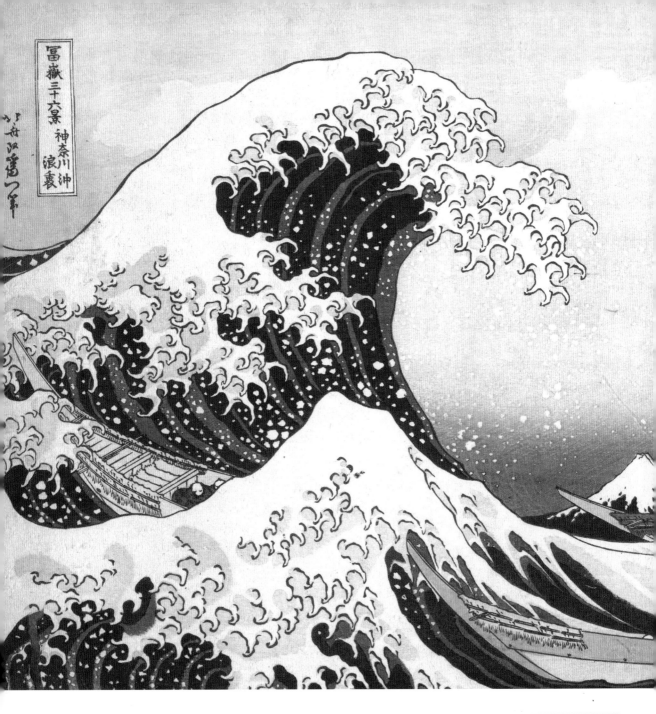

冨嶽三十六景 神奈川沖 浪裏

北斎画

The Great Wave off Kanagawa

*c.*1831• COLOR WOODCUT

10 X 15 IN (25.4 X 37.1 CM)

ORIGINAL IS IN HAKONE MUSEUM,

KANAGAWA-PREFECTURE, JAPAN

Introducing direct observation of nature and ordinary people, Hokusai revolutionized Japanese art. This picture is from his *Thirty-Six Views of Mount Fuji.* Its asymmetrical, dynamic composition features humans engulfed beneath a giant wave, with the sacred Mount Fuji in the background.

KEY WORKS

Fishing Boats at Choshi in Shimosa FROM THE SERIES, *1,000 PICTURES OF THE OCEAN*, *c.*1833, ART INSTITUTE OF CHICAGO, CHICAGO, IL, US

Fuji in Clear Weather FROM THE SERIES, *THIRTY VIEWS OF MOUNT FUJI*, *c.*1831–4, FINE ART MUSEUM OF SAN FRANCISCO, SAN FRANCISCO, CA, US

Kojikisawa in the Kai Province 1823–31, STATE HERMITAGE MUSEUM, ST. PETERSBURG, RUSSIA

Rough Sea at Naruto in Awa Province FROM THE SERIES, *PICTURES OF FAMOUS PLACES IN THE SIXTY-ODD PROVINCES*, 1855, CHAZEN MUSEUM OF ART AT THE UNIVERSITY OF WISCONSIN, MADISON, WI, US

Hokusai

1760–1849 • UKIYO-E

The leading Ukiyo-ē painter and printmaker of Japan's Edo period, Katsushika Hokusai became particularly appreciated in the West when his prints were imported to Paris in the middle of the 19th century.

Hokusai is considered one of the outstanding figures of the Ukiyo-ē, or "pictures of the floating world" (everyday life), school of printmaking. His prints were collected by many European artists during the 19th century, including Monet, Degas, van Gogh, Whistler, and Toulouse-Lautrec, while several art and design movements, including Impressionism, Postimpressionism, and Art Nouveau, reflect aspects of his style.

Born in Edo (now Tokyo), from the age of about 12 Hokusai worked in a bookstore selling books made from popular woodcut blocks. Within a few years, he began training in woodcut printmaking in the studio of leading Ukiyo-ē artist Katsukawa Shunshō (1726–92). Ukiyo-ē focused on images of the courtesans and Kabuki actors in contemporary Japanese cities. Over the following years, Hokusai produced thousands of book illustrations and color prints, drawing his inspiration from the traditions and legends of the Japanese people.

On the death of Shunshō in 1793, Hokusai began exploring other styles and subjects, including European styles he saw in French and Dutch copper engravings. He moved away from the images of courtesans and actors and began focusing on landscapes and images of the daily life of Japanese people. These subjects were revolutionary in Ukiyo-ē. He developed a curving, expressive, and graceful style but it was not until his series the *Thirty-Six Views of Mount Fuji*, published between 1826 and 1833, that he became appreciated internationally. His enormous output of about 30,000 prints gained him acclaim in the Western world, particularly the three-volume book *One Hundred Views of Mount Fuji*, which he produced at the age of 75.

Moonrise over the Sea

1822 OIL ON CANVAS

21.6 X 28 IN (54.9 X 71.1 CM)

NATIONALGALERIE, STAATLICHE MUSEEN

ZU BERLIN, GERMANY

During the early 1820s, Friedrich frequently incorporated human figures into his paintings. This choice of subject matter was quite groundbreaking; the infinite stretch of the sea disappearing into the strange light of the rising moon and the figures almost silhouetted against it.

Friedrich

1774–1840 • ROMANTICISM

The major painter of the Romantic Movement in Germany, Caspar David Friedrich created ethereal visions out of German landscapes, bathing his views in mysterious light and glowing colors.

Trained at the Academy in Copenhagen from the age of 20, Friedrich subsequently settled in Dresden, Germany. He remained there for the rest of his life, often traveling to other parts of the country, but never visiting Italy, as most other artists did. Particularly interested in depicting the effects of light, his landscapes usually feature haunting images of trees, hills, harbors, mists, and other aspects of the northern German landscape, based on close observations of nature and his own spiritual interpretations. Initially producing topographical drawings in pencil and sepia wash, he took up oil painting when he was in his 30s.

An intensely introspective man, one of Friedrich's first oil paintings was *The Cross in the Mountains*, painted as an altarpiece for a private chapel and exhibited in 1808. Apart from the cross, it contains no specifically religious elements and it was the first time in Christian art that an altarpiece was created just as a landscape. It provoked a debate about the use of landscape in sacred art. Many of his other landscapes feature meditative figures, trees, or ruins set against the sky, usually expressing his individual responses to the natural world. His mystical preoccupations are always conveyed through scrupulous observation of reality and composed from many studies. Celebrated from early on in his career, as the world moved swiftly through the 19th century, Friedrich's thoughtful work came to be seen as outdated. He died in obscurity, but at the end of the century, the Symbolists rediscovered him and he became appreciated once more.

KEY WORKS

Cross in the Mountains 1807–8, GEMÄLDEGALERIE, DRESDEN, GERMANY

Winter Landscape 1811, NATIONAL GALLERY, LONDON, UK

Wanderer above the Sea of Fog c.1818, KUNSTHALLE, HAMBURG, GERMANY

The Sea of Ice c.1823–5, KUNSTHALLE, HAMBURG, GERMANY

Calais Pier

1803 OIL ON CANVAS

67¾ x 94½ IN (172 x 240 CM)

NATIONAL GALLERY, LONDON, UK

Painted before Turner became even more expressive, this was not well received when first exhibited in 1803, as critics considered the foreground to be unfinished. Based on Turner's own experience, the painting depicts a packet boat arriving at Calais in northern France. Nature dominates the dramatic composition, with huge waves, storm clouds, and a shaft of hopeful sunlight.

KEY WORKS

The Shipwreck 1805, TATE GALLERY, LONDON, UK
Snow Storm: Hannibal and His Army Crossing the Alps
 1812, TATE GALLERY, LONDON, UK
Frosty Morning 1813, TATE GALLERY, LONDON, UK
The Fighting Temeraire 1838, NATIONAL GALLERY,
 LONDON, UK
Snow Storm—Steam-Boat off a Harbor's Mouth 1842,
 TATE GALLERY, LONDON, UK
Rain, Steam and Speed—The Great Western Railway
 1844, THE NATIONAL GALLERY, LONDON, UK

Turner

1775–1851 • ENGLISH LANDSCAPE, ROMANTICISM

The most famous landscape painter of the Romantic Movement, Joseph Mallord William Turner's precocious talents enabled him to become one of the youngest full members of Britain's Royal Academy of Arts. His early landscapes were influenced by past masters, and his later pioneering and atmospheric studies of light had a profound influence on many later painters.

As a child, Turner's father proudly displayed his son's work in the window of his barber shop in Covent Garden, London. When he was 15, Turner was accepted as a student of the Royal Academy of Arts and three years later, he won the Society of Arts prize for landscape drawing. At the same time he also took lessons with Thomas Malton (1748–1804), an architectural draftsman. He was soon employed as a copyist, with a group of other young artists, by a physician and art collector, Dr Thomas Munro (1759–1833). From 1791, he went on regular sketching tours around Britain, producing drawings that he used later as the basis for watercolor views or engravings. He exhibited his first oil painting at the Royal Academy when he was 21, and three years later, he was made an Associate of the Academy. At the age of 26, he became the second youngest person to be elected as a full member of the academy.

A hugely productive artist, Turner's first paintings show the influence of Claude and of 17th-century Dutch marine painters. As well as exploring the British Isles with enthusiasm, between 1802 and 1830 he made frequent trips abroad to study and sketch the scenery. In addition, he visited Paris and studied the old masters that had been plundered by Napoleon. As his career flourished, Turner's style became looser and more personal. After 1830, he applied paint in any way necessary to achieve the expressive atmosphere he was aiming for, such as with palette knives or rags. He brightened his palette, and lightened his canvases with an initial coat of white before painting them, and then applied pale washes in layers. Many of his works were revolutionary at the time for their composition, themes, and effects and although he was extremely popular, he also had many critics. Unusually, those who admired him appreciated his originality, and he was elected Professor of Perspective at the Royal Academy in 1811 and appointed acting president in 1845. The respected art critic, John Ruskin (1819–1900), championed him and further heightened his standing in the art world.

In later life, to ensure freshness, Turner began sending unfinished canvases to exhibitions—on "Varnishing Days," before the exhibition opened, rather than simply varnish his works, he would finish painting in the exhibition room. With his unique images of the moods and atmospherics of nature, he became known as "the painter of light." No landscape painter had ever focused so much on the effects of light and he laid the foundations for the Impressionists and later, the Abstract Expressionists.

Constable

1776–1837 • ENGLISH LANDSCAPE, ROMANTICISM

Best-known for his tranquil landscape paintings of the English countryside, John Constable brought a new energy and importance to landscape painting. By painting in oils in the open air, he began a trend that was taken up throughout Europe and America for the rest of the 19th century, contributing to the development of Impressionism.

Constable is known mainly for his landscape paintings of Dedham Vale in Suffolk, eastern England, the area around his home. As the son of a mill owner and corn merchant, he was trained for a career in the family business, which he interspersed with sketching trips in the surrounding countryside. Sir George Beaumont (1753–1827), a local baronet who was also a collector and amateur painter, showed Constable his collection of paintings, which included *Hagar and the Angel* by Claude Lorrain. This further strengthened Constable's ambition to become a painter. By the age of 23, his father reluctantly allowed him to study art at the Royal Academy in London and independently, he copied paintings by the great landscape artists of the past, including Claude, Gainsborough, Rubens, and the Dutch landscapists, in particular Jacob van Ruysdael (c.1628–82).

At 26, Constable exhibited at the Royal Academy, but as his paintings were not the traditional heavenly landscapes depicting stories from the Bible or mythology, they were unpopular. He had developed his own style, which was more realistic than Gainsborough and Claude, and closer to the style of van Ruysdael. He believed that the study of nature was imperative and that painting from the imagination or from predetermined traditions was not honest. He produced scores of sketchbooks, filled with studies made from direct observation of nature, and also painted almost complete oil paintings and watercolors in the open air, finishing them off in the studio, which was not the usual practice. For his large canvases (which he called "six-footers"), he also worked unconventionally, creating full-sized oil sketches before embarking on the final painting. Although success eluded Constable in Britain, in 1824 *The Hay Wain* won a gold medal at the Paris Salon and

was particularly admired by, among others, Delacroix and Géricault. Eventually, when he was 52, he was made a full member of the Royal Academy, elected by a majority of only one vote.

Developing new ways to represent the effects of changing light in the open air, the formation and movement of clouds across the sky, and his love for the countryside of his youth, Constable's best works are of the places he knew. To represent natural light and weather effects, he rejected the smooth finish encouraged by the academies, instead applying paint in expressive and descriptive marks. Although he was never financially successful, he became a major influence on later artists, particularly Delacroix and Géricault, the painters of the Barbizon School and the Impressionists.

KEY WORKS

Boatbuilding 1814, VICTORIA AND ALBERT MUSEUM, LONDON, UK

The White Horse 1819, THE FRICK COLLECTION, NEW YORK, US

The Hay Wain 1821, THE NATIONAL GALLERY, LONDON, UK

Salisbury Cathedral from the Bishop's Grounds c.1825, METROPOLITAN MUSEUM OF ART, NEW YORK, US

Hadleigh Castle 1829, YALE CENTER FOR BRITISH ART, NEW HAVEN, CT, US

The Leaping Horse 1824–5, ROYAL ACADEMY OF ARTS, LONDON, UK

Flatford Mill

1816–17 OIL ON CANVAS

40 X 50 IN (102 X 127 CM)

TATE BRITAIN, LONDON, UK

Views of ordinary people and places—with no embellishment or symbolism—were not esteemed topics in the early 1800s, and the sheer size of this view of the countryside around Constable's childhood home was unusual. Based on a close study of his surroundings, Constable achieved natural and lifelike effects by applying a wide range of greens as seen in nature. Painting from a high viewpoint gives the work an almost panoramic view. Without any artificial enhancements, the painting's emphasis on the commonplace was unpopular with critics.

La Grande Odalisque

1814 OIL ON CANVAS

35 x 64 IN (88.9 x 162.6 CM)

MUSÉE DU LOUVRE, PARIS, FRANCE

Commissioned by Napoleon's sister, Queen Caroline Murat of Naples, and exhibited at the Paris Salon of 1819, this exotic Turkish harem mistress is portrayed in the tradition of the reclining Venuses of the Venetian Renaissance. Her languid sensuality, elongated spine, and pale limbs show influences from the Mannerists and contrast with the heavy surrounding drapery. Like David, Ingres' forms are smooth and sculptural and his palette is muted and cool.

KEY WORKS

The Valpinçon Bather 1808, MUSÉE DU LOUVRE, PARIS, FRANCE

Louis-François Bertin 1832, MUSÉE DU LOUVRE, PARIS, FRANCE

Louise de Broglie, Countess d'Haussonville 1845, FRICK COLLECTION, NEW YORK, US

The Source 1856, MUSÉE D'ORSAY, PARIS, FRANCE

The Turkish Bath 1862, MUSÉE DU LOUVRE, PARIS, FRANCE

Ingres

1780–1867 • NEOCLASSICISM

The French Neoclassical painter, Jean Auguste Dominique Ingres, believed firmly in the supremacy of line over color. Considered revolutionary in his lifetime because his ideas conflicted with those of his tutor, David, he ended up as revered as his master for his interpretation of Neoclassicism. He divided his time between Paris and Italy.

Born in Montauban, southwestern France, Ingres received his first training (in art and music) from his father, who was a painter and miniaturist. He showed a precocious talent, so at the age of 11 he was enrolled at the Académie Royale de Peinture, Sculpture et Architecture in Toulouse to study sculpture and painting. Six years later, he attended David's studio in Paris and four years after that, he won the coveted Prix de Rome. Due to the government's lack of funds he remained in Paris till 1806, painting portraits to earn a living.

During his first years in Rome, Ingres studied the Renaissance artists. When his four-year Prix de Rome period ended, he remained in Italy, drawing and painting portraits. He also began painting bathers—a theme that he returned to frequently during the course of his career. These elongated, smooth-skinned female nudes epitomized his belief in accuracy of line and demonstrated his admiration of mannerism and the works of antiquity. Yet for all his triumphs as a student, and his subsequent time in Rome, success in Paris was not forthcoming: the works he sent back (as part of the Prix de Rome's rules) were not well received. He remained in Italy for 17 years and when he returned to France, his style was not as popular as the Romanticism that artists such as Delacroix were producing.

Although he considered himself a history painter in the tradition of David, Ingres's large history paintings are not as powerful as his smaller, more intimate portraits, and bathers, or "odalisques." These paintings, with their cool colors, smooth surfaces, and imperceptible brushstrokes, gradually gained him recognition and *The Vow of Louis XIII*, exhibited at the Paris Salon of 1824, finally brought him critical acclaim and he became celebrated throughout France. In 1835, he returned to Rome as director of the French Academy of Arts there, and six years later, on his return to Paris, a great welcoming parade was held in his honor. By then, he was celebrated as equal to David for his Neoclassical approach and skill. His influence on later artists, and on academic art, was profound. Although his work is often seen as a direct contrast with Romanticism, the styles have many similarities.

Géricault

1791–1824 • ROMANTICISM

One of the most original pioneers of the Romantic Movement, Jean Louis André Théodore Géricault was a hugely influential painter and lithographer. His passionate temperament—and disregard for convention—helped to elevate him to the status of a legend during his remarkable, yet tragically short, career of just 12 years.

A dandy and a keen horseman, whose dramatic paintings reflected his colorful personality, Géricault was born in Rouen, France, to wealthy parents. His family moved to Paris when he was a child, and as he was avidly interested in horses and art, as a teenager he was taught by the artist Carle Vernet (1758–1836), who shared his passion. Next he studied with the Neoclassical painter Guérin, who also taught Delacroix. As with many artists of his era, however, Géricault received his most influential instruction over about six years, copying paintings at the Louvre. He was particularly inspired by the vigor of Rubens' paintings, and after a two-year stay in Italy in 1816, he also integrated much of Caravaggio's drama and chiaroscuro and Michelangelo's classical techniques and forms into his own work.

Géricault's first success was *The Charging Chasseur*, exhibited at the Paris Salon of 1812, which shows the influence of Rubens. It won him a gold medal and inspired many other artists who preferred this idea of realism and passion, rather than the cool and deliberate style of Neoclassicism. For a while he painted fairly small works, but after his trip to Italy, he began painting more dramatic and passionate works, often quite monumental in scale. With the energy and emotional intensity he portrayed, he showed the art world how the imagination and drama could enhance the impact of paintings. This violated the conventions of history painting, but rather than being condemned for it, his ideas and style became fashionable. His work always conveyed some sort of excitement or spirit, reflecting his own personality. Subjects included horses, cavalry officers, and portraits of all types of people, including the insane—and even a couple of severed heads.

In 1819, he painted his over-life-sized *Raft of the Medusa*, which provoked a furore at the Salon, although it won him another medal. Using strongly contrasting effects of light, vivid realism, and an exceptionally dramatic composition, he depicted the survivors of a recent disaster that had occurred partly because of government incompetence. Tragically, Géricault died at the age of 32, as a result of his reckless lifestyle and a series of riding accidents.

> **KEY WORKS**
>
> **An Officer of the Imperial Horse Guards Charging, also Chasseur Charging** 1814, MUSÉE DU LOUVRE, PARIS, FRANCE
>
> **The Blacksmith's Signboard** 1814, KUNSTHAUS, ZURICH, SWITZERLAND
>
> **Horse Races in Rome** 1817, MUSÉE DES BEAUX-ARTS, LILLE, FRANCE

The Raft of the Medusa

1818–19 OIL ON CANVAS

193 X 282 IN (491 X 716 CM)

MUSÉE DU LOUVRE, PARIS, FRANCE

This painting broke all the rules with its morbid depiction of human suffering. It is the moment when some of the survivors of the wrecked frigate, the *Medusa*, see another ship on the horizon. At least 147 passengers had been clinging to a hastily constructed raft and only 15 survived, experiencing starvation, dehydration, madness, and cannibalism. The incident became an international scandal because the French captain had been acting under the authority of the recently restored French monarchy. Undertaking extensive research, Géricault worked for over a year on the work, interviewing survivors and visiting morgues and hospitals to study the dying and dead.

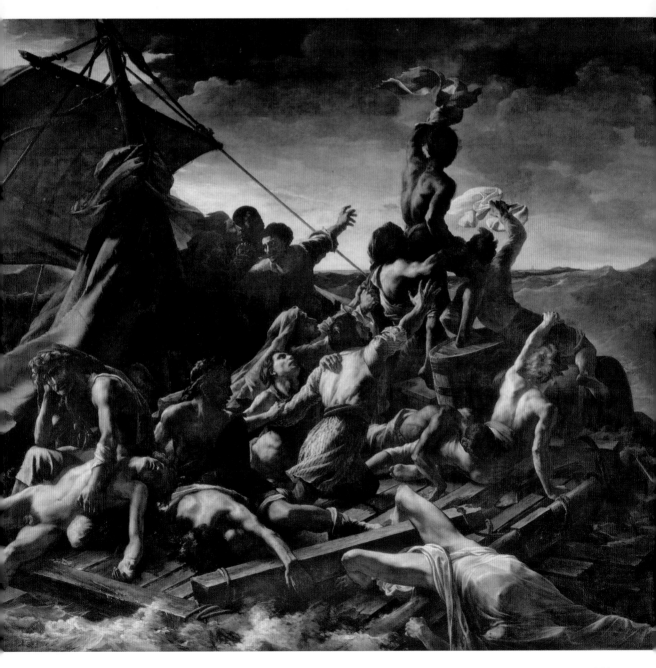

Corot

1796–1875 • NATURALISM, BARBIZON SCHOOL, REALISM

A critical figure in French landscape painting, Jean-Baptiste Camille Corot was the leading painter of the Barbizon School in the mid-19th century and influenced the Impressionists.

Landscape painting had appeared as a subject in its own right in 17th-century Holland, and in England during the 18th and 19th centuries, but apart from the works of Poussin and Claude, in France, landscape was not a conventional artistic theme. Camille Corot was a shy boy, born in Paris to a bourgeois family. At the age of 19, he attended evening classes run by one of David's former pupils. A couple of years later, he had a studio built in his parents' new house near Versailles. He became apprenticed to a draper, but hated commercial life and at the age of 26, with financial aid from his parents, he began his career as an artist. He trained with Achille-Etna Michallon (1796–1892) and then Jean-Victor Bertin (c.1767–1842) both landscape painters.

Corot traveled widely around France, and visited Italy from 1825 to 1828, and again in 1834 and 1843 (although he declared he learned more from the harmony of nature and brilliant Mediterranean light than he did from the old masters). He also painted landscapes in Switzerland, the Netherlands, and England, but he remained particularly attached to the countryside around Paris. He painted outdoors, as Constable had done, and from the 1850s he turned toward a more evocative and lyrical style of painting, using a vibrant, light touch and a muted palette. By adding white to many of his colors, he gave his pictures an ethereal, silvery appearance. He won his first medal at the Salon of 1833 and 14 years later, he was awarded the Légion d'Honneur. His growing popularity helped draw attention to naturalism, and his landscapes had an inspiring influence on the Impressionists.

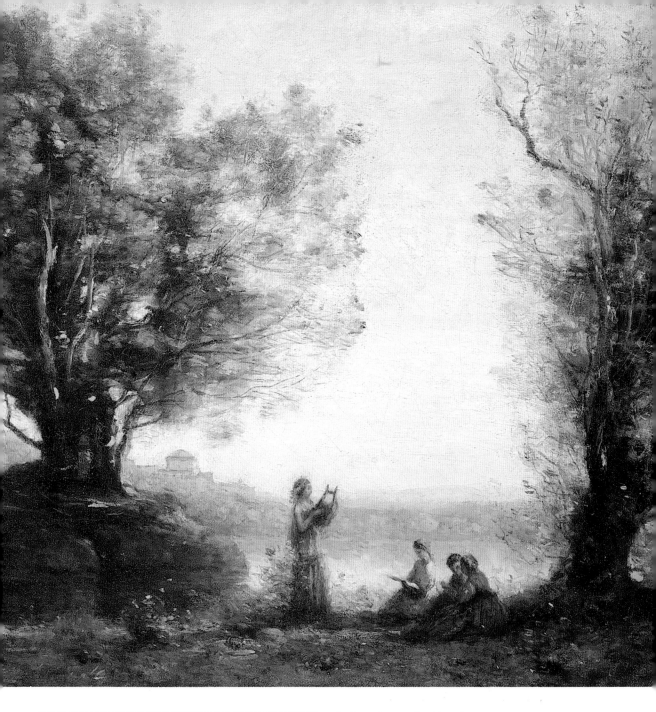

KEY WORKS

View of Riva in the Italian Tyrol 1834, NEUE PINAKOTHEK,
 MUNICH, GERMANY
Morning, Dance of the Nymphs 1850–1, MUSÉE D'ORSAY,
 PARIS, FRANCE
Souvenir of Mortefontaine 1864, MUSÉE DU LOUVRE,
 PARIS, FRANCE
Lady in Blue 1874, MUSÉE DU LOUVRE, PARIS, FRANCE
The Mill of Saint-Nicolas-les-Arraz 1874, MUSÉE D'ORSAY,
 PARIS, FRANCE

Orpheus Lamenting Eurydice

*c.*1861–5 OIL ON CANVAS

16½ x 24 IN (41.9 x 61 CM)

KIMBELL ART MUSEUM, FORT WORTH, TX, US

Committed to painting in the open air directly from nature, Corot often
created dreamlike fantasy landscapes out of the views he studied. Here,
from the opera *Orpheus and Eurydice*, Eurydice has just died from the
bite of a serpent and a heartbroken Orpheus plays his lyre.

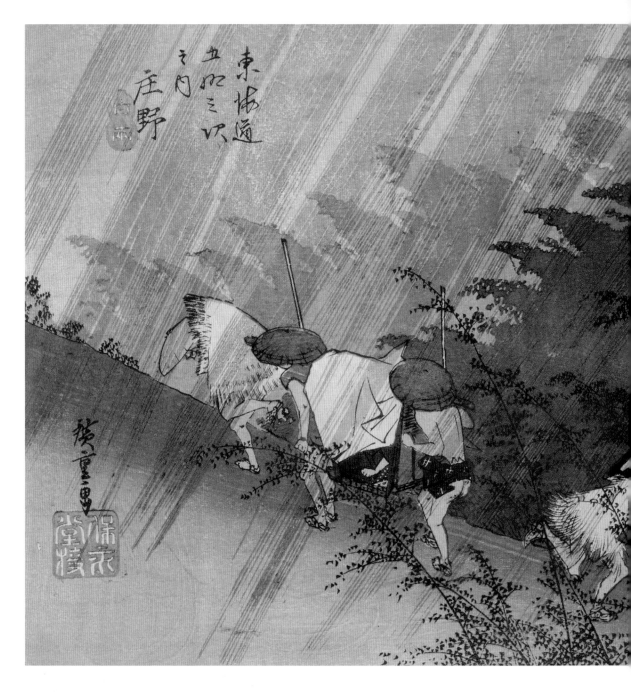

Sudden Rainstorm at Shōno

1833–4 COLOR WOODCUT PRINT

10 X 13¾ IN (25 X 35 CM)

THE MINNEAPOLIS INSTITUTE OF ARTS,

MINNEAPOLIS, MN, US

In this masterpiece Hiroshige has captured the effects of a
sudden storm. The figures rush on, bent against the wind and
rain. The diagonal composition adds to the feeling of energy and
the different tones are portrayed in a simplified, stylish manner.

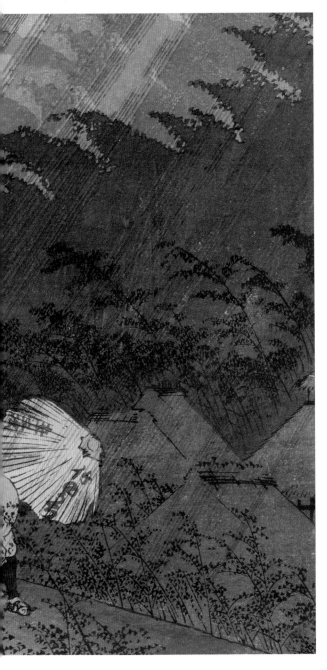

Hiroshige

1797–1858 • UKIYO-E

One of the most influential artists of Japan's Ukiyo-ē period, Andō Hiroshige's brightly colored and original work had a lasting effect on the Impressionists and Postimpressionists.

Ukiyo-ē, or "pictures of the floating world," began during the second half of the 17th century in Japan and focused on beautiful courtesans, actors, and scenes of everyday life. Ukiyo-ē was a sophisticated style that emphasized harmonious color and graceful compositions. Artists usually produced woodcuts for middle-class buyers and occasionally paintings for wealthier individuals. Allegedly inspired by Hokusai, as a child Hiroshige learned drawing in the Kanō School style and then studied with Ooka Unpo (1765–1848), an artist who favored the Chinese style. As a teenager, he entered the workshop of Utagawa Toyohiro (1773–1828) as an apprentice for a year, and then began working. He firstly followed Ukiyo-ē traditions, and then gradually began to produce more landscape scenes. His first publications, which were refreshingly original, appeared when he was 21. These were *Eight Views of Ōmi*. They were fairly successful, but did not attract much attention. However, his next work— *Ten Famous Places in the Eastern Capital*—with its blend of the Kanō and Shijo painting styles, drew attention to his name.

In 1832, Hiroshige produced a series of prints, *The Fifty-Three Stations of the Tokaido*, which depicted various aspects of the highway between Kyoto and Edo. They were instantly successful and were followed by *Sixty-Nine Stations of the Kisokaido* and *One-Hundred Famous Views of Edo*. With their vibrant colors, dynamic compositions, and spatial harmonies, these prints evoked the atmosphere of the countryside and provincial towns at a time when travel was restricted for most Japanese people. As one of the last great figures of the Ukiyo-ē period, Hiroshige boldly used elements of Western-style perspective, creating simplified, yet natural-looking, evocations of mood and atmosphere that portrayed elements of the East through universally appealing themes.

KEY WORKS

Kanaya FROM *FAMOUS VIEWS OF THE FIFTY-THREE STATIONS*, c.1855, PRINCETON UNIVERSITY ART MUSEUM, PRINCETON, NJ, US

Nihon Bridge and Edo Bridge FROM THE SERIES *ONE-HUNDRED FAMOUS VIEWS OF EDO*, 1857, CHAZEN MUSEUM OF ART AT THE UNIVERSITY OF WISCONSIN, MADISON, WI, US

Dyers' Quarter, Kanda 1857, THE BROOKLYN MUSEUM, NEW YORK, US

Delacroix

1798–1863 • ROMANTICISM

Frequently named as the greatest painter of the Romantic Movement, Delacroix created sweeping, dramatic scenes in strong colors. His work was admired by his contemporaries for its compelling, evocative nature and his handling of paint was influential in the development of Impressionism. With its emphasis on emotion and color, his painting was the antithesis of Neoclassicism.

At the end of the 18th century, as the Rococo period was losing its momentum, Ferdinand Victor Eugène Delacroix was born near Paris. The son of a diplomat, he had a good education and grew up with a love of literature, music, and art. He began studying for an artistic career when he was 17, with Pierre-Narcisse Guérin (1774–1833), and at the École des Beaux-Arts a year later. He also spent time copying the old masters in the Louvre, which instilled in him a huge admiration for Rubens and the Venetian painters of the 16th century. From them he developed his energetic, passionate style and warm, rich palette.

While his contemporary, Ingres, believed that a painting was nothing without drawing, Delacroix advocated the spontaneity of painting directly onto canvas without meticulous planning. He maintained that compositions should be constructed through the placement of color, and stories and themes should be conveyed with passion and vitality.

In 1822, his painting *The Barque of Dante* was received with great acclaim at the Paris Salon and was bought by the state. Two years later, he won a gold medal (the same Salon that had awarded Constable a gold medal for *The Hay Wain*). In 1825 he traveled to England and, socializing with English artists and literary figures, he became acquainted with Romantic English literature and the theater, which became significant sources of inspiration in his work. A trip to Spain, Morocco, and Algeria in 1832 further stimulated him, broadening his range and providing him with new kinds of subjects. From then on, his fluid, spirited, and vibrant paintings exuded a blend of exoticism and vigor.

His dynamic, flowing compositions and gestural brushstrokes were perceived as unstructured, but Delacroix always planned his works carefully and saw himself as following the established traditions of painting in the Grand Manner, albeit with a modern slant. From 1833, Delacroix spent a lot of time painting prestigious, large-scale state commissions, including the Salon du Roi in the Palais Bourbon (now the Assemblée Nationale), the Galerie d'Apollon in the Louvre and the Chapelle des Anges in the church of St. Sulpice.

Delacroix continued to produce smaller paintings and lithographs and over the years received many awards for his work. His output was enormous. In his journals he wrote profusely about art, revealing insights into his methods, his life, and the times in which he lived. His use of bold colors and freely applied pigment, along with his lively compositions and observations of nature, had an enormous influence on young forward-thinking artists for the rest of the century, including the Impressionists.

KEY WORKS

The Barque of Dante 1822, MUSÉE DU LOUVRE, PARIS, FRANCE

The Massacre at Chios 1824, MUSÉE DU LOUVRE, PARIS, FRANCE

Liberty Leading the People 1830, MUSÉE DU LOUVRE, PARIS, FRANCE

The Women of Algiers 1834, MUSÉE DU LOUVRE, PARIS, FRANCE

Sultan of Morocco 1845, MUSÉE DES AUGUSTINS, TOULOUSE, FRANCE

The Death of Sardanapalus

1827 OIL ON CANVAS

121 x 163 IN (392 x 496 CM)

MUSÉE DU LOUVRE, PARIS, FRANCE

Inspired by a tragedy by the poet Byron, this painting depicts the story of an Assyrian king, who, rather than surrender to his attackers, set fire to himself and his entourage. The chaos and terror of the situation is rendered with force and zeal. Delacroix has applied curves, diagonals, rich, warm colors, and broad brushstrokes to convey the atmosphere of the moment. Viewers are drawn into the composition, from the foreground massacre to the figure of Sardanapalus watching the destruction of all his possessions.

The Gleaners

1857 OIL ON CANVAS

32¾ x 43¾ IN (83.5 x 111 CM)

MUSÉE D'ORSAY, PARIS, FRANCE

Millet's sympathy for peasants is expressed in their poise. The figures are heavy, with curved backs and anonymous faces scouring the newly harvested field. They fill their aprons with any leftover grain they can find—a practice known as gleaning. In the past, gleaning had been represented in art through the Old Testament story of Ruth, who was a modest and virtuous woman. In this painting, the figures' rounded shapes and the calmness of the surrounding countryside convey Millet's interest in rural life.

Millet

1814–1875 • NATURALISM, BARBIZON SCHOOL, REALISM

Often described as the painter of peasants, Jean-François Millet represented the change from traditional painting to Modernism. His empathy with peasants, their difficult rural lives, and the countryside in which they lived, was portrayed in many dignified works that were admired by socialists, but heavily criticized as subversive by conservative thinkers.

Millet was born into a prosperous farming family in northern France. He studied art locally, then moved to Paris in his early 20s to continue his artistic education with the celebrated painter, Paul Delaroche (1797–1856), at the École des Beaux-Arts. Initially Millet worked as a portrait painter, but after the 1848 French Revolution he moved to the village of Barbizon near Fontainebleau Forest and began concentrating on painting rural life. Although many criticized what they saw as a glorification of peasants, others admired his bold stance and approach. Those who disapproved of working-class people being the subject of paintings—regarding it as Millet's criticism of French society—were countered by those who viewed the works as celebrations of honest and hardworking lives, depicted in surprisingly varied colors.

Millet's style, although Realist, had none of Courbet's dark, dramatic contrasts and unfinished areas. Whether working in oils or pastels, every mark was deliberate, every nuance of color and tone intended. Like Bruegel had done in the 16th century, Millet aimed to show the peasant world to those who had little knowledge of it. He instilled great dignity into his scenes, creating timeless, compassionate, and serene works filled with atmospheric light and some sentimentality.

Millet remained in Barbizon for the rest of his life, except for a short period during the Franco-Prussian War from 1870 to 1871, when he returned to his home village of Gruchy. He became one of the central figures of an informal group of painters that later became known as the Barbizon School. United in their opposition to classical artistic traditions, and inspired by the work of Constable in England and the 17th-century Dutch landscape painters, they painted landscapes "en plein air" (literally, out of doors) objectively and for its own sake.

One of Millet's closest friends was Théodore Rousseau (1812–67), one of the leaders of the Barbizon painters. He often helped Millet financially (he had a large family to support), and encouraged him to paint pure landscapes, which he did increasingly in later life. In the 1860s, as the controversy around his peasant paintings diminished, Millet became renowned and financially successful. At the 1867 Exposition Universelle in Paris, he was honored with a retrospective of his work and the following year he was awarded the Légion d'Honneur. By the time of his death, at the age of 61, he was a celebrated figure, both for his sentiments and his work, and his paintings became very popular. He was enormously influential on late 19th-century artists, including Pissarro, Seurat, and van Gogh.

KEY WORKS

Woman Baking Bread 1854, KRÖLLER-MÜLLER MUSEUM, OTTERLO, THE NETHERLANDS
Washerwomen 1855, MUSEUM OF FINE ARTS, BOSTON, MA, US
Girl Carrying Water 1856, RIJKSMUSEUM, AMSTERDAM, THE NETHERLANDS
The Angelus 1857–9, MUSÉE D'ORSAY, PARIS, FRANCE
The Knitting Lesson 1869, ST. LOUIS ART MUSEUM, ST. LOUIS, MO, US

Courbet

1819–1877 • REALISM

Frequently categorized as the father of the Realist Movement, Courbet used the term Realist to describe his own work and even issued a manifesto on the subject. As with many artists who broke with artistic conventions, his work was condemned and ridiculed by contemporary critics, but was later hailed by avant-garde artists as revolutionary and influential.

One of the most powerful personalities of 19th-century art, Courbet was born at Ornans in eastern France. He moved to Paris when he was 20, but his country upbringing remained prominent in his art. He trained in and around his home town, but even in Paris, he learned more from viewing the work of artists such as Caravaggio and Velázquez in the Louvre than he did from his teachers. His first works were quite Romantic in concept and often influenced by literary sources, but he soon began focusing on studies of real life.

Between 1841 and 1847, only three of his paintings were accepted by the Salon jury. In 1846 and 1847, he visited the Netherlands and Belgium, where he saw paintings by Rembrandt and other Dutch masters. This increased his resolve to only paint what he saw around him. In 1848, after the Revolution, the Salon was held without a jury. Courbet exhibited ten of his works the following year and won a gold medal, but when three of his 14 submissions were rejected from the Exposition Universelle in 1855, he set up his own pavilion. He called his exhibition "Le Réalisme" and although attendance and sales were low, his positive influence on young avant-garde artists was secured.

Many of Courbet's works became the object of public derision. Paintings featuring ordinary people were considered inappropriate, as most people favored mythology and idealistic subjects; Courbet declared he could not paint an angel as he had never seen one. Critics also scoffed at his painting technique, with its strong tonal contrasts applied quickly and roughly with a palette knife, resulting in a coarsely textured surface. Again, he maintained that this was more realistic than the smooth finish of academic paintings.

After the abdication of Napoleon III in 1870, Courbet's republican friends declared him head of the arts commission of the Commune, the interim revolutionary government of Paris. When the Commune was overthrown, he was accused of helping to destroy the Vendôme Column, a monument to Napoleon, and imprisoned for six months. On his release, he was told to pay for the rebuilding of the column. Unable to do so, he fled to Switzerland, where he spent his final years.

KEY WORKS

A Burial at Ornans 1849–50, MUSÉE D'ORSAY, PARIS,
FRANCE
The Meeting, or "Bonjour Monsieur Courbet" 1854,
MUSÉE FABRE, MONTPELLIER, FRANCE
Young Ladies on the Banks of the Seine BEFORE 1857,
NATIONAL GALLERY, LONDON, UK
The Cliff at Etretat after the Storm 1869, MUSÉE D'ORSAY,
PARIS, FRANCE

The Studio of the Painter

1855 OIL ON CANVAS

141¼ X 235 IN (359 X 598 CM)

MUSÉE D'ORSAY, PARIS, FRANCE

Painted for the 1855 Paris Exposition Universelle, this is an allegory of
Courbet's life as a painter with figures used to symbolize his qualities,
ideals, loves, and hates. Lit from an indefinite source, friends and
admirers are shown on the right, and challenges and opposition to
the left. The friends include the art critics, Champfleury and Charles
Baudelaire, while on the left are figures who represent the principles
Courbet rejected.

Moreau

1826–1898 • SYMBOLISM

One of the precursors of the Symbolist Movement, French painter Gustave Moreau's highly distinctive and mystical style was influenced by Romanticism and the great masters of the Renaissance.

Turning away from a world increasingly dominated by science and technology, Parisian-born Moreau developed a distinctive painting method that incorporated a flowing style, symbolic elements, and jewellike details— and explored romantic imagery of myth, history, the Bible, and the bizarre and exotic.

The son of an architect, in his teens Moreau trained with the history painter François-Édouard Picot (1786–1868), and from the age of 20, he studied at the École des Beaux-Arts. A great admirer of Romanticism, his early style shows a strong influence of his friend Théodore Chassériau (1819–56) and Delacroix (1798–1863). Gradually, he developed his unique style, building up mysterious, dreamlike images, with thick, smooth paint and intense, rich colors.

After visiting Italy in 1841 and 1857, he began blending elements of the High Renaissance with Romanticism in his work. Focusing on the intellectual content of his themes, his religious, historical, and mythological subjects were explored for their underlying meanings and sentiments, featuring both subtle and overt symbolism. His thoughtful observations, imagination, taste for the exotic, and interest in the effect of embellished details, often prompted accusations of pretentiousness and his sensitivity to disapproval made him reluctant to exhibit.

For prolonged periods, he refrained from showing his work, but slowly he became appreciated, particularly by intellectuals, and he grew more willing to exhibit. In 1864 he won a medal at the annual Paris Salon, even though he had disdained the Salon in previous years. From that decade, he began creating a more Baroque style, but still depicted unreal worlds of fantasy and the imagination on his canvases, and soon achieved great public acclaim. Although he had some success at the Salon, he had private means so did not need to rely on this. Much of his time was spent in seclusion, but in 1892 he became a professor at the École des Beaux-Arts and proved to be an inspiring teacher, bringing out his students' individual talents and self-expression, rather than trying to impose his own ideas on them. These students included Marquet and Matisse, and his favorite Rouault, who became the first curator of the Moreau Museum, his house in Paris, which Moreau left to the nation on his death. He was later considered to be a forerunner of Surrealism.

Orpheus

1866 OIL ON WOOD

60 X 39 IN (154 X 99.5 CM)

MUSÉE D'ORSAY, PARIS, FRANCE

In Greek mythology, Orpheus charmed all with his music, but he was killed. His story was a popular Symbolist theme as it shows that an artist lives on through his creations. Here, a girl, adorned with iridescent jewels, holds his severed head on his lyre.

KEY WORKS

Oedipus and the Sphinx 1864, METROPOLITAN MUSEUM OF ART, NEW YORK, US

Jason 1865, MUSÉE D'ORSAY, PARIS, FRANCE

The Apparition c.1874–6, MUSÉE GUSTAVE MOREAU, PARIS, FRANCE

Galatea c.1880, MUSÉE D'ORSAY, PARIS, FRANCE

Hesiod and the Muse 1891, MUSÉE D'ORSAY, PARIS, FRANCE

Rossetti

1828–1882 • PRE-RAPHAELITE BROTHERHOOD

Dante Gabriel Rossetti was one of the founders of the Pre-Raphaelite Brotherhood. A talented, charismatic, and enthusiastic poet and painter, he became the central figure of the group.

Rossetti grew up in London within a strong artistic and literary environment. His father was an Italian academic and political refugee. His sister was a poet and his brother a critic, and from an early age Rossetti aspired to be either a poet or a painter. Although painting became his profession, he continued writing poetry throughout his life.

Fascinated by Medieval art and the poetry of his namesake Dante Alighieri, the charismatic young man enthused fellow art students at Henry Sass's Drawing Academy with his ideas about legends and literature. One of these students was Millais. After four years, in 1845, he enrolled at the Royal Academy and three years later, he left to study under Ford Madox Brown (1821–93), with whom he retained a close friendship throughout his life. That year, after seeing a painting by William Holman Hunt (1827–1910), *The Eve of St. Agnes*, depicting a poem by John Keats (1795–1821), Rossetti befriended Hunt, as one of his own poems, "The Blessed Damozel," was inspired by Keats. Hunt shared his artistic and literary beliefs and together Rossetti, Hunt and Millais developed the Pre-Raphaelite Brotherhood.

This association of young painters challenged the established view of painting, aiming to reform English art by rejecting the adherence to one academic style that followed Raphael and was based on the formal training program introduced by Sir Joshua Reynolds in the 18th century. Instead, they advocated a return to the vibrant colorings, meticulous details, and complex compositions of 15th-century Italian and Flemish art. They published a manifesto of their intentions in a periodical called the *Germ*.

From the start, Rossetti was the Pre-Raphaelite Brotherhood's driving force, insisting that painting should be objective and taken directly from nature in emulation of the work of some of the great Italian artists who had preceded Raphael. He made elaborate studies, reproducing colors vividly onto wet, white ground, similar to Italian frescoes. This had the effect of making the colors appear particularly bright. His paintings were sensual and gemlike and his personal life and relationships were closely linked to his work. Although a great deal of the Pre-Raphaelite Brotherhood's work received hostile criticism, Rossetti's paintings were usually well-received. Many of his works depicting biblical, literary, and mythological stories inspired many younger artists. By the end of his life, his work commanded exceptionally high prices and he became a major influence on the Symbolist Movement.

KEY WORKS

The Girlhood of Mary Virgin 1849, TATE BRITAIN, LONDON, UK
Ecce Ancilla Domini ("The Annunciation") 1850, TATE BRITAIN, LONDON, UK
Beata Beatrix 1864–70, TATE BRITAIN, LONDON, UK
The Bower Meadow 1872, CITY ART GALLERIES, MANCHESTER, UK
The Blessed Damozel 1875–8, FOGG MUSEUM OF ART, HARVARD UNIVERSITY, CAMBRIDGE, MA, US

La Ghirlandata (The Bower Meadow)

1873 OIL ON CANVAS

45½ x 35½ IN (115.6 x 87.6 CM)

THE GUILDHALL ART GALLERY, LONDON, UK

The various greens of this lush, leafy glade complement the glowing hair of the models, Alexa Wilding and May Morris, while flowers in shades of sapphire and ruby fill the bottom of the canvas and a garland of roses and honeysuckle adorns the harp, which represents music and love.

Ophelia

1851–2 OIL ON CANVAS

30 X 40 IN (76.2 X 111.8 CM)

TATE BRITAIN, LONDON, UK

Depicting the death of Ophelia in Shakespeare's *Hamlet*, Millais
painted this work in two separate locations: outside by the Hogsmill
River at Ewell in Surrey and in his studio in London. Millais spent nearly
four months painting the background, including symbolic flowers, such
as daisies for innocence; roses for youth, love, and beauty; violets for
faithfulness, and poppies for death. The model was Rossetti's future
wife, Elizabeth Siddal. For months, she posed in the heavy antique dress
in a bathtub of water, heated from below with oil lamps.

> ### KEY WORKS
>
> **Isabella** 1848–9, WALKER ART GALLERY, LIVERPOOL, UK
> **Christ in the House of his Parents** 1850, TATE BRITAIN,
> LONDON, UK
> **Mariana** 1851, TATE BRITAIN, LONDON, UK
> **Autumn Leaves** 1855–6, MANCHESTER CITY ART GALLERY,
> MANCHESTER, UK
> **Bubbles** 1886, LADY LEVER ART GALLERY, LIVERPOOL, UK

Millais

1829–1896 • PRE-RAPHAELITE BROTHERHOOD

The youngest ever pupil to be accepted at the English Royal Academy of Arts, John Everett Millais was a founding member of the Pre-Raphaelite Brotherhood, which emerged in the middle of the 19th century. As involved with modern artistic developments as much as with the old masters, his jewellike paintings have shaped many people's visions of Victorian life and attitudes.

Growing up in a prosperous family, Millais was very hardworking as well as gifted. At the age of nine, he won a silver medal for his art and two years later, he was accepted at the Royal Academy Schools. There he forged friendships with his fellow students, Rossetti and Holman Hunt. When Millais was 19, the three artists formed the Pre-Raphaelite Brotherhood in an effort to counteract the conservatism of academic painting, with its brown undertones and idealization of subjects. Millais's concern for moral values and social behavior derived from new attitudes in British society as a result of the Industrial Revolution, as old values began to be questioned. All the Pre-Raphaelites agreed on their approach—to be faithful to nature and exploit the luminosity of color.

Millais's early paintings were scrupulously observed and planned. He often painted landscape backgrounds over months in the open air, and figures and interior scenes over further months in the studio. His first religious painting, *Christ in the House of his Parents*, completed when he was 21, attracted a barrage of criticism when it was exhibited at the Royal Academy. Showing Christ and his family as ordinary, working-class people, critics objected to the lack of reverence shown. Millais's paintings show eclectic influences, including van Eyck and Velázquez as well as pre-Renaissance art and the work of the Nazarenes, a group of German artists who lived in Rome. Of all the Pre-Raphaelites, Millais was the most heavily criticized, but he carried on, believing in himself and gradually the disapproval diminished. Medieval themes, literature, poetry, and the Bible were the basis for many of his works.

The greatest art critic of the day, John Ruskin (1819–1900), became the Pre-Raphaelites' champion, convinced that Millais would become as great as Turner. Largely through Ruskin, critics began to appreciate the qualities of Pre-Raphaelite paintings, particularly those by Millais. But just as the Pre-Raphaelites had attained the success they sought, they disbanded. Millais began to conform to the ideals of the Royal Academy and became an associate. Always an accomplished painter, he became preoccupied with literary, historical, and genre paintings and portraits and many of his works attained critical success.

In his aspirations to earn money, many of Millais's later works appeared quite sentimental, particularly in comparison to his Pre-Raphaelite paintings. He believed that all art should be beautiful, no matter what the subject. In 1880, Oxford University conferred an honorary degree on him and in 1885 he was made a baronet.

Impressionism to Postimpressionism
c.1865–1910

The group title "Impressionists" was originally intended as a derogatory term, used by a critic who thought Monet's *Impression, Sunrise* was insubstantial when it was shown at an exhibition in 1874. The Impressionists were united in their rejection of many styles and subjects that preceded them; the Postimpressionists in turn rejected Impressionism.

The rejected

While Courbet and other Realists can be said to have foreshadowed Impressionism, the most obvious start of "modern" painting emerged in Manet's technique and unusual subject-matter. He met with huge disapproval, but continued producing what he believed in, inspiring other young artists with his controversial approach. In 1863, the Paris Salon—the main way in which artists in France could attain recognition in the official art world—rejected an unprecedented number of works. The rebuffed artists protested vehemently. Rejected paintings had a red "R" stamped on the back for refusé (rejected), which made it difficult to sell these works. Napoleon III intervened and created another exhibition, called the Salon des Refusés, at which all artists who had

been rejected could exhibit. Although most of the works were ridiculed by visitors, the exhibition also highlighted how the Salon jury selected only a particular type of painting and it set a powerful precedent for independent or unofficial exhibitions.

Momentary effects

The Impressionists, as they came to be known, rejected the traditionalist rules of academic painting. They were inspired by many artists and styles, including the free brushstrokes and bold colors of Delacroix; the direct observation of Courbet and the Barbizon School; and the changing natural light and atmosphere captured by Constable and Turner. They emphasized overall e ffects or "impressions" rather than closely rendered details,

c.1873–76
The Dance Class,
Degas
(1834–1917)

1875
The Gross Clinic,
Eakins
(1844–1916)

1880
The Tea,
Cassatt
(1844–1926)

1882
Bar at the
Folies-Bergère,
Manet (1832–83)

1860 **1880**

1871
Arrangement in Grey
and Black, No 1 or
The Artist's Mother,
Whistler (1834–1903)

1874
Proserpine,
Rossetti
(1828–82)

1876
La Moulin
de la Galette,
Renoir
(1841–1919)

1880–1917
The Gates of Hell,
Rodin
(1840–1917)

1884
Bathers at Asnières,
Seurat
(1859–91)

and focused on the changing qualities of light. Working quickly, applying broken marks of pure, unblended color, the Impressionists achieved immediate and momentary effects as the eye sees them. This was in total contrast to the carefully finished works celebrating history or religious themes that the Académie favored.

The artists included Monet, Degas, Renoir, Morisot, Alfred Sisley (1839–99), Frédéric Bazille (1841–70), Pissarro, Cézanne, and Armand Guillaumin (1841–1927). They shared common philosophies about painting, but their styles differed widely. Manet led their discussions when they met at the Café Guerbois on Batignolles Street (today Avenue Clichy) in Paris. He also encouraged them to exhibit their works independently outside the Salon— they organized the Société Anonyme Coopérative des Artistes Peintres, Sculpteurs, Graveurs, holding their first exhibition in 1874 at a photographer's studio. The ensuing scathing review by Louis Leroy was mockingly called "The Exhibition of the Impressionists." Yet despite early ridicule, the term Impressionists soon stuck and was even accepted by the artists themselves. From 1874 to 1886, they held eight exhibitions. The Impressionists gradually won a degree of public acceptance and they began changing attitudes about art. Many of the artists, seeking inspiration for their paintings, settled in towns and villages around Paris, where they could capture the transient effects of light.

Contributing factors

Impressionism developed as the culmination of many things. As well as the influence of the diverse styles and approaches of many earlier artists, the contemporary sociopolitical climate and technological advances, some even more direct developments played a part. These included portable, ready-mixed paints in lead tubes, which contrasted with the powdered pigment they previously had to mix themselves. The newly established medium of photography gave artists fresh ideas about composition and capturing likenesses. Japanese art prints, which had only recently been available in France, also provided ideas about unusual compositions and simplicity.

Impressionism's demise

Inevitably, however, once Impressionism had been established, younger artists found fault with it. Some criticized the triviality of subject matter; others thought there was a lack of intellectual thought behind the works. Most of these artists simply had new ideas that they wanted to explore. They first became called Postimpressionists in 1910, after an exhibition of their work was held in London and referred to by the group term of Postimpressionism. There is no one set style, but it all derives from Impressionism.

1888
Sunflowers,
van Gogh (1853–90)

1892
The Card Players,
Cézanne
(1839–1906)

1897
Boulevard
Montmartre at Night,
Pissarro (1830–1903)

1899
The Gulf Stream,
Homer
(1836–1910)

1895

1910

1890
At the Moulin Rouge:
The Dance,
Toulouse-Lautrec
(1864–1901)

1894–95
Guaranty Building,
Sullivan
(1856–1924)

1897–98
Where do we come
from? What are we?
Where are we going?,
Gauguin
(1848–1903)

1899
Bridge over a Pond
of Water Lilies,
Monet
(1840–1926)

Pissarro

1830–1903 • IMPRESSIONISM

Often called the "father of Impressionism" because he advised so many younger artists, Jacob-Abraham-Camille Pissarro was the only Impressionist to take part in all eight Impressionist exhibitions. He developed his own style, painting landscapes in the open air, building up forms from dabs and flecks of pure, brilliant color, and subtly conveying the innumerable variations of light.

Born in St. Thomas in the Virgin Islands, Pissarro was sent to a Parisian boarding school at the age of 12. He returned to work in his father's store in 1847, but five years later, as his father was set against his artistic ambitions, he ran away to Venezuela to become a painter. In 1855, his father capitulated and Pissarro traveled to Paris where he entered the École des Beaux-Arts and then the Académie Suisse. His masters included Corot, Courbet, and Charles-François Daubigny (1817–78) and their encouragement to paint from nature had a profound effect on him. Corot, in particular, advised him to make small sketches working directly in the landscape "to study light and tonal values." At the Académie Suisse he also met Monet, Cézanne, and Armand Guillaumin (1841–1927). Although older than most of the future Impressionists, he became part of their circle, meeting with them to discuss their artistic ideas.

Attracted by country scenes, Pissarro moved to various homes around Paris and painted the surrounding landscapes. By the 1860s, landscape painting had become more acceptable in France, and although in 1863 he exhibited at the Salon des Refusés, from 1864 to 1870 he regularly exhibited at the official Salon. These early works were broadly and expressively painted, showing the influence of his teachers, but in a brighter palette.

In 1870, during the Franco-Prussian War, Pissarro escaped to the safety of London. There he met the art dealer Paul Durand-Ruel (1831–1922), who bought two of his London paintings. He also met Monet there, and the two friends painted together and visited art galleries. After the war, he settled in Pontoise and was often joined by Cézanne, who shared his interest in composition and structure. After about 1874, he began experimenting with Impressionist techniques, sometimes working with palette knives and applying paint in patches of color.

During the 1880s he also began painting the bridges, quays, barges, steamboats, and smoking factory chimneys of modern industrial life. He painted market scenes and figures more frequently, creating vibrant and luminous effects with small dabs and dashes of complementary colors and flecks of light with his flickering brushwork. Believing that all painting was a learning process, he frequently advised younger artists and experimented with new ideas. In the 1880s, he tried Pointillism with Seurat, painting in dots of pure color that merged when viewed from a distance. Despite his changes of style, throughout his career Pissarro always focused on direct observations of light and atmospheric conditions, refusing to yield to social or artistic conventions.

KEY WORKS

L'Hermitage *c.*1868, SOLOMON R. GUGGENHEIM MUSEUM, NEW YORK, US

A Fair at the Hermitage near Pontoise *c.*1878, COURTAULD INSTITUTE GALLERIES, LONDON, UK

Apple Picking 1886, OHARA MUSEUM OF ART, KURASHIKI, OKAYAMA, JAPAN

The Boieldieu Bridge at Rouen, Setting Sun, Foggy Weather 1896, MUSÉE D'ORSAY, PARIS, FRANCE

The Boulevard Montmartre on a Cloudy Morning 1897, NATIONAL GALLERY OF VICTORIA, MELBOURNE, AUSTRALIA

Boulevard Montmartre at Night

1897 OIL ON CANVAS

21 X 25½ IN (53.3 X 64.8 CM)

NATIONAL GALLERY, LONDON, UK

Toward the end of his life, Pissarro suffered with eye problems and painted townscapes more than landscapes, mainly from the windows of hotels and apartments. One of several works painted at different times of day and in different weather conditions, this was painted from the Hôtel de Russie on the corner of the Boulevard des Italiens and the Rue Drouot in Paris at night. These views may have been inspired by Monet's series paintings. The orange-yellow of the street lights is reflected in the silver and ultramarine of the dark, wet streets.

Manet

1832–1883 • REALISM

Modern art begins with Édouard Manet. With his painting technique and interpretation that defied established artistic conventions, he attempted to capture modern life and the impressions of passing moments; to depict what the eye perceives within seconds. All too predictably, these innovations were viewed as outrageous, but his influence on subsequent painting was immense.

Manet came from a bourgeois Parisian family (his father was an official in the Ministry of Justice and his mother was the daughter of a diplomat). His decision to become an artist met with parental opposition but, inspired by the old masters, particularly the Spanish painters with their dramatic compositions and tonal contrasts, he was determined to achieve his aim. After an episode in the merchant marines, he studied with Thomas Couture (1815–79) for five years. In 1856, he visited art collections in Holland, Germany, Prague, Austria, and Italy—and in Spain ten years later.

From 1852, Paris underwent a massive modernization program. Its cramped, Medieval alleyways were destroyed and replaced by long, wide boulevards lined with cafés and stores. In the midst of all this change, Manet rejected the old style of painting, choosing instead to paint contemporary life around him. With his bold brushwork, absence of half tones, juxtapositions of strong color, flattening of forms, inconsistencies of scale, and irreverent subject matter, his version of modernization caused outrage.

Although he was striving to be modern, Manet still sought acceptance. When one of his works was rejected from the Salon in 1863, he exhibited at the Salon des Refusés. The painting was *Déjeuner sur l'Herbe*. Featuring a naked woman between two fully clothed men, it scandalized viewers. The unfinished treatment also appeared to insult academic art. For several years, the Salon jury continued to reject his paintings, not understanding what he was trying to do and seeing him simply as a bad artist who only wanted to shock. Nevertheless, Manet inspired the young group of artists who became known as the Impressionists. For the next few years, he led these artists' discussions in the Café Guerbois and he continued to paint a broad range of contemporary subjects in loose brushstrokes. He was not intentionally scandalous, and for his entire life he sought recognition in the official art quarters. He simply aspired to do something new and his innovations gradually changed ideas about art.

KEY WORKS

Music in the Tuileries Gardens 1862, NATIONAL GALLERY, LONDON, UK

Le Déjeuner sur l'Herbe 1862–3, MUSÉE D'ORSAY, PARIS, FRANCE

Olympia 1863, MUSÉE D'ORSAY, PARIS, FRANCE

Luncheon in the Studio 1868, NEUE PINAKOTHEK, MUNICH, GERMANY

The Execution of the Emperor Maximilian of Mexico 1867–8, STAATLICHE KUNSTHALLE, MANNHEIM, GERMANY

The Railway 1872, THE NATIONAL GALLERY OF ART, WASHINGTON DC, US

Bar at the Folies-Bergère

1882 OIL ON CANVAS

37¾ x 51¼ IN (96 x 130 CM)

COURTAULD INSTITUTE OF ART, LONDON, UK

In his last great work, Manet captured the interior of a popular bar and restaurant. The barmaid boldly looks back at the viewer and the glittering, bustling interior is reflected in the long mirror behind her. Manet was awarded a medal for it at the Paris Salon in 1882. He died the following year.

144

Degas

1834–1917 • IMPRESSIONISM

Although he exhibited with the Impressionists and is regarded as one of their founders, the work of Hilaire-Germain-Edgar Degas has distinct differences. He became famous for his work in painting, sculpture, printmaking, and drawing, concentrating on photographically inspired compositions and contours. His dynamic work turned mundane moments and situations into scenes shaped by light.

With his skills in the depiction of movement, sensitive portraiture, and masterful understanding of color and line, Degas's work can really be viewed as a mixture of Impressionism, Realism, and Neoclassicism. Like Manet, he was born in Paris to an affluent family and was initially trained for the law, but left to study art with Louis Lamothe (1822–69), who had been a pupil of Ingres. He also went to the École des Beaux-Arts but preferred to study on his own, copying old masters in the Louvre. He also visited Italy, staying in Naples, Rome, and Florence, and studying artists such as Botticelli and Raphael.

In 1859, Degas mainly produced history paintings and portraits. They reveal his admiration of the great masters of the past, including van Dyck, Holbein, Velázquez, and Goya. Although quite reclusive, he became friends with Manet, who introduced him to the circle of artists who met at the Café Guerbois. In the late 1860s, he turned to contemporary themes, including racecourses, women at work, interiors, ballet, and theater, clearly inspired by photographic compositions and Japanese prints. As his subject matter changed, so too did his technique. Unlike the other Impressionists, he never applied small, variegated brushstrokes but he began using slashing strokes and bright colors, capturing passing moments like snapshots. With their academically structured contours, some of his paintings were accepted by the official Salon from 1865 until 1870. He served in the artillery during the Franco-Prussian War and then traveled to New Orleans to stay with his brother René, producing several works before returning to Paris in 1873.

The following year, Degas helped to organize the first Impressionist exhibition and over the next 12 years, he participated in seven of the eight subsequent Impressionist exhibitions. He was one of the first artists to take up photography, both for enjoyment, and in order to accurately capture action and unusual compositions for painting. From the early 1870s, he began painting ballet dancers regularly, fascinated by their movements and physical discipline. His viewpoints and angles are often oblique and unexpected, as in photography. Making many sketches from life, he observed, analysed, and recorded with great care before beginning a final work. In this way, he depicted both the movement and atmosphere of his subjects. At the age of 50, Degas's eyesight started to fail and he turned to pastel and sculpture, where he followed his fascination for capturing snatched moments.

The Dance Class

1874 OIL ON CANVAS

32¾ X 30¼ IN (83.2 X 76.8 CM)

METROPOLITAN MUSEUM OF ART, NEW YORK, USA

Viewers' eyes are drawn around this unusual asymmetrical composition that is clearly influenced by photography and Japonisme. Ballet students and their mothers crowd in a dance studio, while Jules Perrot, one of the best known ballet masters of the time, conducts a class. Appearing as a frozen moment in time, Degas worked hard to make the dancers appear spontaneous and natural.

KEY WORKS

Horses Before the Stands 1866–8, MUSÉE D'ORSAY, PARIS, FRANCE

Portraits in a New Orleans Cotton Office 1873, MUSÉE DES BEAUX-ARTS, PAU, FRANCE

Mlle La La at the Circus Fernando 1879, NATIONAL GALLERY, LONDON, UK

Little Fourteen-Year-Old Dancer 1879–81, METROPOLITAN MUSEUM OF ART, NEW YORK, US

The Tub 1886, MUSÉE D'ORSAY, PARIS, FRANCE

Whistler

1834–1903 • REALISM, AESTHETICISM, ART NOUVEAU, TONALISM

A truly international artist, James Abbott McNeill Whistler was born in America, spent much of his childhood in Russia, most of his life in England, and studied art in France. A fan of Japanese art and decoration, he was original and intelligent. He pioneered ideas about nonrepresentational painting and became internationally influential.

Although his early work derives from Realism, Whistler pioneered a new style of painting that emphasized harmony and design, as well as the drama of fleeting moments. Born in Massachusetts in the US, at the age of nine he moved with his family to St. Petersburg in Russia, where his father was employed in the building of the St. Petersburg–Moscow railway. When he was 11, he enrolled at the Imperial Academy of Fine Arts in St. Petersburg and also learned French, but on the sudden death of his father in 1849, his mother took her children to Connecticut in the US. Two years later, Whistler entered West Point Military Academy, but after three years he was expelled for failing an exam.

In 1855, after a brief period of employment with a cartographer, Whistler traveled to Paris, intending to study for a career as an artist. After a short period at the École Impériale et Spéciale de Dessin, he enrolled at the studio of Charles-Gabriel Gleyre (1806–74). There he joined a group of young English artists that included Edward Poynter (1836–1919), Thomas Armstrong (1832–1911), Thomas Lamont (1826–98), and George du Maurier (1834–96). He also studied and copied paintings at the Louvre and socialized with Delacroix, Courbet, Manet, Degas, and the poet Charles Baudelaire (1821–67).

In 1859, Whistler moved to London, although he often returned to Paris. He immediately became a well-known figure. His paintings and prints were either heavily praised or condemned, and his dandified appearance and the fashionable circles in which he mingled (he was a close friend of both Oscar Wilde and Rossetti) were frequently written about in the press. Famous as much for his biting wit and fashionable dress as for his art, he was always a controversial figure, the center of public quarrels and a famous libel case involving the art critic, John Ruskin. Despite winning it, the libel case led to his bankruptcy and the acceptance of a commission to etch in Venice, where he recovered his reputation and financial losses.

Whistler's art broke new ground with its soft suggestions of elements and firm, yet minimal design aspects and reduced palette. During the 1870s, his strong sense of design became even more apparent and the parallels he drew between art and music led him to call many works "arrangements," "harmonies," and "nocturnes," rather than following the contemporary assumption that paintings should tell stories. Always fascinated by Japanese art, he adapted his signature into the shape of a butterfly and created Japanese-inspired interior designs. In 1886 he became president of the Society of British Artists.

KEY WORKS

The Last of Old Westminster 1862, THE MUSEUM OF FINE ARTS, BOSTON, MA, US

Rose and Silver: The Princess from the Land of Porcelain 1864, FREER GALLERY OF ART, WASHINGTON, DC, US

Nocturne: Blue and Silver–Cremorne Lights 1872, TATE GALLERY, LONDON, UK

Nocturne in Black and Gold: The Falling Rocket 1874–7, THE DETROIT INSTITUTE OF ARTS, DETROIT, MI, US

Harmony in Red: Lamplight 1886, HUNTERIAN ART GALLERY, GLASGOW, UK

Arrangement in Gray and Black, No 1 or The Artist's Mother

1871 OIL ON CANVAS

56¾ X 63¾ IN (144.3 X 162.4 CM)

MUSÉE D'ORSAY, PARIS, FRANCE

"Art for art's sake" was Whistler's motto and his paintings are vehicles for the creation of perfect compositions, each one made up of delicate gradations of tones. This portrait of his mother, to whom he was deeply attached, is intensely personal and atmospheric, but overall the painting is primarily an arrangement of colors and shapes. His admiration of Japanese art led him to simplify lines and refine harmonies of tones.

The Gulf Stream

1899 OIL ON CANVAS

28 X 49 IN (71.5 X 124.8 CM)

METROPOLITAN MUSEUM OF ART, NEW YORK, US

This was based on studies made during two winter
trips to the Bahamas. A man lies helpless on the deck
of a small boat that has been seriously damaged by a
hurricane. Around him, the turbulent sea and circling
sharks are closing in, yet on the horizon, a rigger can just
be seen, indicating hope for the future.

Homer

1836–1910 • GENRE PAINTING, INFLUENCE OF REALISM AND IMPRESSIONISM

The greatest painter of New England country life, Winslow Homer was one of the leading figures in 19th-century American art. A thoughtful artist, his expressive landscapes, marine, and genre paintings explored the relationship between man and nature, independent from artistic conventions. Homer's primary aim was to accurately portray nature and the times in which he lived.

Homer was born in Boston, Massachusetts and his mother, a gifted amateur watercolorist, gave him his first art lessons. He became apprenticed to a commercial lithographer in Boston when he was 19 and within four years he had moved to New York, where he produced illustrations for the magazine *Harper's Weekly*. When the American Civil War broke out in 1861, *Harper's Weekly* sent him to illustrate the fighting. With his powerful record of the horrors of the war, he developed a reputation for realism.

After exhibiting his popular painting, *Prisoners from the Front*, at the National Academy of Design in 1867, Homer followed it to Paris where it was displayed at the Exposition Universelle. With no formal art training, he painted landscapes while working as an illustrator, and in Paris he studied the new art that was being produced by artists such as Millet, Manet, and Courbet. His own style involved clear contrasts of tone and color, dynamic groupings of people and vigorous and energetic brushwork. He followed the traditions of the Hudson River School, a mid-19th-century group of American landscape painters influenced by Romanticism and the French Barbizon School. His professional background gave him effective skills in close observation and confident contours and compositions.

In 1875, Homer left his job as a commercial illustrator, intending to survive on his painting alone. But despite the praise critics heaped on him, he struggled financially. During the 1870s he painted in watercolor as well as oils, producing mostly rural or idyllic scenes of farm life, children playing, and courting couples. His watercolors often sold more readily than his oils. In all his works, he explored the luminous and translucent effects of light and increasingly painted outdoors, in front of his subject. For two years, he lived and painted in an English fishing village in Northumberland; he returned to the US in 1882 and settled on the Maine coast, in isolation. Moving away from the spontaneity and brightness of his earlier work, a mood of the overpowering strength of nature characterized his later work.

KEY WORKS

Artists Sketching in the White Mountains 1868, PORTLAND MUSEUM OF ART, PORTLAND, ME, US

Breezing Up (A Fair Wind) 1876, NATIONAL GALLERY OF ART, WASHINGTON, DC, US

Cloud Shadows 1890, SPENCER MUSEUM OF ART, UNIVERSITY OF KANSAS, LAWRENCE, KS, US

Cézanne

1839–1906 • IMPRESSIONISM, POSTIMPRESSIONISM

Paul Cézanne was the single most influential artist in shaping 20th-century art movements. His aim was to find an enduring pictorial form that would make sense of the world and he changed the history of art completely. Both Matisse and Picasso declared that Cézanne "is the father of us all."

Cézanne's art was misunderstood and ridiculed by the public for most of his life, but it eventually changed many of the conventional values of 19th-century painting. He was born into a wealthy family in Aix-en-Provence in the south of France—his father was a hat-maker and banker. While at school he formed a close friendship with Émile Zola (1840–1902). Like Manet and Degas, he initially began studying for a career in law, but after two years he joined Zola in Paris, intending to become an artist. Rejected from the École des Beaux-Arts, he enrolled at the Académie Suisse, where he met Pissarro and his circle. In 1863 he exhibited at the Salon des Refusés. Every year from 1864 to 1869 he submitted work to the official Paris Salon, but was constantly rejected. At that point, his work consisted of dark, thickly painted portraits, often created with slabs of paint applied with palette knives. He also painted from his imagination—inspired by Delacroix—in a fairly crude manner.

As part of the group, Cézanne exhibited twice with the Impressionists, in 1874 and in 1877. By then he was dividing his time between Provence and Paris, but during the Franco-Prussian War he moved to L'Estaque near Marseilles, where he painted landscapes. In 1872, he briefly moved to Auvers-sur-Oise, just outside Paris and went on painting expeditions with Pissarro, who lived nearby. For a long time, Cézanne described himself as Pissarro's pupil and under his influence, began to lighten his palette and use smaller brushstrokes. Nearly a decade later, he also painted in the countryside with Renoir and Monet. But whereas most of the Impressionists sought to capture the effects of light, Cézanne was always more interested in exposing the underlying structures of things. His work attracted the most scathing reviews of all the artists in the Impressionist group.

Cézanne's father had a studio built for his son at the family home in Provence, the Jas de Bouffan. There Cézanne evolved a technique of applying even strokes that followed the surfaces they depicted, using a restricted palette. In 1886 his father died, leaving him relatively wealthy, and he spent even more time in Aix, painting still lifes, portraits, and local landscapes. By that time, he was painting interlocking patches of color to represent forms. He abandoned traditional perspective and painted objects from several angles at once to try to show more of each form. He attempted to extract the essential structure of things by eliminating superfluous details. A year after his death, Cézanne's work received rave reviews from artists including Picasso, Matisse, and Braque.

KEY WORKS

The House of the Hanged Man 1873, MUSÉE D'ORSAY, PARIS, FRANCE

Hortense Fiquet in a Striped Skirt 1877–8, MUSEUM OF FINE ARTS, BOSTON, MA, US

The Bridge of Maincy near Melun c.1879, MUSÉE D'ORSAY, PARIS, FRANCE

Canyon of Bibemus 1898, BARNES FOUNDATION, LINCOLN UNIVERSITY, PHILADELPHIA, PA, US

Mont Sainte-Victoire 1900, HERMITAGE, ST. PETERSBURG, RUSSIA

Still life with Apples and Oranges

*c.*1895–1900 OIL ON CANVAS

29 X 36 IN (74 X 93 CM)

MUSÉE D'ORSAY, PARIS, FRANCE

This is one of a series of six still lifes that Cézanne painted in his Parisian studio. Although he painted still lifes throughout his career, this is more intricate than his earlier examples. Avoiding classical perspective, he placed the objects at particular angles so he could portray them from several viewpoints at once. The tablecloth links all the elements together and emphasizes the solidity of all the objects in the painting.

The Lunch: decorative panel

*c.*1873 OIL ON CANVAS

63 X 79 IN (160 X 201 CM)

Musée d'Orsay, Paris, France

Monet exhibited this in the second Impressionist exhibition of 1876. He captured a spontaneous moment when lunch has just been eaten, but has not yet been cleared away; figures can be seen in the cool shadows. In the dappled shade, his son Jean plays quietly and where the sunlight falls, color seems to sparkle.

KEY WORKS

Terrace at Saint-Adresse 1867, METROPOLITAN MUSEUM OF ART, NEW YORK, US

The Magpie *c.*1868–9, MUSÉE D'ORSAY, PARIS, FRANCE

Regatta at Argenteuil *c.*1872, MUSÉE D'ORSAY, PARIS, FRANCE

Rouen Cathedral at Twilight 1894, MUSEUM OF FINE ARTS, BOSTON, MA, US

The Water Lily Pond; Pink Harmony 1900, MUSÉE D'ORSAY, PARIS, FRANCE

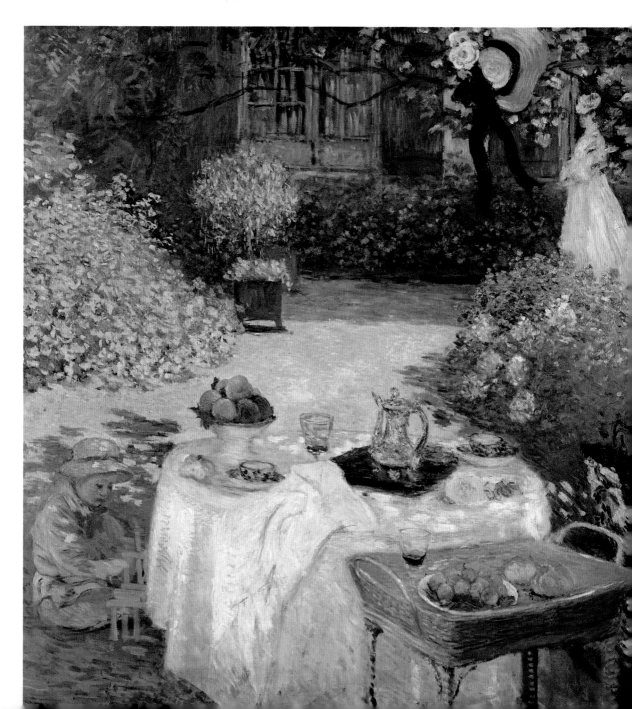

Monet

1840–1926 • IMPRESSIONISM

Recognized as the leader of Impressionism, Oscar Claude Monet was the most constant and prolific artist of the movement. In rejecting the idea of painting a given subject according to a set of rules governing technique and ideals of beauty, his innovative techniques led to a complete rethinking of the practice and purpose of art.

While still at school in Le Havre, Monet earned money selling caricatures of locals. In 1858 he met Eugène Boudin (1824–98), who encouraged him to paint in the open air. After undergoing military service in Algeria, Monet went to Paris. Rejecting conventional art training, he joined the Académie Suisse, where he met Pissarro and Cézanne. In 1862 he entered Gleyre's studio, where he met Bazille, Renoir, and Sisley and soon became one of the central figures in the circle of young, radical artists. At the 1863 Salon des Refusés, he was overwhelmed by the ideas in Manet's *Déjeuner sur l'Herbe* and after a difficult start, the two artists became close friends.

In London during the Franco-Prussian War, Monet admired the work of the English landscape painters, particularly Turner. On his return to France, he lived around Paris and painted the local environments. Several of the other avant-garde artists joined him, including Pissarro, Renoir, Manet, Sisley, and Caillebotte, and although by now the art dealer Durand-Ruel was promoting his work, he was still not receiving much positive recognition. In 1874, in an atmosphere of increasing hostility from official artistic circles, he and his friends formed their group, the Société Anonyme des artistes, peintres, sculpteurs, et graveurs, and exhibited independently for the first time. Monet's painting of Le Havre was ridiculed for its sketchy effect—the antithesis of respected academic paintings at that time. From then on, this group of artists—who all captured the fleeting effects of light—became known as Impressionists. Monet took part in five of the group's eight exhibitions, displaying paintings diffused with atmospheric light. For years, he remained poor and unappreciated. Then, in the late 1880s, he began attracting positive attention and his work grew popular. Yet even when he was well-known and wealthy, he continued to paint all day as earnestly as when he first began.

Monet's originality did not diminish. Whatever his theme, light was always his main subject and he painted with small brushstrokes and pure colors, always recording scenes with a fresh eye. In later life, he began painting several canvases of the same subject under different lighting conditions and at different times of day. In 1890, he bought a house at Giverny and built a magnificent garden with a huge lily pond. For the last 15 years of his life, he rarely left his home, painting every day and producing works of optical vibrancy that came close to abstraction. More than anyone, he kept faith with Impressionism, adhering to its ideals throughout his life.

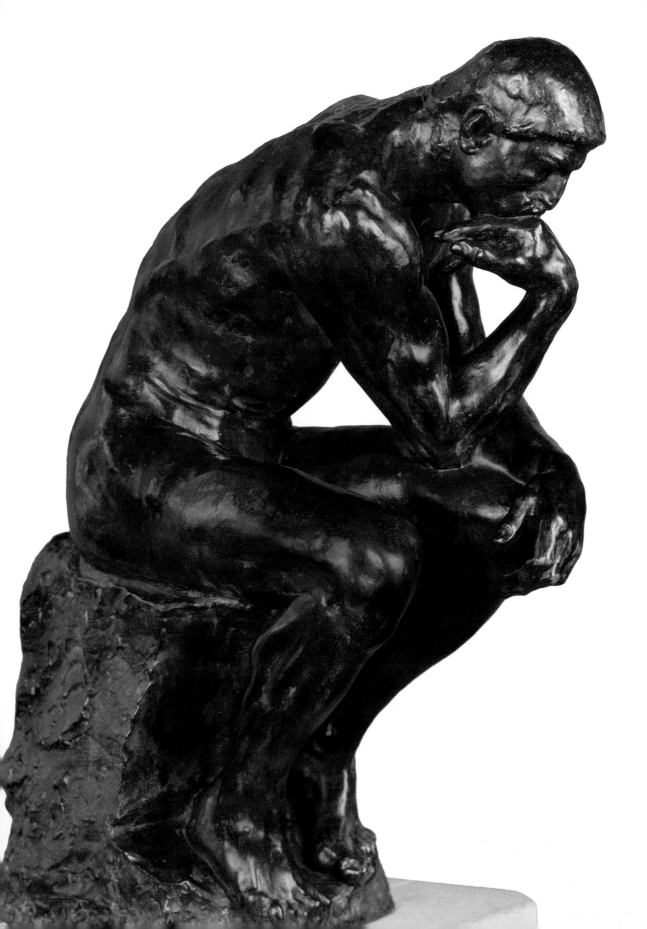

Rodin

1840-1917 • REALISM

One of the most influential artists of the late 19th and early 20th centuries was not a painter. François-Auguste-René Rodin, generally considered the originator of modern sculpture, was also an excellent draftsman and innovator. Like Manet, he did not aim to shock, but his radical art was born out of a genuine desire to create something original and honest.

By the start of the 20th century, Rodin was the most celebrated sculptor since the Neoclassical period. He was born to a working-class family in Paris and at the age of 14 he entered a school of decorative arts. His drawing teacher, Horace Lecoq de Boisbaudran (1802–97), believed that his pupils should develop their personalities so that they would emerge in their art as individuality. Rodin also studied sculpture with Jean Baptiste Carpeaux (1827–75). In 1857 he applied to the École des Beaux-Arts but was rejected on three occasions, so the following year he began working as an ornamental mason. In 1862, traumatized by the sudden death of his sister, Maria, he attempted to join a Christian order, but was dissuaded by the father superior, who recognized his talents and encouraged him to pursue a career in art.

So once again, Rodin followed his first desire and in 1864 he submitted a marble head called *The Man with the Broken Nose* to the Paris Salon. It was rejected, but when he renamed it "Portrait of a Roman," it was accepted. That year, he entered the studio of the Rococo-style sculptor, Albert-Ernest Carrier-Belleuse (1824–87), and remained there for six years. During the Franco-Prussian War he and Carrier-Belleuse went to Brussels, where they began the sculptural decoration of the Bourse (Stock Exchange). The next year they quarreled and Carrier-Belleuse returned to Paris, while Rodin completed the work with another artist. In 1875 he traveled to Italy, and was enthralled by the works of Donatello and Michelangelo.

On his return, now in his mid-30s, Rodin created *The Age of Bronze*, which was exhibited at the Salon in 1877. The realism of the figure caused a huge controversy. It was so lifelike, and different from conventional idealized works, that it was believed to have been cast from a living model: an illegal practice. Next, he was commissioned to create a monumental entrance for a planned Museum of Decorative Arts. Although he never finished the project, it provided the basis for some of his most influential and powerful work, including *The Thinker* and *The Kiss*.

Rodin's depictions of the human form—including its natural movements and individual emotions—were powerfully realistic and encapsulated all the innovations of Modernism in three dimensions. His work was always about feelings and personality and despite the controversy it often caused, he refused to change his style and his reputation grew. By 1900, he was widely considered the greatest living sculptor and a pavilion was devoted to him at that year's World Fair. As his career progressed, his work took on an abstract quality.

The Thinker

MODEL 1880, CAST 1902 BRONZE

28 x 15¾ x 23 IN (71.5 x 40 x 58 CM)

MUSÉE RODIN, PARIS, FRANCE

Depicting a man thinking, this was originally named *The Poet,* and was part of the commission by the state to create a monumental door for a decorative arts museum. Rodin based his theme on "The Gates of Hell" from *The Divine Comedy* by Dante, and this was meant to depict Dante himself, contemplating his poem.

KEY WORKS

The Man with the Broken Nose 1865, MUSÉE RODIN, PARIS, FRANCE

The Age of Bronze 1877, ALTE NATIONALGALERIE, BERLIN, GERMANY

The Burghers of Calais 1884–6, RODIN MUSEUM, PHILADELPHIA, PA, US

The Monument to Balzac 1898, MUSÉE RODIN, PARIS, FRANCE

The Kiss 1901–4, TATE MODERN, LONDON, UK

La Moulin de la Galette

1876 OIL ON CANVAS

51½ x 68¾ IN (131 x 175 CM)

MUSÉE D'ORSAY, PARIS, FRANCE

This was shown at the Impressionist exhibition of 1877. The Moulin de la Galette was a windmill converted into a popular dance hall. Renoir put up his easel in the garden and included some of his friends. His main aim was to convey the joyful atmosphere, the moving crowd, and the natural and artificial light in small, flickering brushstrokes.

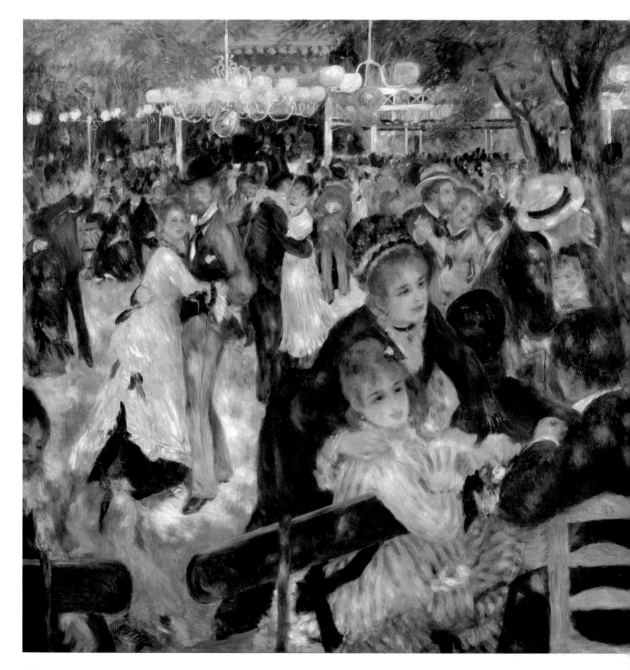

Renoir

1841–1919 • IMPRESSIONISM

Pierre-Auguste Renoir was a leading Impressionist painter who celebrated beauty and charm in a diversity of subjects, but especially feminine sensuality. Of all the Impressionists, he was the most significant figure painter and he has been described as "the final representative of a tradition which runs directly from Rubens to Watteau."

Renoir was born in Limoges but grew up in Paris in a large working-class family. From the age of 13, he was apprenticed to a porcelain painter and consequently became skilled in the use of small brushes and applications of clear, bright paint. But, determined to become an artist, with the money he had saved from painting porcelain he entered Gleyre's studio in 1862. Here he became friends with Monet, Sisley, and Bazille, and soon also with Pissarro and Cézanne.

By 1864, he began exhibiting at the Salon, but recognition did not automatically follow. In 1869 he painted by the River Seine with Monet, frequently at a place where Parisians relaxed at weekends called La Grenouillère. These paintings prefigure the Impressionist style with their rapid paint marks in pure, unblended colors. In the late 1870s he achieved success as a portraitist. He participated in four of the eight Impressionist exhibitions and became one of the most prolific of the Impressionists, completing about 6,000 paintings during his career. Renoir was particularly interested in people, painting portraits, dancers, the theater, and the company of friends, as well as flowers and landscapes. By 1881 the art dealer Durand-Ruel began buying his work regularly. That year, Renoir traveled to Algeria, because of its associations with Delacroix, to Madrid to see the work of Velázquez, and to Italy to see Titian's and Raphael's work.

Perhaps more than any of the other Impressionists, Renoir found charm in the modern sights of Paris. He painted his figures in natural positions and surroundings, focusing on the changes to colors that occur in sunlight and shade. In the 1880s he abandoned his feathery Impressionist brushstrokes for what is often called his "dry style," which is characterized by crisp brushmarks. Working carefully and meticulously, his colors became cooler and smoother. He later returned to vibrant, rich colors and free brushwork to portray nudes in dappled sunlight and he was one of the few Impressionists to use pure ivory black. By the turn of the 20th century, his right arm had become paralysed by arthritis, but by now his work was in great demand, so he strapped a brush to his wrist and carried on painting.

> **KEY WORKS**
>
> **Little Miss Romaine Lacaux** 1864, CLEVELAND MUSEUM
> OF ART, CLEVELAND, OH, US
> **Woman Reading** 1875–6, MUSÉE D'ORSAY, PARIS, FRANCE
> **Madame Charpentier with Her Children** 1878,
> METROPOLITAN MUSEUM OF ART, NEW YORK, US

Mary Cassatt

1844–1926 • IMPRESSIONISM

Painter and printmaker, the American artist Mary Stevenson Cassatt lived much of her adult life in France, exhibited with the Impressionists and became close friends with Degas. As a woman, many themes were not possible for her to depict, so she produced individual and personal images of the social and private lives of women and children.

Born in Pennsylvania in the US to wealthy parents, Mary Cassatt was one of seven children. As a child, she was taken on a four-year tour of Europe and learned German and French. In Paris for the Exposition Universelle in 1855, she became fascinated by the art of Ingres, Delacroix, Corot, and Courbet. When she was 15, she went to the Pennsylvania Academy of Fine Arts in Philadelphia, although her father was against her artistic aspirations. In 1865, she moved to Paris with her mother to continue her artistic training. Women were not yet accepted at the École des Beaux-Arts, so she studied privately with Jean-Léon Gérôme (1824–1904), a celebrated painter in the academic style. She also studied and copied in the Louvre.

As a woman, she could not socialize in cafés, so her visits to the Louvre doubled as social events where she met other artists. She also went to the painting classes of Charles Chaplin (1825–91), a fashionable Parisian artist, and two years later studied with Couture, who had taught Manet. In 1868, one of her paintings was accepted by the Paris Salon. During the Franco-Prussian War, Cassatt returned to the US, where her father still opposed her wish to become an artist. However, she was commissioned by the archbishop of Pittsburgh to paint two copies of paintings by Correggio in Italy. In Parma, she attracted a lot of positive attention and within months, she had successfully submitted a painting to the Paris Salon of 1872. Cassatt next traveled to Spain and in 1874, she moved permanently to France with her sister.

In 1877, Degas, by now her friend and mentor, invited her to participate in an Impressionist exhibition. She took part in four of the Impressionist exhibitions from 1879 to 1886. Her style gained a new spontaneity, with small, soft brushstrokes and a bright palette. She began capturing visits to the theater, mothers with children, and ladies in relaxed situations. By the 1890s, she was creating more solid forms, with simple compositions, unusual viewpoints, and blocks of pure color, inspired by an exhibition of Japanese art she had seen. After 1900, she concentrated almost exclusively on mother and child subjects, evoking sensitive and enchanting moments in time.

The Child's Bath

1893 OIL ON CANVAS

39½ X 26 IN (100.3 X 66.1 CM)

THE ART INSTITUTE OF CHICAGO, IL, US

The unusual viewpoint, cropped forms, firm outlines, and x-shaped composition was a response to the work of Edgar Degas and Japanese prints. Cassatt made the most of the restrictions she had to adhere to as a female artist—she produced many of these tender images of mothers with children without over-romanticizing the subjects, instead focusing on pattern, shape, and color.

KEY WORKS

Self-Portrait c.1878, METROPOLITAN MUSEUM OF ART, NEW YORK, US

Woman Wearing a Pearl Necklace in the Loge 1879, PHILADELPHIA MUSEUM OF ART, PHILADELPHIA, PA, US

Young Girl in a Garden c.1880–2, MUSÉE D'ORSAY, PARIS, FRANCE

The Bath c.1893, ART INSTITUTE OF CHICAGO, CHICAGO, IL, US

Maternal Kiss 1897, PHILADELPHIA MUSEUM OF ART, PHILADELPHIA, PA, US

Gauguin

1848–1903 • POSTIMPRESSIONISM, SYMBOLISM, PRIMITIVISM, SYNTHETISM, LES NABIS, CLOISONNISM

With an unsettled and stormy life as colorful as his work, Eugène Henri Paul Gauguin originated many art movements and directions of thought. His bold experiments with color initiated Synthetism, whereby his own emotions were transposed onto canvas, and his interest in Primitive art inspired Primitivism. Categorized as a Postimpressionist, he also instigated Cloisonnism and the Nabis.

Gauguin turned away from his life as a successful, wealthy stockbroker and family man to devote his life to art. He was born in Paris, but after the death of his father, he was brought up in Peru with his mother's family. Later, the family returned to France and lived in Orléans. At the age of 17, he became a sailor in the merchant navy. He left the service in 1872—the first known drawings by Gauguin date from that year—and he began working as a broker's agent in Paris. At around the same time, he started to study painting at the Académie Colarossi. Gauguin also painted in the open air and in the Louvre, and mixed with other Parisian artists.

In 1874, Gauguin met Pissarro and the other Impressionists at the first exhibition of their work. With his comfortable income from the stock exchange, Gauguin was able to collect their works. From 1876, he exhibited both at the Paris Salon and with the Impressionists. But gradually, he adopted a more simplified style featuring pure, bright colors. After the economic crash of 1883, he left his job. Two years later, he also left his Danish wife and their five children.

In 1886 and 1888, he worked in Pont-Aven in Brittany, where he and fellow artist Émile Bernard (1868–1941) worked together to develop new Cloisonnist and Synthetist techniques. Cloisonnism is where bright colors are enclosed with dark outlines, as in cloisonné enamel. Synthetism is the simplification of images using broad areas of nonnaturalistic color and symbolic subject matter.

Also in 1888, Gauguin and van Gogh spent nine weeks in Arles in the south of France, but the visit ended in a disastrous quarrel. Gauguin's restlessness then took him to Tahiti in 1891. There he began to develop his characteristic style: simplified figures, clear outlines, flattened forms, expressively bright colors, and exotic tropical settings. But, tormented by anxieties and self-doubt, he became plagued by illness, depression, and financial worries and in 1898 he attempted suicide. Although the Tahitians were already partly Westernized, Gauguin continued to produce his enigmatic depictions of native life, mainly gleaned from European textbooks. In 1901 he moved from Tahiti to the island of Dominique in the Marquesas, where his colors grew even more rich and luxuriant and his style more influenced by the art of Polynesian cultures.

Gauguin died in poverty in the Marquesas in 1903. He was barely recognized as an artist, but three years later, a huge retrospective exhibition of 227 of his paintings and engravings was held in Paris. His work and life story became greatly inspirational to younger artists and designers, and his influence continued throughout the 20th century.

KEY WORKS

Vision after the Sermon; Jacob Wrestling with the Angel 1888, NATIONAL GALLERY OF SCOTLAND, EDINBURGH, UK

Van Gogh Painting Sunflowers 1888, RIJKSMUSEUM VINCENT VAN GOGH, AMSTERDAM, THE NETHERLANDS

Parau Api (What's New?) 1892, GEMALDEGALERIE NEUE MEISTER, DRESDEN, GERMANY

Nafea Faa ipoipo? (When Will You Marry?) 1892, KUNSTMUSEUM BASEL, BASEL, SWITZERLAND

Tahitian Landscape 1893, THE MINNEAPOLIS INSTITUTE OF ARTS, MINNEAPOLIS, MN, US

Tahitian Women or On the Beach

1891 OIL ON CANVAS

27 X 36 IN (69 X 91.5 CM)

MUSÉE D'ORSAY, PARIS, FRANCE

Fascinated by the indolent charm of the women of Tahiti, Gauguin used a vibrant palette and layers of flat color to create a decorative, solid image. He advised his followers: "Don't trust the model. The simple stained glass window attracting the eye by its divisions of colors and forms is the best thing. Don't copy from nature: art is an abstraction."

van Gogh

1853–1890 • POSTIMPRESSIONISM, EXPRESSIONISM, SYMBOLISM

Probably the best-known artist in the world, Vincent Willem van Gogh only painted for ten years of his tragic life. During that time, he produced nearly 1,000 paintings and a similar number of drawings. Although he was little appreciated while he lived, his revolutionary paintings had an enormous influence on 20th-century art.

While he was alive, van Gogh only sold one painting. Now he is generally considered the greatest Dutch artist after Rembrandt, and his life and work are inextricably intertwined. The son of an evangelical pastor, born exactly one year after a stillborn brother also called Vincent, he grew up intelligent and sensitive, but lacking in self-confidence. At 16, he was apprenticed to The Hague branch of Goupil and Co, an international picture dealer, where his uncle and younger brother, Theo, also worked. From 1872 until the end of his life Vincent corresponded regularly with Theo.

In 1873 he was sent to the London branch of Goupil's, but after an unrequited love experience, depression overwhelmed him and he was dismissed from his job. He taught for a while in England and by the end of 1878, he was working as a missionary in the poor Borinage mining district of Belgium. However, his zealous intensity led to his dismissal once more. Remaining in Belgium, he attended formal art classes and with the encouragement of his cousin-in-law, artist Anton Mauve (1838–88), he began painting. In 1885 he painted his first major work, *The Potato Eaters*, a dark, thickly painted image of peasants in the Borinage. That year he went to Antwerp where he discovered Rubens and began collecting Japanese prints. In 1886 van Gogh

joined Theo, who was working at Goupil's in Paris. He studied with the painter Fernand Cormon (1845–1924), and met Pissarro, Monet, Gauguin, and other forward-looking artists. Through their example, he lightened his palette and shortened his brushstrokes. Diligent and fervent, he worked all day and discussed his ideas throughout the evenings with his new acquaintances. But he was a difficult companion and in 1888 he moved to Arles in the south of France, hoping to found an artists' colony there. His work became even brighter, as he used color and symbolism to express his feelings. He also incorporated Impressionist and Japanese Ukiyo-ē (woodblock printing) ideas.

Gauguin later joined him at Arles, but they rowed constantly. During one argument, and while experiencing an epileptic fit, van Gogh was driven to slash part of his earlobe. He committed himself to the asylum in Saint-Rémy, but he continued to experience further erratic fits of madness and lucidity. His paintings became even more striking, with rhythmic and dynamic compositions. In May 1890, he moved to Auvers-sur-Oise, where the sympathetic Dr Gachet treated him and updated Theo, who paid the bills. Despite this help, two months later van Gogh shot himself, dying in Theo's arms. He was 37.

Sunflowers

1888 OIL ON CANVAS

36¼ x 28¾ IN (92 x 73 CM)

NATIONAL GALLERY, LONDON, UK

This is one of four sunflower paintings that van Gogh created to welcome Gauguin to Arles. To him, the flowers signified happiness. He wrote to Theo: "I am working at it every morning from sunrise on, for the flowers fade so quickly." Bold outlines, impasto paint, and shades of yellow show the influences of Japanese art, Impressionism, and Rembrandt.

KEY WORKS

The Potato Eaters 1885, VINCENT VAN GOGH MUSEUM, AMSTERDAM, THE NETHERLANDS

Café Terrace at Night 1888, RIJKSMUSEUM KRÖLLER-MÜLLER, OTTERLO, THE NETHERLANDS

The Yellow Chair 1888, NATIONAL GALLERY, LONDON, UK

Self-Portrait with Bandaged Ear 1889, COURTAULD INSTITUTE GALLERIES, LONDON, UK

The Starry Night 1889, MUSEUM OF MODERN ART, NEW YORK, US

Seurat

1859–1891 • POSTIMPRESSIONISM, POINTILLISM, DIVISIONISM, NEO-IMPRESSIONISM

With his development of Neo-Impressionism, Georges-Pierre Seurat altered the direction of modern art. Taking the Impressionists' preoccupation with color and light, he created a scientifically ordered and analytical system of painting whereby dots of pure color are placed side by side, enhancing their brilliance and elaborating on the color theories of the time.

Born to a wealthy Parisian family, Seurat had a short but traditional artistic training. At 16, he attended drawing classes and in 1878 he was admitted to the École des Beaux-Arts. He studied and copied the old masters in the Louvre and was strongly influenced by Rembrandt and Goya. He also visited the 1879 Impressionist exhibition. Seeing these artists' works for the first time, he realized the possibilities of breaking away from academic tradition. While doing a year of military service, he spent his free time drawing and reading about theories of color and vision. Back in Paris, he shared a studio with two friends before moving into one of his own. He spent 1881 to 1882 producing black-and-white drawings using Conté crayon—a mixture of graphite and clay—exploring tonal contrast and soft contours.

In 1883, 20 years after Manet had shocked Paris with his *Déjeuner sur l'Herbe*, Seurat submitted his first major painting to the Paris Salon—a huge canvas called *Bathers at Asnières*. It was rejected and Seurat turned away from the official art establishment. In 1884, he helped form a group of artists called the Société des Artistes Indépendants and befriended the artist Paul Signac (1863–1935). He enthused Signac with his ideas about painting dots of pure color on canvases which would be blended by viewers' eyes and so appear brighter to them than premixed colors.

Seurat advocated juxtaposing complementary colors, such as blue and orange, as the Impressionists and other Postimpressionists had done, to make each color appear even more vibrant and luminous. Still experimenting with this technique, from 1884 to 1886 he painted his huge canvas, *Sunday Afternoon on the Island of La Grande Jatte*. He exhibited it at the final Impressionist exhibition, where a critic described his work as "Neo-Impressionist" and the technique as "Pointillism." In the four years before his sudden death aged 32, he adhered to his method, producing one large-scale painting each year. His technique was closely followed by other Neo-Impressionists and later appeared in various 20th-century art styles.

KEY WORKS

Sunday Afternoon on the island of La Grande Jatte
1884–6, ART INSTITUTE OF CHICAGO, CHICAGO, IL, US

Models 1886–8, BARNES FOUNDATION, LINCOLN
UNIVERSITY, MERION, PA, US

Invitation to the Sideshow (La Parade de Cirque) 1887–9,
METROPOLITAN MUSEUM OF ART, NEW YORK, US

Le Chahut 1889–90, RIJKSMUSEUM KRÖLLER-MÜLLER,
OTTERLO, THE NETHERLANDS

Bathers at Asnières

1884 OIL ON CANVAS

79 X 118 IN (201 X 300 CM)

NATIONAL GALLERY, LONDON, UK

A group of factory workers takes a break by the River Seine at Asnières,
an industrial suburb of Paris. This was Seurat's first large-scale
composition, before he had finalized his Pointillist technique, so it is not
completely executed in dots. However, he later reworked areas of the
painting with dots of contrasting colors to create a shimmering effect.

Toulouse-Lautrec

1864–1901 • POSTIMPRESSIONISM, ART NOUVEAU

Epitomizing the Parisian nightlife of the 19th century, Henri Marie Raymond de Toulouse-Lautrec-Monfa was a French painter, printmaker, draftsman, graphic artist, and illustrator. Known as much for his physical deformities and tragic life as he is for his exuberant, elegant, and provocative images of the period, his impact on the graphic design of the 20th century was profound.

The last in line of a family that dated back 1,000 years, Toulouse-Lautrec was born in southern France to the wealthy Comte and Comtesse de Toulouse-Lautrec. Through an inherited illness, he was weak and often sick. During adolescence he broke his legs. The bones did not heal properly and his legs stopped growing. As he matured, his body was of a normal size, but his legs were short; his head looked abnormally large, and he walked with difficulty. This embarrassed and repelled his father, and precluded Toulouse-Lautrec from living a normal upper-class life. So he spent most of his time painting and drawing and in 1882, he began studying in Paris with Léon Bonnat (1833–1922).

At the age of 19, he was given an allowance and a studio in the Montmartre area. He began painting his surroundings and the shabbily glamorous people who lived and worked there. To overcome his embarrassment about his deformities, he began drinking heavily. He became a well-known figure, sketching in nightclubs and dance halls, capturing the energy and atmosphere around him. During the day, he transferred his sketches to canvas or print, creating brightly colored works in economical, flowing lines. When the Moulin Rouge opened as a cabaret, he was commissioned to produce a series of posters.

Almost all Toulouse-Lautrec's work is of the nightclubs, cafés, and brothels of Montmartre and figures such as the cabaret singer and actress Yvette Guilbert and the dancer Louise Weber, known as La Goulue ("The Glutton"), who invented the can-can dance. With their asymmetry, simple lines, bold colors, and flat shapes, many of his compositions display a Japanese influence. He was also inspired by Gauguin's fluid contours and Degas' intimate understanding of the figure, but his own strong sense of design and honesty created a unique style, which was both empathetic and detached. Unlike most of the other Postimpressionists, his work sold during his lifetime but in the 1890s, syphilis and alcohol began to affect his health and he died aged just 36.

KEY WORKS

Red-Haired Woman (The Toilette) 1889, MUSÉE D'ORSAY, PARIS, FRANCE

Training of the New Girls by Valentin "the Boneless" (Moulin-Rouge) 1889–90, THE PHILADELPHIA MUSEUM OF ART, PHILADELPHIA, US

La Goulue Entering the Moulin Rouge 1891–2, THE MUSEUM OF MODERN ARTS, NEW YORK, US

At the Moulin Rouge 1892–3, THE ART INSTITUTE OF CHICAGO, CHICAGO, IL, US

Poster: Jane Avril at the Jardin de Paris 1893, MUSÉE TOULOUSE-LAUTREC, ALBI, FRANCE

At the Moulin Rouge: The Dance

1890 OIL ON CANVAS

45½ x 59 IN (115.6 x 149.9 CM)

PHILADELPHIA MUSEUM OF ART,

PHILADELPHIA, US

The Moulin Rouge was one of the most fashionable places in Paris. Toulouse-Lautrec painted the figures in his brutally frank, but compassionate manner, using the angled floorboards to lead viewers' eyes into the action. The male dancer is teaching a young woman the can-can. In the foreground, a woman in pink faces the dancers.

Modernism to Pop

c.1900–1970s

From the end of the 1800s to the middle of the 20th century, there was an explosion of new ideas, technologies, and discoveries. Communications, science, and medicine were all advancing rapidly, changing everyone's lives irrevocably. As a result, the challenges to accepted artistic conventions became even more inevitable, frequent, and revolutionary.

A changing world

Modernism is a term that is often broadly interpreted and even its dates are not agreed on. It comprises fine art, design, literature, music, and poetry. Rejecting the academic art of the past, Modernism welcomed everything that was fresh and avant-garde. It began predominantly in France with the Impressionists, gathered momentum by about 1890 and ended as an international phenomenon by the 1950s. The year 1900 is often cited as a watershed in the history of Western art, when the academies more or less lost their power and artists began to lead the way. Central to Modernism is the recognition and acceptance of new ideas and technologies and the changing nature of the

modern world. This sits alongside the need to move on from outdated, traditional forms of art, architecture, literature, and social thinking. Some Modernists self-consciously broke with the past, rejecting all established customs, while others simply attempted to reinterpret tradition and to give it a new, modern twist.

While scientists such as Charles Darwin (1809–82), Sigmund Freud (1856–1939), Friedrich Nietzsche (1844–1900), and Albert Einstein (1879–1955) were refuting accepted theories and principles, new inventions including cars, trains, factories, and electricity were changing the look of the world. These changes undermined certainties in the ways in which people lived, and initiated even more experimentation in art

1893
The Scream,
Munch
(1863–1944)

1906
The Pool of London
Derain
(1862–1918)

1907–08
The Kiss,
Klimt
(1862–1918)

1910
Candlestick and
Playing Cards on
a Table, *Braque*
(1882–1963)

1912
Nude Descending
a Staircase,
Duchamp
(1887–1968)

1917
Anna
Zborowska,
Modigliani
(1884–1920)

1890

1910

1892–93
Tassel House,
Horta (1861–1947)

1906
The Joy of Life,
Matisse
(1869–1954)

1907
Les Demoiselles
d'Avignon, *Picasso*
(1881–1973)

1911
Cossacks,
Kandinsky
(1866–1944)

1915
Suprematist
Composition:
Airplane Flying,
Malevich
(1878–1935)

and design. Modernist artists explored new methods, materials, and ideas, spurred on by the Impressionists, Postimpressionists, Pre-Raphaelites, and Symbolists. It was no longer enough to simply paint in one approved manner; artists had to invent new ideas, to express new thoughts and attitudes—to keep pace with the new machine age. And as the 20th century progressed, overshadowed by the two most atrocious wars the world had ever known, those expressions often became angry, confused, and violent.

New directions

While artists enjoyed having their own autonomy, their reasons for producing art, such as celebrating national pride, no longer seemed relevant. Almost all Modern artists were greeted with contempt or hostility and it began to be normal for them to shock. Sometimes this was deliberate, but often it was unintentional—the artists were simply trying to express themselves in new ways.

The rapidly changing styles and movements illustrated the doubts and uncertainties of society. Scientific examination, analysis of the subconscious, capitalism, and distaste for the establishment—these were some examples of ways that artists tried to make sense of the world around them. Artists often gathered in groups to discuss ideas and work together. Some

consciously planned, discussed, and wrote their own manifestos. Others developed and built on previous ideas and some simply came up with similar ideas at the same time. And so art movements tumbled along in quick succession. Some occurred simultaneously, others successively; some comprised many artists, others were made up of only one or two individuals. Movements were named derogatively by critics, by the artists themselves. or labeled long after the movement was over.

After World War II, Modernism began to pale as an idea. With the disillusionment and upheaval, Modernist attitudes seemed naively hopeful and utopian. The ensuing styles—particularly in design—became called Postmodernism, which meant beyond Modernism. This was a more philosophical, eclectic approach enabling designers and artists to draw ideas, imagery, or styles from any culture of any period and represent them as individually as they liked. Pop art, which emerged in the 1950s and peaked by the late 1970s, took much of its imagery from advertising. In fine art, the term Modern art became applied more than either Modernism or Postmodernism, describing all art produced after Realism up to the end of the 20th century. Contemporary art usually describes work that has been produced since the new millennium. The ambiguity of labels and dates illustrates the increasingly uncertain function of art today.

1920
Temple Gardens, *Klee* (1879–1940)

1923
Calla Lily Turned Away, *O'Keeffe* (1887–1986)

1928
Potato, *Miró* (1893–1983)

1931
The Persistence of Memory, *Dalí* (1904–89)

1937
Composition with Yellow, Blue, and Red *Mondrian* (1872–1944)

1949
Three Men Walking II, *Giacometti* (1901–66)

1953
Study after Velázquez's Portrait of Pope Innocent X, *Bacon* (1909–92)

1967
Marilyn, *Warhol* (1928–87)

1930

1970

1920
Family Picture, *Beckmann* (1884–1930)

1923
Bird in Space, *Brancusi* (1876–1957)

1929
The Bus, *Kahlo* (1907–54)

1933
The Human Condition, *Magritte* (1898–1967)

1945
There were Seven in Eight, *Pollock*, (1912–52)

1950
No. 10, *Rothko* (1903–70)

1952–53
Woman V, *de Kooning* (1904–97)

1963
Thinking of Him, *Lichtenstein*, (1923–97)

Klimt

1862–1918 • VIENNA SECESSION, ART NOUVEAU

Criticized for being too sensual and erotic in his time, Gustav Klimt produced highly ornamental paintings featuring Symbolist elements. Focusing mainly on the female body, he was extremely important in the development of Art Nouveau and one of the founders and leaders of the Vienna Secession—a group of forward-looking artists and designers.

The second of seven children, Klimt was born in a suburb of Vienna into a working-class family. His father was an engraver and, with a view to following in that career, Gustav was awarded a scholarship to study at the School of Applied Art at the age of 14. He remained at the school for seven years, along with his brother Ernst and their friend Franz Matsch (1861–1942). They studied a range of techniques, from mosaic to architectural painting and fresco techniques. As the three worked so well together, a teacher helped them to receive and accept commissions.

Klimt revered the work of the Austrian artist Hans Makart (1840–84). Makart had started work on a commission in the Kunsthistorisches Museum, but after his untimely death, Klimt completed the work. In honor of the 25th wedding anniversary of Emperor Franz Josef and the Empress Elizabeth, Klimt and his partners produced several woodcuts based on the work of Dürer. From 1886 to 1888 they worked on the interior of the Burgtheater, but by then Klimt's work had surpassed that of his partners. He became sought-after for his exceptionally realistic portraits. In 1888, he received the Golden Cross of Merit from the emperor and was made an honorary member of the Universities of Munich and Vienna. Yet despite his public successes,

he was more interested in creating a fresh style of art. Influenced by Impressionism, Symbolism, Dürer, Art Nouveau and Japanese, classical Greek, Byzantine, and ancient Egyptian art, he began developing a unique and original approach. Art Nouveau was an international style that developed in the 1890s and was expressed in various media, including sculpture, jewelry, ceramics, and print. Inspired by organic, natural forms it featured asymmetrical compositions and elongated contours.

In 1892, both his brother Ernst and his father died. The tragedies affected Klimt's outlook. By 1897, he and other like-minded artists formed a group called the Secession, aiming to counter traditionalist attitudes toward art and promote their own work. Klimt was the group's president. His art developed as a mixture of decorative and realistic styles, mostly featuring sensual women. His colorful, stylized works were interlaced with symbols along with two-dimensional, mosaic-like embellishments and lifelike features. When his unique work was first seen—in some allegorical murals for Vienna University—it was denounced as pornographic. From then on, official commissions dwindled, but Klimt remained popular with private patrons and his influence began to reverberate around Europe.

KEY WORKS

Idylle (Idylls) 1884, HISTORICAL MUSEUM OF THE CITY OF VIENNA, AUSTRIA

Judith and Holophernes 1901, THE ÖSTERREICHISCHE GALERIE BELVEDERE, VIENNA, AUSTRIA

The Beethoven Frieze 1902, THE ÖSTERREICHISCHE GALERIE BELVEDERE, VIENNA, AUSTRIA

The Three Ages of Woman 1905, GALLERIA NAZIONALE D'ARTE MODERNA, ROME, ITALY

The Virgin 1913, NARODNI GALLERY, PRAGUE, CZECH REPUBLIC

The Kiss

1907–8 OIL ON CANVAS

70 X 70 IN (180 X 180 CM)

ÖSTERREICHISCHE GALERIE, VIENNA, AUSTRIA

A man and woman embrace, dressed in adorned clothes—the woman's robe is floral and the man's geometric, while a golden veil unites them. Tenderly kissing the woman's cheek, the man bends toward her, touching her face with particularly expressive hands. The predominance of gold paint reflects Klimt's interest in many other art forms and styles.

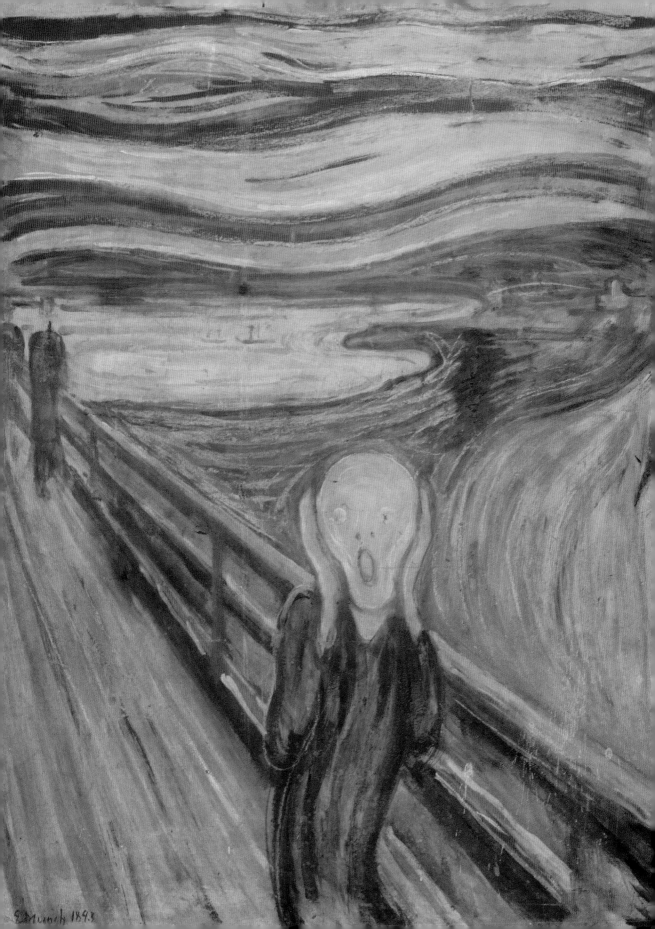

E Munch 1893

Munch

1863–1944 • EXPRESSIONISM, SYMBOLISM

Considered the greatest Norwegian artist, Edvard Munch was a painter and printmaker whose intense portrayals of psychological and emotional themes—including misery, fear, sickness, anguish, and death—made him an important forerunner of German Expressionism. Influenced by Impressionism and Symbolism, Munch created his own personal art style, involving swirling lines, discordant colors, and unsettling images.

The second son of five children, Munch was born in the small town of Loten, but grew up in Kristiania, the capital of Norway (now Oslo). When he was five, his mother died of tuberculosis and nine years later, his sister Sophie died of the same disease. The pain and despair Munch experienced over their deaths and his anxiety about his father's subsequent grief-stricken, pious austerity affected his health and later emerged in his work. As he grew up he was frequently ill and experienced morbid visions and nightmares. As an adult, he suffered bouts of depression and mental illness.

By the age of 16, Munch was at Oslo Technical College, planning to become an engineer, but within 18 months he had left and enrolled at the Royal Drawing School instead. In addition, he also began taking private lessons with the Realist painter Christian Krohg (1852–1925). In 1885 he made the first of a number of visits to Paris, where he saw the work of the Impressionists, Postimpressionists, Symbolists, and emerging Art Nouveau designs. On his return to Norway, he painted the haunting *The Sick Child* (1885–6), based on his sister's death. The painting attracted unfavorable criticism; it was considered too somber and depressing—the handling of the subject insensitive and distasteful.

Throughout the 1880s and early 1890s, Munch tried a variety of brushstroke techniques and colors as he struggled to define his style. Most of his works appeared Impressionistic, but others caused further controversy at the rawness of emotion exposed through the use of dark colors and anguished lines. Yet in 1889, he held his first one-man show and from it he received a two-year state scholarship to study in Paris under French painter Léon Bonnat (1833–1922), who had taught Toulouse-Lautrec. Munch arrived in Paris during the Exposition Universelle and discovered the work of Gauguin, van Gogh, and Toulouse-Lautrec. From then on, he changed his palette to attempt their methods of using color to convey emotion. That year, his father died and from then on, he assumed financial responsibility for his destitute family.

For the next 16 years, Munch spent a great deal of time in Paris and Berlin, mixing with an international circle of writers, artists, and critics. His output was prodigious and he became known for his prints, etchings, lithographs, and woodcuts, along with paintings that were heavily imbued with Symbolism. He achieved success during his lifetime, exhibiting internationally and winning awards. His greatest legacy was in exposing his innermost fears and phobias to the wider world.

The Scream

1893 OIL, TEMPERA AND PASTEL ON CARDBOARD

36 X 29 IN (91 X 73.5 CM)

NASJONALGALLERIET, OSLO, NORWAY

Munch described his inspiration for this eerie painting: "I was walking down the road ... suddenly, the sky turned as red as blood ... Tongues of fire and blood stretched over the bluish-black fjord. My friends went on walking, while I lagged behind, shivering with fear. Then I heard the enormous, infinite scream of nature."

KEY WORKS

The Sick Child 1885/86, NASJONALGALLERIET, OSLO, NORWAY

Evening on Karl Johan Street 1892, RASMUS MEYER COLLECTION, BERGEN, NORWAY

Puberty 1894, NASJONALGALLERIET, OSLO, NORWAY

Ashes 1894, NASJONALGALLERIET, OSLO, NORWAY

The Dance of Life 1899–1900, NASJONALGALLERIET, OSLO, NORWAY

Kandinsky

1866–1944 • EXPRESSIONISM, ABSTRACTION, THE BLUE RIDER,
THE BLUE FOUR, BAUHAUS

Credited with producing the first abstract art, Wassily Wassilyevich Kandinsky was a Russian painter and art theorist. His pioneering achievements derived from his intelligence and sensitive nature—his explorations of color and shape evolved from his synesthesia (the capacity to see sound and hear color) and his study of Theosophy. He wrote, taught, and started an art movement, ensuring that his influence spread far and wide.

Growing up to become one of the most important figures in the development of abstract art, Kandinsky was born in Moscow but spent his childhood in Odessa. In 1886 he began studying law and economics at the University of Moscow. While still a student, he was commissioned to join a group on a research expedition to Vologda in northern Russia. His later idea of working bright colors on dark backgrounds was inspired by the peasants' painted houses he saw there. After graduating in 1892, he lectured in law and economics at the university. Three years later, after seeing a French Impressionist exhibition in Moscow, he gave up teaching and went to Munich. There he studied with Anton Azbè (1862–1905) and befriended two other Russian students, Alexei von Jawlensky (1864–1941) and Marianne von Werefkin (1860–1938).

By 1900, Kandinsky was studying at the Munich Academy of Fine Arts under Franz von Stuck (1863–1928) and from 1906 to 1908 he traveled around Europe. His fascination with color symbolism and psychology had been developing since his youth and his paintings of that time featured expressive colors, showing the influence of Monet, Signac, Art Nouveau, and the peasant houses he had admired in Vologda. At this point, he became fascinated with Theosophy, a philosophy based on spirituality. Drawing on this, and other interests, including ethnology, the natural sciences, and music—and also using his synesthesia—Kandinsky began to base his work on connections between vision and sound. He started naming paintings in musical terms, such as "improvisations" or "compositions."

He helped to found the Neue Künstlervereinigung München (New Artists' Association), becoming its president in 1909, but it disbanded in 1911. In 1910, he wrote his theoretical treatise, *Concerning the Spiritual in Art,* and in 1911, he formed a new group, Der Blaue Reiter (The Blue Rider), with other artists including Jawlensky, von Werefkin, August Macke (1887–1914), and Franz Marc (1880–1916). The name came from one of his paintings of 1903 and because he believed blue was the color of spirituality. The artists' individual approaches varied but they all aimed to express spiritual truths through their work. Kandinsky's reputation grew and his work became even more rhythmic and abstract. By the start of World War I, Kandinsky had brought the group to an end and returned to Moscow. He went back to Germany seven years later, where he taught at the Bauhaus School until 1933. After that, he moved to France where he remained for the rest of his life.

KEY WORKS

Houses in Murnau on Obermarkt 1908, COLLECTION THYSSEN-BORNEMISZA, MADRID, SPAIN
Munich-Schwabing with the Church of St. Ursula 1908, STÄDTISCHE GALERIE IM LENBACHHAUS, MUNICH, GERMANY
Cossacks 1910–11, TATE BRITAIN, LONDON, UK
Moscow I 1916, THE TRETYAKOV GALLERY, MOSCOW, RUSSIA
Composition VIII 1923, THE SOLOMON R. GUGGENHEIM MUSEUM, NEW YORK, US

Improvisation 11

1910 OIL ON CANVAS

38 X 42 IN (97.5 X 106.5 CM)

THE RUSSIAN MUSEUM, ST. PETERSBURG, RUSSIA

When Kandinsky heard a lively note, he saw yellow in his mind's eye.
Soft sounds evoked greens or blues. Similarly, shapes corresponded to
sounds. For instance, circles were tranquil while zigzags were harsh.
He thought that painting should be like music and not have to try to
represent the real world. His ideas changed the history of art.

Matisse

1869–1954 • FAUVISM, EXPRESSIONISM

One of the most innovative and influential artists of the 20th century, Henri Matisse is often referred to as the "master of color." In 1905, he became the leader of a group of artists known as Les Fauves (the Wild Beasts), because of their use of explosive colors, rough textures, and unrestrained flat patterns.

With his orderly and academic mind, Matisse would probably have made a great lawyer. Instead he became one of the most important French artists of the 20th century. Born in northern France, the son of a grain merchant, he studied for a career in law. At 21, while recovering from appendicitis, his mother bought him a box of paints and he discovered the exhilaration of painting. He left law studies, moved to Paris, and began studying art under Moreau and then Odilon Redon (1840–1916). His early work consisted mainly of fairly traditional landscapes and still lifes, but after visiting the painter John Peter Russell (1858–1930) in Brittany, he discovered Impressionism and the work of van Gogh and began experimenting with brighter colors and freer styles.

Matisse was influenced by many diverse sources, including Poussin, Manet, Cézanne, Gauguin, van Gogh, Seurat, and Signac. In 1898, after his honeymoon to Corsica, his interest in light and color intensified. In 1904 he spent the summer with Signac in St. Tropez in the south of France, and in 1905 he went south again with André Derain (1880–1954). Later that year, he exhibited at the Salon d'Automne with Derain, Albert Marquet (1875–1947), Maurice de Vlaminck (1876–1958), Georges Rouault (1871–1958), and others—an exhibition set up to challenge the conventional Paris Salon. The work they exhibited broke with the tradition of trying to represent the natural world, instead using distorted colors and shapes to depict emotion. Visitors were shocked and the art critic Louis Vauxcelles scornfully commented that the artists painted like wild beasts, unintentionally giving the new style its name: Fauvism. Matisse became the recognized leader of the group.

Within a few years the Fauve Movement ended, but Matisse continued developing new ideas. In 1906 he visited Algeria and Morocco, where the radiant light, exotic surroundings and Moorish architecture inspired him. In 1910 he went to an exhibition of Islamic art in Munich and in 1911, he visited Seville. From 1914 to 1918 he divided his time between Collioure (a small fishing village in the south of France), Paris, and Nice. He posed his models amid brightly colored textiles and ceramics, using color and pattern to evoke the brightness and intense heat of Africa and the Mediterranean. In his paintings, every element has a function, but the most important was always color. Never trying to imitate nature, his work portrayed happiness or calmness. He designed stage sets, ballet costumes, and stained glass and also illustrated books. Although quite disabled after 1941, he continued to work into his old age, experimenting with innovative printing and paper cutout effects.

Yellow Odalisque

1937 OIL ON CANVAS

21¾ X 18 IN (55.2 X 46 CM)

PHILADELPHIA MUSEUM OF ART, PENNSYLVANIA, US

Enchanted by Islamic patterns and the brilliant light, rich colors and Moorish architecture of the Mediterranean and North Africa, in the 1920s and 1930s Matisse painted several interior views of women in harems. He juxtaposed contrasting patterned surfaces, vibrant colors, and assorted textures, displaying his passion for color, pattern, and diverse exotic and cultural influences.

KEY WORKS

Green Stripe (Madame Matisse) 1905, STATENS MUSEUM FOR KUNST, COPENHAGEN, DENMARK

The Dance 1909–10, STATE HERMITAGE, ST. PETERSBURG, RUSSIA

Interior in Eggplants 1911–12, MUSÉE DE PEINTURE ET DE SCULPTURE, GRENOBLE, FRANCE

Bathers by a River 1916–17, ART INSTITUTE, CHICAGO, IL, US

The Snail 1952, TATE MODERN, LONDON, UK

Mondrian

1872–1944 • DE STIJL, NEOPLASTICISM

A pioneer of purely abstract art, Piet Mondriaan developed completely nonrepresentational art through the mystical principles of Theosophy and was an important contributor to the De Stijl Movement and group. His overwhelming influence on the art and design of the 20th century came as much from his theoretical writing as from his painting.

Mondrian (who dropped the extra letter "a" in his surname in about 1906) was born in Amersfoort in the Netherlands. His father was a headmaster and drawing teacher and to please him, Mondrian first studied to be a teacher. After graduating in 1892, though, he joined Amsterdam's Academy of Fine Arts, where he studied painting with the artist August Allebé (1838–1927). He began teaching in a primary school while also painting portraits and making copies of the old masters in local museums. He also began painting outdoors in the traditional Dutch landscape style and then in the style of the Impressionists.

In 1903, he traveled to Spain and then to Brabant in Belgium, and from then on his paintings became brighter, often made up of dots, like Pointillism, and vivid colors, like Fauvism; they also frequently contained Symbolist elements. In 1908, Mondrian visited the Dutch Art Nouveau artist Jan Toorop (1858–1928), and the following year he joined the Theosophic Organization, where the theories of Theosophy (the study of religious philosophy) were discussed in-depth. Between 1912 and 1914, he divided his time between Paris and the Netherlands, becoming strongly inspired by Cubism and producing a series of paintings of a tree, progressively

simplifying it, reducing it from a complex, naturalistic image to an uncomplicated, almost abstract design of straight lines and flat colors. By 1914, he had begun to paint broad planes of color, predominantly featuring patterns of horizontal and vertical lines. He was starting to become convinced that to imitate the real, three-dimensional world on a flat surface was superficial. He believed that artists should seek inner truths, rather than simply copying the objects around them. In his search for expression through pure form and color, he limited his palette to the three primary colors, plus black, white, and gray, with only horizontal and vertical lines.

In 1915, Mondrian met Theo van Doesburg (1883–1931), and within two years they were collaborating on a journal which they called *De Stijl* (The Style). They formed a group with several other artists and designers, also called De Stijl. Through the group, Mondrian explored his theories on art, which were based on his philosophical beliefs about the spiritual order underlying the world. He called it Neoplasticism. In 1919 he moved to Paris; in 1938 he lived in London for two years; and in 1940 he settled in New York where he influenced the Abstract Expressionists, who also believed in an underlying spiritual order underpinning human existence.

KEY WORKS

Woods near Oele 1908, GEMEENTEMUSEUM, THE HAGUE, NETHERLANDS

Apple Tree in Flower 1912, GEMEENTEMUSEUM, THE HAGUE, NETHERLANDS

Composition with Red, Yellow, and Blue 1928, WILHELM-HACK-MUSEUM, LUDWIGSHAFEN AM RHEIN, GERMANY

Broadway Boogie-Woogie 1942–3, MUSEUM OF MODERN ART, NEW YORK, US

Composition with Yellow, Blue, and Red

1937–42 OIL ON CANVAS

28½ x 27 IN (72.7 x 69.2 CM)

TATE MODERN, LONDON, UK

Mondrian wanted his work to be a part of its surroundings, not cut off by a frame. This painting conveys peace, energy, and rhythm in an asymmetrical, yet balanced composition. The edges are as important as the center of the canvas. Like music, it was intended to be pleasurable within the often aggressively paced modern world.

Brancusi

1876–1957 • MODERNISM, ABSTRACTION

One of the most revered and influential modern sculptors, Romanian Constantin Brancusi's cutting-edge, sleek, and simplified works introduced abstraction and primitivism into three-dimensional art. His originality made him internationally renowned as one of the leading avant-garde artists of the 20th century and many of his works are acknowledged as icons of modern art.

As a child in the village of Hobitza, near Romania's Carpathian Mountains, Brancusi helped his peasant parents and siblings tend the land and also learned the traditional folk crafts of wood- and stone-carving. He gained a reputation for his woodworking skills and was given a place at the School of Arts and Crafts in Craiova, later progressing to study sculpture at the National School of Fine Art in Bucharest at the age of 22. Five years later, he traveled to Munich and then to Paris.

In Paris, Brancusi worked for two years with the sculptor and painter Antonin Mercié (1845–1916) at the École des Beaux-Arts. After seeing the work of Matisse and others at the Salon d'Automne, with their shockingly bright colors, he realized that the artist's role was no longer to imitate the appearance of nature. In 1906, he admired the paintings and primitive-looking wood sculptures at a retrospective of Gauguin's work. Later that year, he was invited to enter Rodin's workshop. Brancusi greatly admired Rodin and intended to learn much from him, but he left his studio after just two months, claiming, "Nothing can grow under the shadow of a great tree." During that brief period, he carved some of Rodin's marble sculptures. The skills of this process, known as "direct carving" had all but died out, but Brancusi, using his physical strength and technical skill combined with intellectual discipline, worked as Medieval craftsmen had done. Since the Gauguin exhibition, several artists in Paris, including Matisse and Picasso, had become particularly interested in the simplified styles of primitive cultures. In 1909, Brancusi met Amedeo Modigliani (1884–1920), and together they visited several ethnographic museums, fascinated by tribal masks and their symbolic representations of the face.

From 1907, Brancusi blended the realism he had learned from Rodin and others with the skilled crafts he had learned in Romania and the abbreviated styles of primitive cultures, developing an original and highly influential style. Like other artists at the time, he believed that artists' depictions of the things around them are only a reflection of their copying skills. For art to be uplifting, it should attempt to portray a spiritual truth, which is only possible through abstract or abstracted art. He focused on a few themes, such as heads, birds, and an embracing couple, and was particularly fond of ovoid forms and curved smooth lines. He reduced elements down to a minimum, condensing natural forms into almost abstract simplicity, and his serene sculptures are widely acknowledged as icons of Modernism.

Bird in Space

1941 BRONZE AND MARBLE

76 x 5¼ x 6⅓ IN (193.4 x 13.3 x 16 CM)

CENTRE POMPIDOU, PARIS, FRANCE

For about 20 years from the 1920s, Brancusi was absorbed by the theme of a bird in flight. He wanted to depict the spirit of a bird as it moves its limbs in graceful harmony. Ignoring wings and feathers, he elongated the body and simplified and slanted the head and beak.

KEY WORKS

Sleeping Muse 1910, METROPOLITAN MUSEUM OF ART, NEW YORK, US

Maiastra 1911, TATE MODERN, LONDON, UK

The Muse 1912, SOLOMON R. GUGGENHEIM MUSEUM, NEW YORK, US

Torso 1917, CLEVELAND MUSEUM OF ART, CLEVELAND, OH, US

Danaïde 1918, TATE MODERN, LONDON, UK

Malevich

1878–1935 • CUBISM, ABSTRACTION, SUPREMATISM

Before the 1917 Revolution, wealthy Russians looked to France for their culture. Modern art was bought from France by a few collectors, but there was no tradition of homegrown contemporary artists. Gradually, some Russian artists began producing their own Modernist styles and Malevich became one of the most important pioneers of geometric abstract art.

Kazimir Malevich was born near Kiev, to Polish Roman Catholic parents. His father was the manager of a sugar factory and Malevich and his siblings spent their formative years living in various Ukrainian villages. He became proficient in the arts and crafts of the peasants, including embroidery and colorful peasant-style painting. When he was 17, he studied drawing at Kiev School of Art and in 1904, after the death of his father, he moved to Moscow and studied at the Moscow School of Painting, Sculpture, and Architecture until 1910. He began working in a Postimpressionist style, with flat colors and bold shapes. He participated in exhibitions that were organized by avant-garde artists and in 1912 and 1913, he helped to organize two shows with the artists Natalia Goncharova (1881–1962) and Mikhail Larionov (1881–1964).

Malevich's developing style demonstrated his appreciation for Russian folk art and the Russian Cubist painter Aristarkh Lentulov (1882–1943). He described his work—peasant subjects in clear colors and cylindrical shapes, reminiscent of Fernand Léger (1881–1955)— as Cubo-Futurist. As a devout Christian, Malevich thought along mystical lines and felt very dissatisfied with representational painting. In 1913, he produced an abstract backdrop for the Futurist opera, *Victory over the Sun*, which consisted of a rectangle divided into a black upper segment and a lower white one. From then on, he produced some of the most radical paintings of the 20th century. Unlike Kandinsky, he did not align his painting with music, but completely separated it from any recognizable subject. He said that he wanted to "free art from the burden of object."

In 1914, Malevich exhibited at the Salon des Indépendants in Paris with other Russian artists, including Alexander Archipenko (1887–1964) and Sonia Delaunay (1885–1979). In 1915, at the "0.10" show in Petrograd (now St. Petersburg), he named his abstract, geometric painting style Suprematism. While Suprematism began before the Russian Revolution, the influence of Malevich's radical approach to art was pervasive in the early Soviet period. After the Revolution, he and other activist artists were supported by the Soviet government and given prominent administrative and teaching positions. As a result, Suprematism became the popular and fashionable style of postrevolutionary Russia. From 1919, Malevich held various teaching posts, exhibited frequently and was made a curator at the Kremlin. Then, in 1932, Stalin suppressed independent abstract artists and it was only during the 1950s that his work became influential to young artists once more.

KEY WORKS

Woodcutter 1912–13, STEDELIJK MUSEUM, AMSTERDAM, NETHERLANDS
Englishman in Moscow 1914, STEDELIJK MUSEUM, AMSTERDAM, NETHERLANDS
Black Suprematist Square 1914–15, THE TRETYAKOV GALLERY, MOSCOW, RUSSIA
Suprematism. (Supremus #56) 1915, THE RUSSIAN MUSEUM, ST. PETERSBURG, RUSSIA

Suprematist Composition: Airplane Flying

1915 OIL ON CANVAS

22 X 19 IN (58.1 X 48.3 CM)

MUSEUM OF MODERN ART, NEW YORK, US

Following the outbreak of World War I in Europe, coupled with unrest in Russia prior to the Revolution, Malevich painted this work, unusually referring to an actual object. Fascinated by the notion of a fourth dimension and still interested in Futurism, the ambiguous image heralds the machine age with brightly colored shapes floating against a white space.

183

Klee

1879–1940 • EXPRESSIONISM, ABSTRACTION, THE BLUE RIDER, THE BLUE FOUR

Paul Klee was one of the quirkiest—and most subtly mocking—artists of the 20th century. A Swiss painter of German nationality, he developed a highly individual style influenced by Expressionism, Cubism, and Surrealism. He painted and wrote extensively about color theory, and also infused his individual and colorful paintings with Orientalism, humor, personal philosophies, and rhythm.

Born near Bern in Switzerland, from a young age Klee demonstrated equal talents in music and art. His father was a music teacher and his mother had trained as a singer, but from the age of 19 he began studying art at the Munich Academy of Fine Arts. There, he excelled at drawing and also developed a love of literature. After graduating, he spent six months in Italy, studying the old masters. From 1902, he returned to live with his parents, taking occasional art classes and experimenting with techniques and materials. He also played in an orchestra and wrote concert and theater reviews to earn money.

In 1906, Klee moved to Munich and in 1912, exhibited with Kandinsky's Der Blaue Reiter group. That year he traveled to Paris, where he saw Cubist works and met Robert Delaunay (1885–1941). In 1914, he visited Tunisia. Until then, he had mainly produced satirical etchings, but the colors of Delaunay's work and the intense light in Tunisia had a life-changing effect. He wrote: "Color has taken possession of me; no longer do I have to chase after it, I know that it has hold of me forever. That is the significance of this blessed moment. Color and I are one. I am a painter." He began producing vivid compositions of colored shapes, reminiscent of the mosaics he had seen in both Italy and Tunisia. He also began incorporating letters and numerals into some works as part of his thoughts about the unconscious mind and the power of symbols.

After World War I, Klee returned to Munich, where a large exhibition of his work secured his reputation. He was invited to teach at the Bauhaus, a newly formed school of art and crafts where avant-garde ideas were welcomed. He taught bookbinding, stained glass, and mural painting. In 1923, along with Kandinsky, Jawlensky, and Lyonel Feininger (1871–1956) he began Die Blaue Vier (The Blue Four). Two years later, his work was exhibited in Paris, where it inspired the French Surrealists. When the Nazis closed the Bauhaus in 1933, they labeled Klee "degenerate" and seized 102 of his works. Dismissed from his job, he fled to Switzerland and spent the rest of his life there.

KEY WORKS

On a Motif from Hamamet 1914, KUNSTMUSEUM BASEL, BASEL, SWITZERLAND

Fish Magic 1925, THE PHILADELPHIA MUSEUM OF ART, PHILADELPHIA, PENNSYLVANIA, US

Polyphony 1932, KUNSTMUSEUM, BASEL, SWITZERLAND

Ad Parnassum 1932, KUNSTMUSEUM, BERNE, SWITZERLAND

Red Waistcoat 1938, KUNSTZAMMLUNG NORDRHEIN-WESTFALEN, DUSSELDORF, GERMANY

Templegärten, 1920, 186 (Temple gardens)

1920 WATERCOLOR AND PEN ON PAPER ON CARDBOARD

7¼ X 10¼ IN (18.4 X 26.7 CM)

METROPOLITAN MUSEUM OF ART,

THE BERGGRUEN KLEE COLLECTION, NEW YORK, US

This was inspired by Klee's visit to Tunisia in 1914 and is reminiscent of stained glass, or a child's collage. He moved sections of of the composition about until they reached his desired balance and harmony. Stairways lead to the doors of various garden pavilions, while domed towers, minarets, and palm tree fronds can be seen over sections of high walls.

Picasso

1881–1973 • CUBISM, PRIMITIVISM, ABSTRACTION, EXPRESSIONISM, SURREALISM

Probably the most famous artist of the 20th century, Pablo Ruiz y Picasso was a painter, draftsman, sculptor, and ceramicist. During a career lasting more than 75 years, he produced over 20,000 works and changed the course of painting. A child prodigy, he cofounded Cubism, and became one of the most influential artists of his time.

The son of a painter, curator, and art teacher, Picasso demonstrated exceptional artistic skill as a child. He grew up painting in a highly realistic manner, and at 14 he was accepted at La Llotja Academy, where he completed art exercises in a day that took older students more than a month. In 1900, he moved to Paris with a friend, Carlos Casagemas. When Casagemas committed suicide, Picasso began painting mournful, elongated subjects inspired by El Greco and in a predominantly blue palette—his Blue Period. Three years later, while still in Paris, he became part of a circle of writers, actors, musicians, and artists and his palette took on pinker tones—his Rose Period.

Seeing the work of the Fauves at the Salon d'Automne in 1905, and meeting Matisse the following year, stimulated his use of different techniques and materials. In 1906 the art dealer Ambroise Vollard (1866–1939), who helped to promote several artists before they became appreciated (including Cézanne, Renoir, Gauguin, and van Gogh), bought many of Picasso's pictures. From then on, Picasso never struggled financially again. Impressed by Iberian sculptures at the Louvre and by Cézanne's ideas, he began to analyse structure and simplify his figures and faces. His explorations culminated in *Les Demoiselles d'Avignon*,

a painting that distorted everything that had previously been valued in painting. It was soon seen as the seminal painting of the 20th century, prefiguring Cubism, which he developed with Braque. In Cubism, Picasso and Braque challenged the principles of perspective that had been practiced since the Renaissance, by painting from several angles at once. Because objects shown at different angles take on geometric shapes, a critic called them "little cubes." The name Cubism stuck.

After World War I, Picasso designed costumes and scenery for *Parade*, a ballet composed for Sergei Diaghilev's Ballets Russes. The developments of Cubism gave way to a more classically inspired style, and then Surrealism. By this time, Picasso had produced collages, etchings, and sculpture, as well as paintings. In 1937, while in the midst of Spanish Civil War, the Spanish Republican government asked Picasso to create a mural glorifying Spain for the Universelle Exposition. Instead, he produced a monumental work showing the effects of the appalling bombing of a defenseless Spanish town, Guernica. The painting is a violent but controlled expression of horror. After World War II, he moved to the south of France and began to produce ceramics. He continued experimenting for the rest of his life, his ideas as diverse and original as his technical skills were masterful.

KEY WORKS

The Tragedy 1903, THE NATIONAL GALLERY OF ART, WASHINGTON, DC, US

Tumblers (Mother and Son) 1905, STAATSGALERIE, STUTTGART, GERMANY

Self-Portrait 1907, NARODNI GALLERY, PRAGUE, CZECH REPUBLIC

Women Running on the Beach 1922, MUSÉE PICASSO, PARIS, FRANCE

Guernica 1937, MUSEO REINA SOFIA, MADRID, SPAIN

Weeping Woman 1973, TATE GALLERY, LONDON, UK

Les Demoiselles d'Avignon

1907 OIL ON CANVAS

96 X 92 IN (243.9 X 233.7 CM)

MUSEUM OF MODERN ART, NEW YORK, US

Often called the most important painting of the 20th century, this portrays five prostitutes. Picasso revolutionized the art world when the work was first seen. With unpainted patches, flat, angular, distorted figures and faces that are a mixture of African and Iberian mask styles, the painting is often seen as the starting-point for Cubism.

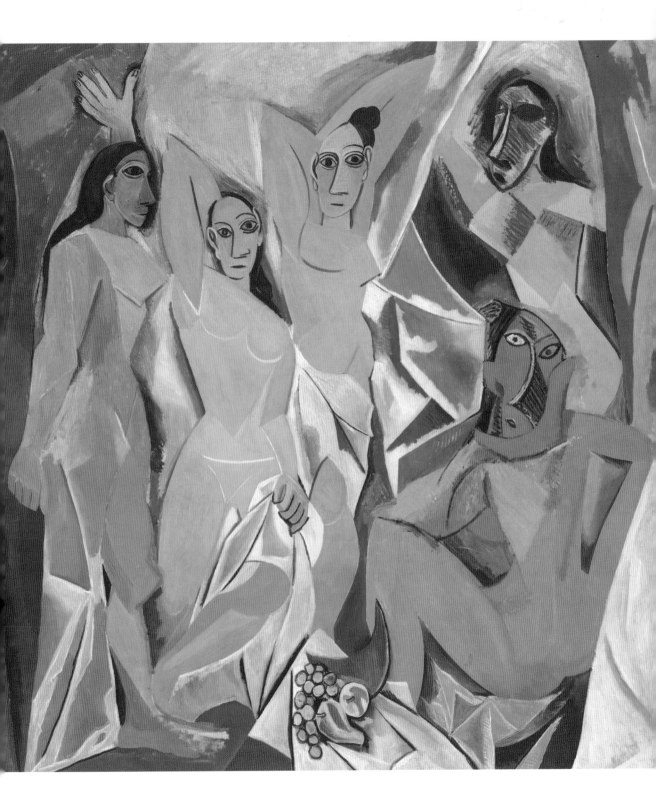

**Candlestick and
Playing Cards on a Table**

1910 OIL ON CANVAS

25 X 21 IN (65.1 X 54.3 CM)

METROPOLITAN MUSEUM OF ART, NEW YORK, US

In subdued tones, and from different viewpoints, thick, dark
structural lines contrast with a lighter application of paint. This is
one of Braque's first oval compositions. On the corner of a table
is the round base of a brass candlestick and on the right are two
playing cards—the ace of hearts and the six of diamonds.

Braque

1882–1963 • FAUVISM, CUBISM, SURREALISM

Initially interested in painting surface textures on still lifes, and in creating color and form on the surface of images, Georges Braque developed Cubism with Picasso. In the process, he helped to change the course of Western painting. He was one of the first artists to include decorators' techniques in paintings and introduced the idea of using unexpected materials in fine art.

Braque was born in Argenteuil, France, but grew up in Le Havre and trained to be a house painter and decorator like his father. He also took evening classes at the École des Beaux-Arts in Le Havre. After being awarded his decorator's certificate in 1902, he moved to Paris and studied in various art schools. Three years later, he visited the Salon d'Automne and adopted a freer approach inspired by the Fauves. After viewing Cézanne's memorial exhibition at the Salon d'Automne in 1907 and then meeting Picasso and seeing *Les Demoiselles d'Avignon*, he completely changed his style. He began experimenting with structure and perspective, following both Cézanne and Picasso's experiments.

Within two years, he and Picasso were working closely together, investigating multiple viewpoints, which they felt was an honest way of representing the world on two-dimensional surfaces. Braque and Picasso collaborated on their new approach to painting for more than five years. Braque's divided and reconstructed his subjects, arranging fragmented parts from varied angles on his canvases, employing low-key color harmonies. Like many others, the name given to their art was coined by a hostile critic. Cubism does not adequately describe the appearance of their work and diminishes the depth of their analysis.

By breaking up images, Braque countered the established traditions of visual illusion and representation. During the early phase of Cubism from 1909 to 1912, Braque's and Picasso's work was extremely similar. By 1911, when they painted together in the French Pyrenees, Analytic Cubism, as it came to be known, reached the peak of its expression, with splintered, geometric planes intersecting where objects were depicted from several views at once.

Braque then began to insert words and numbers and to use "trompe l'oeil" (literally, deceives the eye) effects that he had learned when training to be a decorator. In 1912, he and Picasso began to experiment with collage on their canvases, such as snippets cut from newspapers and magazines, and found objects, such as labels, theater tickets, and even bits of rope. This use of collage became known as Synthetic Cubism. In both Analytic and Synthetic Cubism, Braque's palette was deliberately subdued so as not to detract from explorations of structure and perspective. After World War I, Braque no longer worked with Picasso. He had fought with the French army and suffered a head wound. He continued with his Cubist work, curving more lines, adding sand to create textures, and softening his palette. The legacy of the Cubist Movement spread quickly throughout Paris and Europe.

> **KEY WORKS**
>
> **Viaduct at L'Estaque** 1908, MUSÉE NATIONAL D'ART MODERNE, CENTRE GEORGES POMPIDOU, PARIS, FRANCE
>
> **Violin and Candlestick** 1910, SAN FRANCISCO MUSEUM OF MODERN ART, SAN FRANCISCO, CALIFORNIA, US
>
> **The Portuguese** 1911, KUNSTMUSEUM BASEL, BASEL, SWITZERLAND
>
> **Woman with a Guitar** 1913, MUSÉE NATIONAL D'ART MODERNE, CENTRE GEORGES POMPIDOU, PARIS, FRANCE
>
> **Le Jour** 1929, NATIONAL GALLERY OF ART, WASHINGTON, DC, US

Modigliani

1884–1920 • EXPRESSIONISM, PRIMITIVISM

During a short and tragic life, Amedeo Clemente Modigliani formed his stylized, elongated figures in two and three dimensions through the influence of Cubism and African sculpture.

Born in Livorno, Italy, Modigliani was the fourth child of intellectual Jewish parents. His birth coincided with the collapse of his father's business. Growing up, he was often ill so his mother taught him at home. At 11 he became ill with pleurisy, and a few years later, he contracted typhoid fever. When he recovered, his mother took him to Florence and then enrolled him with the best painting master in Livorno: Guglielmo Micheli (1866–1926).

From the start, Modigliani excelled at painting nudes. Two years later, his studies were once again interrupted by an attack of pleurisy and then tuberculosis, from which he never entirely recovered. After his convalescence, his mother took him to Naples, Capri, Rome, and Amalfi, and then back north to Florence and Venice, where he was inspired by the work of Botticelli, Titian, and Domenico Morelli (1826–1901). In 1906, he moved to Paris and copied in galleries each day. He also became influenced by the work of Toulouse-Lautrec, Picasso (who was in his Blue Period), Cézanne, and Brancusi, who introduced him to primitive African sculpture. Having been exposed to erudite philosophical literature as a child by his grandfather, he continued to read and be influenced by the writings of Nietzsche, Baudelaire, Carducci, Comte de Lautréamont, and others, and developed the belief that the only route to true creativity was through defiance and disorder. Within a year of arriving in Paris, he had succumbed to alcoholism and drug addiction, and he destroyed nearly all of his early work.

At Brancusi's suggestion, he devoted himself mainly to stone-carving, but with the outbreak of World War I he could longer obtain materials and by 1915, he had turned exclusively to painting. His work focuses almost entirely on the female form and his style displays his enthusiasm for Brancusi and African sculpture. His faces are flat and elliptical, tilted on long necks and featuring almond-shaped eyes, long noses, and small mouths. Yet although these exaggerations occur in all his works, the individuality of each sitter is always recognizable. His palette was deliberately limited in order to emphasize his long, graceful, and rhythmic curves. In 1917, the only solo exhibition held during his lifetime was closed by the Parisian police for "indecency." By the age of 35, he was bitterly ashamed of his poverty and lack of success. He died from tuberculosis, combined with alcohol and drug abuse.

Anna Zborowska

1917 OIL ON CANVAS

51¼ x 32 IN (130.2 x 81.3 CM)

MUSEUM OF MODERN ART, NEW YORK, US

In this portrait of the wife of his patron, contrasting diagonals of her dress and right arm divide the background into three dynamic shapes that produce a shallow, flattened space. Her features are angular, elegant, and long, while her graceful curves balance the entire composition.

Beckmann

1884–1950 • EXPRESSIONISM, NEW OBJECTIVITY

Before World War I, avant-garde artists had gathered in
Germany. After 1918, more artists in Germany tried to come
to terms with the horrors they had experienced.

One of Germany's leading 20th-century artists, Max
Beckmann depicted the world around him with passion.
A versatile painter, draftsman, graphic artist, printmaker,
sculptor, and writer, he was born in Leipzig. At the age
of 19, he moved to Paris and became enthused by Gothic
painting. The following year, 1904, he settled in Berlin
and was awarded a scholarship to study in Florence.
Expressionism began to emerge just before 1914, and
Beckmann was interested in the ideas of expressing
personal emotions through art.

At the outbreak of war, he volunteered for the
medical corps, but after a nervous breakdown in 1915, he
settled in Frankfurt. He became concerned with truth,
the collapse of society, and hidden spiritual dimensions.
Exploring a variety of genres and subjects, he became
linked with the German Expressionist Movement,
Neue Sachlichkeit (New Objectivity), which reflected
the disillusionment of the postwar period, but his style,
which blended realism with imagination, was different
from others in that group. His narrative paintings warn
against vices and depict the poverty, corruption, and
hopelessness of his era. Further experiences of political
upheaval, the rise of Nazism and World War II, affected
his style as he tried to express his concerns for the
anguish and suffering taking place.

Although influenced by Expressionism and Cubism,
Beckmann refused to join any movement or group and
he continually responded to new artistic challenges
and ideas. Achieving prosperity and public recognition
between the wars, under the Nazi regime he was classified
as "degenerate" and fled to Amsterdam in 1937 where
he worked productively for ten years. After the war, he
moved to America for the last three years of his life.

KEY WORKS

The Descent from the Cross 1917, THE MUSEUM OF
MODERN ART, NEW YORK, US

The Night 1918–19, KUNSTSAMMLUNG NORDRHEIN-
WESTFALEN, DUSSELDORF, GERMANY

The Dream 1921, ST. LOUIS ART MUSEUM, MISSOURI, US

Self-Portrait in Tuxedo 1927, BUSCH-REISINGER MUSEUM,
HARVARD UNIVERSITY, CAMBRIDGE, MASSACHUSETTS, US

Temptation 1936–7, BAYERISCHE
STAATSGEMALDESAMMLUNGEN, MUNICH, GERMANY

Family Picture

1920 OIL ON CANVAS

25 X 39¾ IN (65.1 X 100.9 CM)

THE MUSEUM OF MODERN ART, NEW YORK, US

A wounded man clutches an instrument, holding out his hand for alms.
Three stages of life are represented: melancholic youth, despairing old
age, and newspaper-reading middle age. A woman titivates, but the
young men who might have appreciated her have all died in the war.

Rivera

1886–1957 • SOCIAL REALISM, MEXICAN MURALISM

The most celebrated figure in the revival of Mexican Muralism, Diego Rivera was also an active communist and the husband of artist Frida Kahlo—aspects of his life that became as famous as his contribution to modern art. His powerful social commentary on Mexican events made him a revered and influential artist.

Born in the silver mining town of Guanajuato City, Rivera came from a family descended from Spanish nobility. When he was ten, he began studying art at the Academy of San Carlos in Mexico City, but was expelled six years later for joining a student strike. He won a scholarship to study abroad and traveled to Europe in 1907. In France, he became enthralled by the work of the Fauves and Cézanne, but was especially taken with the naïve paintings of Henri Rousseau (1844–1910). He also became friends with Modigliani and his circle of avant-garde artists and writers. Picasso and Braque were producing their Cubist works and Rivera embraced some of their new ways of representing the world. After 1917, he became even more influenced by Cézanne and began simplifying his subjects and employing patches of vivid color.

In 1919, Rivera traveled to Italy where he studied Italian Renaissance frescoes. Two years later, he returned to Mexico and was the first of several artists to paint murals as part of an education program. He initially experimented with encaustic and then mastered fresco techniques. His murals reflect issues about Mexican society and the Mexican Revolution of 1910. His style derived from Rousseau, Cubism, and native Aztec influences, with large, simplified figures and bold colors. In 1922 he joined the Mexican Communist Party and the following year he began a second cycle of murals. His energy and determination was not always welcomed in his native country, but he attracted increasing attention abroad. In 1927, he was invited to Russia for the tenth anniversary celebrations of the Russian Revolution, but was soon ordered to leave because of his involvement in antiSoviet politics.

In 1929, Rivera was expelled from the Mexican Communist Party, married Frida Kahlo, and accepted a commission from the US ambassador to Mexico to paint murals in the Palace of Cortez in Cuernavaca. In November 1930, he went to America to begin work on his first two major US commissions: the American Stock Exchange Luncheon Club and the California School of Fine Arts. In 1931, a retrospective exhibition of his work was organized at the Museum of Modern Art in New York, and between 1932 and 1933 he completed 27 fresco panels in Detroit, Michigan. He returned to Mexico in 1933 and visited America for the last time in 1940, to paint a ten-panel mural for the Golden Gate International Exposition in San Francisco.

KEY WORKS

Night of the Rich 1928, NORTH WALL, COURTYARD OF THE FIESTAS, MINISTRY OF EDUCATION, MEXICO CITY, MEXICO

Detroit Industry 1932–3, DETROIT INSTITUTE OF ARTS, DETROIT, MI, US

The Flower Carrier 1935, SAN FRANCISCO MUSEUM OF MODERN ART, SAN FRANCISCO, CA, US

The Flower Vendor 1941, NORTON SIMON MUSEUM, PASADENA, CA, US

A Dream of a Sunday Afternoon in Alameda Park 1947–8, ALAMEDA HOTEL, MEXICO CITY, MEXICO

The Flowered Canoe

1931 OIL ON CANVAS

78¾ X 39 IN (200 X 100 CM)

MUSEO DOLORES OLMEDO PATIÑO, MEXICO CITY, MEXICO

Rivera and the Mexican Muralist Movement inspired US President Roosevelt's Works Progress Administration (WPA) program in depicting scenes of American life on public buildings. This vibrant, naïve-style work was painted by Rivera when he was in America, reflecting his memories of Mexico and demonstrating his love of color and sophisticated compositional techniques.

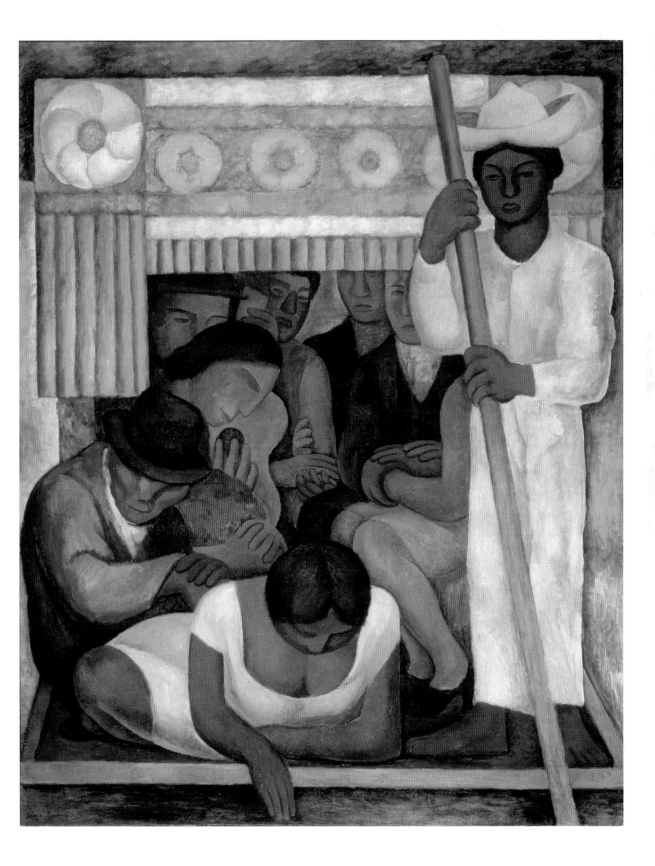

Duchamp

1887–1968 • DADA, SURREALISM

Although he participated in several movements and is linked with Dada and Surrealism, Marcel Duchamp was an individual artist who produced relatively few works. However, his original and fertile ideas have affected art and artists up to the present day. By advising art collectors, he also helped to shape contemporary artistic tastes.

The son of a notary, Duchamp was born near Rouen, France. Three of his siblings became artists: Raymond Duchamp-Villon (1876–1918), Suzanne Duchamp-Crotti (1889–1963), and Jacques Villon (1875–1963). At 17, Duchamp went to Paris. He enrolled at the Académie Julian, although he rarely attended classes. In 1905, he began compulsory military service, where he learned typography and printing processes. Three years later, he exhibited at the Salon d'Automne and the following year, at the Salon des Indépendants. He experimented with various styles, including Symbolism, Cubism, and Fauvism. In 1911, at his brother Jacques' home in Puteaux, he joined a discussion group with other artists and writers including Francis Picabia (1879–1953), Robert Delaunay (1885–1941), Léger (1881–1955), and Juan Gris (1887–1927). They were nicknamed the Puteaux Group and their paintings, focusing on visual sensations, became called Orphism or Orphic Cubism. Meanwhile, Duchamp experimented with methods of showing movement on canvas.

After 1913, Duchamp hardly used conventional artists' materials again. He exhibited his first ready-mades—manufactured everyday objects taken out of context to make viewers see them with fresh eyes. From 1915 until 1923 he lived mainly in New York, where he had become well-known. With Man Ray (1890–1976) and Picabia he formed a Dada group. Dada was a movement that started in neutral Switzerland and the US in response to the horrors of World War I. In questioning a society that allowed the war to happen, Dada defied accepted artistic traditions. It aimed to offend and to this end, at the exhibition of a new Society for Independent Artists in 1917, Duchamp submitted *Fountain*. It was a urinal and he turned it upside down and signed it with the pseudonym, R. Mutt. Two years later, he added a mustache, beard, and graffiti to a print of the *Mona Lisa*. During his time in New York, he worked on a composition called *The Bride Stripped Bare by Her Bachelors, Even* or *The Large Glass*, made of oil and varnish, glass, collage, and other materials. Never completed, the enigmatic work has been the subject of much interpretation and symbolizes many things, including dreams, wishes, and the unconscious.

From 1923, Duchamp lived once more in Paris, spending more time playing chess and writing about art than producing it. By 1942, he settled again in New York. There he helped to edit the Surrealist journal *VVV*, and organized a Surrealist exhibition. His witty, often irreverent legacy has inspired a vast number of subsequent artists and art movements.

Nude Descending a Staircase (No. 2)

1912 OIL ON CANVAS

57 X 35 IN (147 X 89.2 CM)

PHILADELPHIA MUSEUM OF ART, PHILADELPHIA, PA, US

When this work was shown at the Salon des Indépendants in Paris, it provoked criticism; the following year at the New York Armory Show, it scandalized the American public but made Duchamp instantly popular. The fragmented figure portrays action as she walks downstairs. As well as physical movement, the theme also represents the passage of time.

KEY WORKS

Transition of Virgin into a Bride 1912, THE MUSEUM OF MODERN ART, NEW YORK, US

In Advance of the Broken Arm 1915, YALE CENTER FOR BRITISH ART, NEW HAVEN, CT, US

The Bride Stripped Bare By Her Bachelors, Even or The Large Glass 1915–23, THE PHILADELPHIA MUSEUM OF ART, PHILADELPHIA, PA, US

Reproduction of L.H.O.O.Q. 1919, THE PHILADELPHIA MUSEUM OF ART, PHILADELPHIA, PA, US

O'Keeffe

1887–1986 • AMERICAN MODERNISM

A major figure in 20th-century American art, Georgia Totto O'Keeffe blended both the figurative and the abstract in her powerful paintings of flowers, buildings, bones, shells, and landscapes.

Born in Wisconsin on a dairy farm, O'Keeffe was the second of seven children. From an early age, her artistic talents became apparent, and from the age of 18, she studied at the Art Institute of Chicago and then at the Art Students' League in New York, under William Merritt Chase (1849–1916). In 1908, she won the William Merritt Chase still life prize: a scholarship to attend an outdoor summer school in New York, but declaring that she could never distinguish herself as a painter, she went to work in Chicago as a commercial artist. She did not paint for four years, claiming that the smell of turpentine made her sick. In 1912, however, she attended an art class at the University of Virginia Summer School, where she was introduced to the ideas of Arthur Wesley Dow (1857–1922) by Alon Bement (1876–1954). Essentially, this was that artists should express ideas and feelings through harmonious arrangements of line, color, and tonal contrasts.

From 1912 to 1914, she taught art in schools, and took classes from Dow himself at the Teachers' College of Columbia University from 1914 to 1915. For a few years, she worked as a teaching assistant to Bement and also taught at Columbia College in South Carolina, where she produced a series of unusual, innovative, flowing abstract charcoal drawings. When the internationally known photographer and modern art promoter Alfred Stieglitz (1864–1946) saw them, he planned an exhibition for her at his New York art gallery, 291. But when she learned that the exhibition was to take place without her permission, she went to 291 to complain. Stieglitz immediately offered her financial support to paint for a year in New York, which she accepted and left her teaching job. She and Stieglitz married in 1924 and she began producing numerous large-scale vibrant flower paintings and a series of New York buildings. But to stop critics from making Freudian interpretations of these works, she turned to different subjects and to painting more representationally.

She was soon recognized as one of America's most important artists, with an ability to capture flickering light, large and small structures, and delicate color gradations. After Stieglitz's death, she moved to New Mexico, where she depicted her surroundings with flowing lines and clear colors. She painted there from 1929 until 1984, when because of failing eyesight, she began working in clay rather than paint.

KEY WORKS

Music, Pink and Blue No. 2 1919, WHITNEY MUSEUM OF AMERICAN ART, NEW YORK, US

Orange and Red Streak 1919, THE PHILADELPHIA MUSEUM OF ART, PHILADELPHIA, PA, US

Black Iris III 1926, METROPOLITAN MUSEUM OF ART, NEW YORK, US

Oriental Poppies 1928, WEISMAN ART MUSEUM, UNIVERSITY OF MINNESOTA, MINNEAPOLIS, MN, US

New York, Night 1929, SHELDON MUSEUM OF ART, UNIVERSITY OF NEBRASKA ART GALLERIES, LINCOLN, NE, US

Patio with Cloud 1956, MILWAUKEE ART MUSEUM, MILWAUKEE, WI, US

Calla Lily Turned Away

1923 PASTEL ON CARDBOARD

14 X 11 IN (35.6 X 27.6 CM)

THE GEORGIA O'KEEFFE MUSEUM, SANTA FE, NM, US

From the time of her marriage, O'Keeffe began producing magnified still lifes of flowers. Fascinated by them, she produced over 200 flower paintings. The calla lily became a regular subject, which she painted in extreme close-up, cutting off the edges and emphasizing their curving contours.

Miró

1893–1983 • SURREALISM, AUTOMATISM

Closely associated with Surrealism, Joan Miró i Ferrà invented a vocabulary of signs and symbols to free the unconscious mind. His work subsequently influenced graphic design of the late 20th century.

The son of a goldsmith and clockmaker, Miró was born near Barcelona in Spain. He took drawing lessons from the age of seven, but later also took business classes while studying art at the Lonja School of Fine Art. After a brief period working as a book-keeper, he fell ill and while convalescing at his parents' farm in Catalonia, decided to devote himself to art.

For three years he studied at the Francisco Gali Academy in Barcelona, learning to integrate music and poetry into his art. Exhibitions of Impressionism, Fauvism, Primitivism, and Cubism also influenced his early paintings. In 1920, he moved to Paris, where he met Picasso and Braque. To begin with, he painted realistic scenes inspired by Catalonian landscapes and everyday objects, but incorporating symbolism in the pictures. Then he began emulating some of Picasso's and Braque's Cubist paintings. Later, after he had met Kandinsky and Klee, he invented a colorful floating world of shapes. As he featured fewer elements in his work, in an effort to create stronger and more immediate impact, he said: "Emptiness becomes increasingly important in my pictures." His work became full of dreamlike images—inspired by the hallucinations he had when he went to sleep hungry. In 1924, he met André Breton (1896–1966), Paul Éluard (1895–1952), and other Surrealists. The colorful shapes, flattened planes, and sharp lines he featured in his paintings suggest many different interpretations, but he rejected membership of the Surrealist group, even though Breton described him as "the most Surrealist of us all."

In giving his works bizarre titles, such as *Blue II, Daybreak or The Birth of the World*, he suggested even more ambiguous ideas. As a pioneer of automatism, he explored ways of expressing the subconscious, by painting and drawing "automatically," deliberately without conscious thought. These drawings or paintings are believed to reveal underlying feelings that would otherwise be inhibited or suppressed by the conscious mind. In the late 1920s, his work became increasingly abstract and organic, incorporating symbols and shapes that expressed his anxieties during the buildup to the Spanish Civil War. Until then, he had returned to Spain each summer, but the war prevented this. At that time, he began experimenting with collage, and after World War II he returned to Spain, working prolifically, producing ceramics, murals, tapestry design, and sculpture. His influence on postwar fine art and graphic design was immense.

Potato

1928 OIL ON CANVAS

39¾ x 32 IN (101 x 81.6 CM)

METROPOLITAN MUSEUM OF ART, NEW YORK, US

Drawing on automatism, whereby artists allowed their subconscious minds to take over, Miró developed a style that sprang from his own feelings. Here a billowing white female figure attached to a red post stretches her arms above a potato field, as various objects float by.

KEY WORKS

The Farm 1921–2, THE NATIONAL GALLERY OF ART, WASHINGTON, DC, US

The Tilled Field 1923–4, THE SOLOMON R. GUGGENHEIM MUSEUM, NEW YORK, US

Harlequin's Carnival 1924–5, ALBRIGHT-KNOX ART GALLERY, BUFFALO, NEW YORK, US

Dog Barking at the Moon 1926, THE PHILADELPHIA MUSEUM OF ART, PHILADELPHIA, PA, US

Composition 1933, KUNSTMUSEUM, BERN, SWITZERLAND

Magritte

1898–1967 • SURREALISM, MAGICAL REALISM

One of the most imitated artists, Belgian painter René Magritte was a leading exponent of Surrealism. His highly individual, witty, and thought-provoking images challenge viewers' preconceptions, making them reconsider the world around them. Apart from a brief, more painterly period during World World II, he always worked in a precise, prosaic manner and remained true to Surrealism.

Magritte was born in Lessines, in the province of Hainaut, Belgium. Little is known about his childhood, but he started drawing lessons at the age of 12. Two years later, his mother drowned herself in a nearby river. It is thought that Magritte's visions of his mother's body floating on the river with her dress obscuring her face influenced several of his paintings of people with cloth over their heads, although he always denied this.

From the age of 18, he studied at the Académie Royale des Beaux-Arts in Brussels. After graduating, he became a wallpaper designer and commercial artist, painting in his spare time in a Cubist-Futurist style. After 1920, he discovered the works of Giorgio de Chirico (1888–1978) who, from about 1915, had been painting menacing cityscapes, which he called the "pittura metafisica," meaning metaphysical art or dreamlike pictures. In 1925 Magritte assisted in the production of some Dadaist magazines with Jean Arp (1886–1966), Francis Picabia (1879–1953), Kurt Schwitters (1887–1948), Tristan Tzara (1896–1963), and Man Ray (1890–1976). In 1926 his individual style emerged, with his disconcerting paintings *The Lost Jockey* and *The Menaced Assassin*. In these he explored how paintings can create a sense of mystery. After a poor reception from his first solo exhibition in Brussels in 1927, Magritte moved to Paris and joined the Surrealists. Although the other Surrealists believed that Sigmund Freud's book *The Interpretation of Dreams* explained the subconscious mind, Magritte felt that psychoanalysis could never provide all the answers to the mysteries of the universe. His paintings were not dream narratives, but with their odd juxtapositions, they focused on the mystery of existence and developments of thoughts.

Magritte's painting style hardly changed. Using thick, smooth paint and clean lines, his work offers paradoxes—it looks real, but it is unreal at the same time. Exploring issues of visual perception and illusion, he used ambiguous or metaphorical symbols such as mirrors, eyes, windows, drapes, and pictures within pictures. In 1930, having made little impact in Paris, he returned to Brussels and to his advertising career, although he carried on painting in his spare time. During the German occupation of Belgium in World War II, he remained in Brussels and briefly adopted a more colorful, painterly style in opposition to the oppressive political situation. After the war, he produced forgeries of Picasso, Braque, and de Chirico paintings. At the end of 1948, he returned to his original prewar methodical and meticulous style. In 1965 he visited the US for a retrospective of his work.

KEY WORKS

The Reckless Sleeper 1927, TATE MODERN, LONDON, UK
La Durée Poignardée 1938, ART INSTITUTE OF CHICAGO, CHICAGO, IL, US
Perspective II: Manet's Balcony 1950, MUSEUM VAN HEDENDAAGSE KUNST, GHENT, BELGIUM
Gonconda 1953, THE MENIL COLLECTION, HOUSTON, TX, US
The Empire of Lights 1954, MUSÉES ROYAUX DES BEAUX-ARTS, BRUSSELS, BELGIUM

The Human Condition

1933 OIL ON CANVAS

39 X 31 IN (100 X 81 CM)

NATIONAL GALLERY OF ART, WASHINGTON, DC, US

Magritte painted several versions of an easel in front of a window. Here, the easel holds a canvas of a landscape that looks identical to the landscape outside. But the view outside the window is real, while the painting on the easel is a representation of that reality. Or are they both part of one illusion?

Giacometti

1901–1966 • SURREALISM, FORMALISM, EXPRESSIONISM

One of the many young artists who had gathered around Matisse and Picasso, Alberto Giacometti emerged as a major Surrealist sculptor in the 1920s. After World War II, he developed his sculpture, drawings, paintings, and printmaking into a unique and individual style. Giacometti's work has been particularly influential to artists and designers in the 21st century.

The son of a Postimpressionist painter, Giacometti was born in Borgonovo, near Stampa in Switzerland. He began to draw, paint, and sculpt at an early age and studied at the École des Beaux-Arts in Geneva from 1919. In 1921 he traveled to Italy, where he was impressed by the works of Alexander Archipenko (1887–1964) and Cézanne at the Venice Biennale. He was also profoundly moved by the works of Giotto and Tintoretto. In 1922, he settled in Paris. He first studied in Archipenko's studio and then with the sculptor Antoine Bourdelle (1861–1929). In 1927, he moved into a studio with his brother Diego, and exhibited his work in Paris. He also shared an exhibition with his father in Zurich.

The following year, Giacometti participated in another exhibition in Paris; the work sold immediately and the experience brought him into contact with the Surrealists. He befriended one of the group in particular, André Masson (1896–1987), and was taken on by the group's main art dealer, Pierre Loeb (1897–1964). By 1930, he had joined the Surrealist circle and worked with them until 1934, the same year that his first American solo exhibition opened in New York. His success continued and he mixed with other artists such as Miró and Picasso and writers including Paul Éluard and André Breton. He contributed articles and illustrations for Breton's magazine *Le Surréalisme au Service de la Révolution*.

Giacometti's early works had used the natural shapes of large stones to create figurative forms, but by the time he worked with the Surrealists, he was constructing figures out of various materials, basing his ideas on Cubism and Surrealism. Much of his work also showed the influence of the primitive African art he had seen at the Musée de l'Homme, an ethnographic museum that opened in Paris in 1937. In the late 1930s, he concentrated on pictorial and sculptural studies of the human figure, working directly from models, which was completely against the Surrealists' beliefs. During the early 1940s, he became friends with Jean-Paul Sartre (1905–80) and Simone de Beauvoir (1908–86). Consequently, he became the first sculptor to explore Existentialist ideas in his work. He spent World War II in Geneva and in 1946 he returned to Paris. This was the beginning of a new style in which his figures became elongated, slender, and fragile. After the 1950s, Giacometti received honors for his work and he continues to inspire and influence, but his figures still remain obscure and elusive.

Three Men Walking II

1949 BRONZE

30 X 13 X 12¾ IN (76.5 X 33 X 32.4 CM)

METROPOLITAN MUSEUM OF ART, NEW YORK, US

By 1947, Giacometti had adopted what was to become his characteristic style—long, thin figures in three main themes: walking man, standing woman, and the bust or head. His figures seem detached and isolated as they concentrate on their inner thoughts, stepping forward in equal distances, without looking at each other.

KEY WORKS

Hands Holding the Void 1934, YALE UNIVERSITY ART GALLERY, NEW HAVEN, CT, US

Man Pointing 1947, TATE MODERN, LONDON, UK

Figure in the Studio 1954, ART GALLERY OF NEW SOUTH WALES, SYDNEY, AUSTRALIA

Woman of Venice II 1956, METROPOLITAN MUSEUM OF ART, NEW YORK, US

Head of Diego 1958, PALM SPRINGS DESERT MUSEUM, PALM SPRINGS, CA, US

Rothko

1903–1970 • COLOR FIELD, NEW YORK SCHOOL, ABSTRACT EXPRESSIONISM

The Russian-born American painter Mark Rothko, born Marcus Rothkowitz, is usually classified as an Abstract Expressionist painter, although he rejected the label as he was more concerned with the investigation of meaning through his art. Inspired first by Joan Miró and the Surrealists, he later developed Color Field painting, saturating huge canvases with large blocks of solid color.

To avoid persecution in their homeland of Dvinsk in Russia, Rothko's Jewish family emigrated to Oregon in the US when he was ten years old. Extremely well educated, he could speak Russian, Yiddish, and Hebrew, but this only served to make him more conspicuously different from other boys of his age.

Rothko excelled at school and in 1921 he attended Yale University, where he studied English, French, European history, elementary mathematics, physics, biology, economics, the history of philosophy, and psychology. However, in 1923 he left Yale and moved to New York, where he attended the Art Students' League under the Expressionist painter Max Weber (1881–1961) for a short time. During the 1930s, he became influenced by Matisse, painting compositions comprising flat areas of color, and in 1935 he cofounded "The Ten," a group of artists who painted in Expressionist styles. He soon moved into a more Surrealistic phase inspired by Max Ernst (1891–1976) and Miró, but from about 1947, he began developing his distinctive mature style, abandoning any realistic representations and painting large, hazy-edged patches of color. His canvases were usually large and the colors appeared to float, emitting feelings of tranquillity. He said he was not an abstract artist and not interested in color relationships, but in expressing human emotions. He drew on his own inner feelings and said: "The people who weep before my pictures are having the same religious experience as I had when I painted them."

For most of his career, Rothko remained poor. He taught at the California School of Fine Arts in San Francisco over the summers of 1947 and 1949, and in the summer of 1948, he collaborated with artists including Clifford Still (1904–80), Robert Motherwell (1915–91), and Barnet Newman (1905–70) in running a New York art school called The Subjects of the Artist. He also taught in the art department at Brooklyn College from 1951 for three years. By that time, his reputation was growing and he was becoming successful. However, as an extremely intelligent and thoughtful man, he feared that his work was misunderstood. He suspected that people bought his paintings simply because they were fashionable and that the true purpose of his work—the expression of human emotions—was not being realized. By 1958, these expressions were becoming increasingly somber. He began replacing bright reds, yellows, and oranges with dark blues, browns, and maroons, and his last works were a series of monochromatic canvases. He committed suicide in his studio at the age of 67.

KEY WORKS

Untitled (Three Nudes) c.1926–35, NATIONAL GALLERY OF ART, WASHINGTON, DC, US

No. 3 / No. 13 1949, MUSEUM OF MODERN ART, NEW YORK, US

Untitled 1949, NATIONAL GALLERY OF ART, WASHINGTON, DC, US

Light Red over Black 1957, TATE MODERN, LONDON, UK

Black on Maroon 1959, TATE MODERN, LONDON, UK

No. 10

1950 OIL ON CANVAS

90¼ X 57 IN (229.2 X 146.4 CM)

THE MUSEUM OF MODERN ART, NEW YORK, US

With his canvases covered with color, Rothko became known as a Color Field painter, although he refused to adhere to any label. Color to him was "merely an instrument." In the early 1950s, he painted these soft-edged areas of yellow, aligned vertically against the blue ground. Such juxtapositions evoke various emotions in viewers when contemplating the work.

The Persistence of Memory

1931 OIL ON CANVAS

9½ X 13 IN (24.1 X 33 CM)

THE MUSEUM OF MODERN ART, NEW YORK, US

One of the most recognized Surrealist images, the landscape is of Dalí's native Catalonia. The distortions and juxtapositions are disturbing and threatening. The three limp watches, swarming ants, and fleshy distortion of Dalí's face in profile are full of erotic symbolism. His precise, smooth style depicts his own unrelenting and disturbing memories and plays on paranoia.

KEY WORKS

The Basket of Bread 1926, SALVADOR DALÍ MUSEUM, ST. PETERSBURG, FL, US

Lobster Telephone 1936, TATE MODERN, LONDON, UK

Metamorphosis of Narcissus 1937, TATE MODERN, LONDON, UK

The Endless Enigma 1938, MUSEO NACIONAL CENTRO DE ARTE REINA SOFIA, MADRID, SPAIN

Dream Caused by the Flight of a Bee around a Pomegranate, One Second before Awakening 1944, THYSSEN-BORNEMISZA COLLECTION, MADRID, SPAIN

Dalí

1904–1989 • SURREALISM, MAGICAL REALISM

Salvador Dalí was technically skilled and a relentless self-promoter. His art was personal and obsessive and its photographic realism appealed to the general public, making him one of the most well-known Surrealists. His personality, combined with his art's wide-reaching appeal, affected attitudes toward artists in society more than almost any other artist of his time.

Dalí's life and art cannot be separated. With excellent technical skills and a fertile imagination, he was also an outrageous, egotistical showman. Born in Figueres, Spain, his talent for drawing emerged early on, but at first his father, a prosperous notary, did not approve of his desire to pursue a career in art. However, through his mother's encouragement, his father built him a studio. In 1919, Dalí published articles on the old masters in a local magazine, showing his understanding of the theory and history of art. After the unexpected, and devastating, death of his mother when he was 17, Dalí attended the San Fernando Academy of Fine Arts in Madrid. In 1925, his father arranged his first one-man show in Barcelona.

Always interested in classical art, Dalí had been annoyed to find his teachers had concentrated only on Impressionist and Fauvist styles. Independently, he studied the techniques of Raphael, Bronzino, Vermeer, and Velázquez. He tried various stylistic directions, exploring a wide range of media, including painting, sculpture, film, graphic arts, photography, and theater work. Inspired by Miró and Picasso, he began developing a Surrealist style and in 1929, he joined the Surrealist group. His vivid imagination, attention to detail, illusionistic portrayals, and photographically realistic technique resulted in highly lifelike, often macabre, fantastic, and hallucinatory visions that he described as "hand-painted dream photographs."

Although he was expelled from the Surrealist Movement in 1934, Dalí continued to produce Surrealistic paintings and to promote himself outrageously. He produced objects, such as a telephone with a lobster as its receiver and a couch in the shape of actress Mae West's lips, and made several bizarre black-and-white movies. He never painted or portrayed reality. During World War II, Dalí lived in the US with his wife and muse, Gala, where he entered his "classic" phase, in which science and religion recur. Partly due to his provocative lifestyle and self-promotion and partly because of the popularity of his work, his fame continued to grow. He worked prolifically, creating advertising, clothing, stage sets, jewelry, and textiles as well as movies.

Kahlo

1907–1954 • PAINTINGS INSPIRED BY PRIMITIVISM,
SURREALISM, SYMBOLISM,
INDIGENOUS CULTURES

Linked to art movements such as Surrealism, Primitivism,
Magical Realism, and Naïve art, Frida Kahlo's work emerges
primarily from both the events of her life and her Mexican
heritage. Like many of the artists in this section, events in
her traumatic life shaped her work and the two are
inextricably linked.

One of four daughters born to a Hungarian-Jewish father and a Mexican mestizo
mother in a Mexico City suburb, Kahlo contracted polio at the age of six. This left
her right leg thinner than the left, and she grew up disguising the imbalance with
long, colorful skirts. During her childhood, she witnessed violent encounters in
the streets of Mexico City as part of the Mexican Revolution and at 15, she entered
medical school. Her training was abruptly ended three years later when a bus
accident left her a semi-invalid. Her spine, collarbone, and ribs were fractured, her
pelvis crushed, and her foot broken. She spent over a year recovering and underwent
more than 30 operations, but remained in constant pain for the rest of her life.

During her convalescence, to help alleviate the physical pain and psychological
scars, she began to draw and paint, using bright colors and a deliberately naïve
style. Consequently, most of her paintings were autobiographical in some way.
Themes she repeatedly included were her miscarriages, her operations, physical and
mental pain, and her Mexican heritage. In 1922, she met Mexico's most famous
artist, Diego Rivera, and after her recuperation, she took three of her paintings to
him for advice. He was 20 years older than her and already married to his second
wife, but they fell in love and were married in 1929. Their relationship survived
infidelities, divorce, and remarriage. Though a self-taught painter, Kahlo was well-
educated and her knowledge of art history was extensive. She particularly admired
the Renaissance masters and also incorporated elements of modern European
painting in many of her works. Encouraged by Rivera, she began to incorporate
elements of Mexican folk art in her work. She traveled with Rivera to the US
and France, where she met renowned artists and politicians and had her first solo
exhibition in New York in 1938, followed by another in Paris a year later. At 47,
she finally succumbed to the complications of her injuries, and posthumously,
has become something of a cult figure. Her original, poignant, and often bizarre
paintings have been regarded as emblems of her strength in refusing to let her
suffering crush her spirit.

KEY WORKS

Frida and Diego Rivera 1931, SAN FRANCISCO MUSEUM OF
MODERN ART, SAN FRANCISCO, CA, US

My Grandparents, My Parents, and I 1936, THE MUSEUM
OF MODERN ART, NEW YORK, US

Self-Portrait with Monkey 1938, ALBRIGHT-KNOX ART
GALLERY, BUFFALO, NEW YORK, US

The Two Fridas 1939, MUSEO DE ARTE MODERNO, MEXICO
CITY, MEXICO

Self-Portrait 1940, HARRY RANSOM HUMANITIES
RESEARCH CENTER, UNIVERSITY OF TEXAS, AUSTIN,
TX, US

The Bus

1929 OIL ON CANVAS

10 X 22 IN (26 X 56 CM)

DOLORES OLMEDO FOUNDATION, MEXICO CITY, MEXICO

Painted the year Kahlo and Rivera married, this work satirizes the
class divisions in Mexican society through travelers on a bus. They
include a lower-middle-class woman, a workman in blue overalls, a
mother with her baby and child, a capitalist with a bulging money bag,
and a fashionable young woman at the end of the seat.

Pollock

1912–1956 • ABSTRACT EXPRESSIONISM

Mingling European Modernism with liberal artistic developments in the US, Paul Jackson Pollock pervaded many of the contemporary painting movements and became a major Abstract Expressionist. During his lifetime, he became famous, although he was extremely reclusive and an alcoholic. His celebrated "drip" paintings were chiefly inspired by Surrealist automatism.

One of five brothers, Pollock was born in Wyoming, US, and grew up in Arizona and California. His father was a farmer and later a land surveyor, and as a boy, while on surveying trips with his father, Pollock became familiar with indigenous American culture. At the age of 18, he followed his brother Charles to New York, where they both joined the Art Students' League and were taught by the painter Thomas Hart Benton (1889–1975). Briefly during the 1930s, Pollock's work reflected Benton's, but his own ideas soon took over. A more lasting influence however, was Benton's persona as a hard drinker and within six years, Pollock was being treated for alcoholism.

In his early art, Pollock also showed influences of Mexican Muralism and Surrealism. The Depression years were extremely difficult for him and from 1935 he worked for the WPA Federal Art Project; a program that was created to employ out-of-work artists and to provide art for schools, hospitals, and libraries. When the project ended in 1942, Pollock's painting style developed from some representation to a completely abstract approach of swirling, colored lines. He first received critical attention when his paintings were shown in an exhibition in New York in 1943, alongside works by Picasso.

By 1945 Pollock began creating his most original and influential paintings of large, intricately interwoven patterns of spilled and spattered paint whose subject and expressive content became one and the same thing—the act of painting. Even his technique was unconventional. He spread a length of unprimed canvas on the floor and tacked it onto boards rather than stretching it over a frame on an easel. He said: "On the floor, I am more at ease. I feel nearer, more a part of the painting, since this way I can walk around it, work from the four sides and literally be in the painting." He abandoned brushes, splashing, or pouring the paint directly onto the canvas, as he wanted nothing to come between him and the work. He aimed to express his feelings rather than illustrate them—so his emotions would emerge as he applied the paint. In rejecting references to the outside world, viewers were free to interpret the works as they preferred. In 1945, he married the artist Lee Krasner (1908–84) who became an important influence. In 1956, he gained the nickname "Jack the Dripperr," and he achieved fame, or notoriety, but was deeply insecure and needed constant reassurance. Pollock's premature death in a car crash enhanced his image as one of the legends of modern art.

KEY WORKS

Male and Female 1942, PHILADELPHIA MUSEUM OF ART, PHILADELPHIA, PA, US

Blue (Moby Dick) c.1943, OHARA MUSEUM OF ART, KURASHIKI, JAPAN

Lavender Mist, Number 1 1950, NATIONAL GALLERY OF ART, WASHINGTON, DC, US

Autumn Rhythm 1950, METROPOLITAN MUSEUM OF ART, NEW YORK, USA

Blue Poles 1952, THE NATIONAL GALLERY OF ART, CANBERRA, AUSTRALIA

There were Seven in Eight

1945 OIL ON CANVAS

43 X 102 IN (109.2 X 259.1 CM)

THE MUSEUM OF MODERN ART, NEW YORK, US

This is one of Pollock's first Abstract Expressionist paintings. His process of painting became a ritual and an important part of the work. He dripped paint of different consistencies, concentrating on his own inner thoughts. His canvases have no focal areas and his palette is reduced, but as the paint is not blended, colors appear quite vibrant.

Lichtenstein

1923–1997 • POP ART

One of the best-known Pop artists, Roy Lichtenstein's distinctive, oversized comic book images exploited the postwar surge in mass-production, popular advertising, and comics in an ironic, bold style.

Lichtenstein was born in New York into an upper-middle-class American-Jewish family. Although he had been just as interested in jazz as in art, when he was 16, he enrolled for summer classes at the Art Students' League. The following year, in 1940, he began at the School of Fine Arts at Ohio State University, but his studies were interrupted by World War II, when he was drafted into the army from 1943 for three years. On his return, he graduated in 1946, and then worked as an art instructor. In 1949 he received a Master of Fine Arts degree from the Ohio State University and two years later, he had his first solo painting exhibition in New York and then moved to Cleveland. Although he stayed in Cleveland for six years, he traveled back to New York frequently.

Using various materials including enameled metal, brass, and plastics, he continued to produce his own artwork while also working occasionally as an engineering draftsman and a window dresser. At that time his painting style derived mainly from Abstract Expressionism, but also featured elements of Cubism and Expressionism. In 1960 he met several artists who were exploring new ideas based on popular culture, which made art more accessible to the general public. He became interested in this new "Pop art," and explored ways of expressing it. Then one day his son pointed to a Mickey Mouse comic and said, "I bet you can't paint as well as that." Rising to the challenge, in 1961 Lichtenstein painted several enlarged comic book characters with slight changes, derived from the appearance of commercial printing.

Gradually he developed his style, using dramatic compositions, bright blocks of color, Benday dots, lettering, and speech balloons. He said: "Art relates to perception, not nature." He did not stick to comic-book images however, but used the style to represent all kinds of subjects, including landscapes, Chinese-style imagery, figures, art of the past, and even Art Deco designs. Not restricting himself to painting, he even explored these same concepts in sculpture. Despite strong criticism at the time about his work being vacuous, soon critics began to see that he was not merely imitating subjects, but commenting on how the mass media portray them. His bold approach made him one of the leading figures of the Pop art movement and had a powerful influence on modern art and graphic design.

KEY WORKS

Girl with a Beach Ball 1961, THE MUSEUM OF MODERN ART, NEW YORK, US
Blam 1962, YALE UNIVERSITY, NEW HAVEN, CT, US
Takka Takka 1962, MUSEUM LUDWIG, COLOGNE, GERMANY
Whaam! 1963, TATE MODERN, LONDON, UK
Drowning Girl 1963, THE MUSEUM OF MODERN ART, NEW YORK, US

Thinking of Him

1963 MAGNA ON CANVAS

68 X 68 IN (172.7 X 172.7 CM)

YALE UNIVERSITY ART GALLERY, NEW HAVEN, CT, US

Lichtenstein studied the dynamic compositions of commercial and mass-produced comic strips and reproduced his own large, painted versions in precise, bold detail featuring dots that emulate printing techniques. This is a cheerful celebration of the sentimentality of many comic strip stories of the era.

Warhol

1928–1987 • POP ART

Originally a successful commercial artist, Andy Warhol was a leading Pop artist, who became internationally recognized as much for his flamboyant lifestyle as for his artwork.

Born Andrew Warhola in Pittsburgh, Pennsylvania, US, the third son of Czechoslovakian immigrants, at the age of nine Warhol contracted an unpleasant childhood illness which left him with some facial disfigurement. This made him quite nervous, detached from other children, and a hypochondriac.

He grew up drawing, listening to the radio, and collecting pictures of movie stars. At 14, he studied art appreciation and commercial art at Carnegie Institute of Technology in Pittsburgh.

In 1949, he moved to New York, where he dressed department store windows and worked as a commercial artist, designing magazines and advertisements. During the 1950s, he began producing loose, blotted-ink drawings of shoe advertisements, and after exhibiting these, RCA Records hired him to design album covers and promotional materials. Unusually, he began exploiting his commercial printmaking processes as fine art images. One of the elements of these processes was that he left in mistakes, so smudges, smears, and off-registered marks became a feature of his art.

In 1962, he had his first New York solo Pop art exhibition that included his *Marilyn Diptych*, *100 Soup Cans*, *100 Coke Bottle*, and *100 Dollar Bills*. These mass-produced images of things seen every day, such as Brillo pad boxes, Campbell's soup cans, comic strip characters, movie stars, and Coca-Cola bottles, presented as fine art, were accessible to the masses, reflected the era of consumerism he was living in, and announced that art was for everyone. Concurrently, he founded a studio, "The Factory," which became a meeting place for New York's avant-garde. There, he produced his art and short underground movies. In 1964, he took part in a New York exhibition, "The American Supermarket," that was presented as the interior of a typical American small store, except that everything in it was created by six Pop artists. Warhol's print of a can of Campbell's soup exhibited there cost $1,500 and each autographed can sold for $6.

The show triggered the question of what is art? Warhol was making the point that celebrity—whether a person or a brand—had replaced true values. His series, whether of Marilyn Monroe, dollar bills, or soup cans, were to point out the public's obsession with fame, branding, and society's excesses in a media-saturated culture. His ideas transformed art, its culture, the way it is made, and what is acceptable in the art world.

Marilyn

1967 SCREENPRINT (FROM A PORTFOLIO OF TEN)

36 x 36 IN (91.5 x 91.5 CM)

MUSEUM OF MODERN ART, NEW YORK, US

After her death in 1962, Warhol made more than 20 screenprint portraits with deliberate imperfections in the printing of Marilyn Monroe, based on a 1953 publicity photo. The media's focus on her since her death epitomized his views about the cult of celebrity.

KEY WORKS

Campbell's Soup Cans 1962, THE MUSEUM OF MODERN ART, NEW YORK CITY, NEW YORK, US

Marilyn Diptych 1962, TATE MODERN, LONDON, UK

Green Coca-Cola Bottles 1962, WHITNEY MUSEUM OF AMERICAN ART, NEW YORK, US

Elvis 1963, THE NATIONAL GALLERY OF ART, WASHINGTON, DC, US

Brillo Box 1964, TATE MODERN, LONDON, UK

Where to see, what to see

Around the world, there are countless places where you can see the most wonderful works of art. The locations might be large or small, public or private, secular or religious, unassuming, or overwhelming. So the following list is by no means comprehensive, nor is it in any particular order, but it is simply some of the most popular art galleries and museums in various countries, with just some of their collection highlights, to inspire you.

Musée du Louvre, Paris, France important works include: *Mona Lisa,* Leonardo da Vinci, 1503–19; *Portrait of Baltassare Castiglione,* Raphael, *c.*1514–15; *The Fortune Teller,* Caravaggio, *c.*1600; *The Lacemaker,* Vermeer, 1669–70; *Liberty Leading the People,* Delacroix, 1830; *The Raft of the Medusa,* Géricault, 1818–19; *The Wedding at Cana,* Veronese, 1563; *Et in Arcadia Ego,* Poussin, 1637–8; *St. Sebastian,* Mantegna, *c.*1431; *Grand Odalisque,* Ingres, 1814; *The Oath of the Horatii,* David, 1784; *Self-portrait,* Chardin, 1771.

The Metropolitan Museum of Art, New York, US important works include: *Ia Orana Maria,* Gauguin, 1891; *The Gulf Stream,* Homer, 1899; *The Merode Altarpiece,* Robert Campin (The Master of Flemalle), 1425–30; *The Musicians,* Caravaggio, *c.*1595; *View of Toledo,* El Greco, *c.*1604–14; *The Virgin and Child with Saint Anne,* Dürer, *c.*1519.

The National Gallery, London, UK important works include: *The Ambassadors,* Holbein, 1533; *Bacchus and Ariadne,* Titian, 1520–3; *Bathers at Asnières,* Seurat, 1884; *Samson and Delilah,* Rubens, *c.*1609–10; *The Sunflowers,* van Gogh, 1888; *The Arnolfini Portrait,* van Eyck, 1434; *The Baptism of Christ,* della Francesca, 1450; *The Virgin of the Rocks,* da Vinci, *c.*1491–1508; *Still Life: An Allegory of the Vanities of Human Life,* Steenwyck, *c.*1640; *The Agony in the Garden,* Mantegna, *c.*1455.

The Vatican Museums, Rome, Italy important works include: *The Sistine Chapel Ceiling,* Michelangelo, 1508–12; *The School of Athens,* Raphael, 1509; *The Deposition,* Caravaggio, *c.*1600–4; *Stefaneschi triptych,* Giotto, *c.*1320.

The State Hermitage Museum, St. Petersburg, Russia important works include: *Danaë,* Rembrandt, 1636; *The*

Stolen Kiss, Fragonard, *c.*1780; *The Lunch,* Velázquez, 1617; *The Dance,* Matisse, 1910.

Galleria degli Uffizi, Florence, Italy important works include: *Madonna and Child with Angels,* Filippo Lippi, *c.*1465; *The Birth of Venus,* Botticelli, 1486; *Doni Tondo,* Michelangelo, 1506–7; *Judith Slaying Holofernes,* Gentileschi, *c.*1611–12; *Adoration of the Magi,* Leonardo da Vinci, 1481; *Santa Trinità Maestà,* Cimabue, 1280–90.

Museo Nacional del Prado, Madrid, Spain important works include: *The Third of May, 1808;* Goya, 1814; *Las Meninas,* Velázquez, 1656; *The Fall of Man,* Titian, *c.*1570; *Artemisia,* Rembrandt, 1634; *The Three Graces,* Rubens, *c.*1635.

Rijksmuseum, Amsterdam, The Netherlands important works include: *The Nightwatch,* Rembrandt, 1642; *The Milkmaid,* Vermeer, *c.*1660; *Self-Portrait,* Rembrandt, 1629; *Interior with Women beside a Linen Cupboard,* de Hooch, 1663; *Self-Portrait,* van Gogh, 1887.

Kunsthistorisches Museum, Vienna, Austria important works include: *The Tower of Babel,* Brueghel, 1563; *Infanta Margarita Teresa in a Blue Dress,* Velázquez, 1659; *Madonna of the Meadow,* Raphael, 1506; *The Art of Painting,* Vermeer, 1665–6; *Susannah and the Elders,* Tintoretto, 1560–2.

National Gallery of Art, Washington DC, USA important works include: *Portrait of a Lady,* van der Weyden, *c.*1460; *The Assumption of the Virgin,* Poussin, *c.*1626; *The Plum,* Manet, 1878; *The Artist's Garden at Vetheuil,* Monet, 1880; *Open Window Collioure,* Matisse, 1905; *The Family of Saltimbanques,* Picasso, 1905; *The Railway,* Manet, 1872; *The Loge,* Cassatt, 1882; *Symphony in White No. 1, the White Girl,* Whistler, 1862.

Musée d'Orsay, Paris, France important works include: *Bal du Moulin de la Galette,* Renoir, 1876; *Le Déjeuner sur l'Herbe,* Manet, 1862–3; *The Artist's Studio,* Courbet, 1855; *The Card Players,* Cézanne, 1894–5; *Olympia,* Manet, 1863; *The Gleaners,* Millet, 1857; *Whistler's Mother,* Whistler, 1871; *The Church at Auvers,* van Gogh, 1890; *Apples and Oranges,* Cézanne, *c.*1899; *Orpheus,* Moreau, 1866.

The National Museum of Western Art, Tokyo, Japan important works include: *Parisiennes in Algerian*

Costume, Renoir, 1872; *Conversation,* Pissarro, *c.*1881; *On the Boat,* Monet, 1887; *The Loving Cup,* Rossetti, 1867; *Salome at the Prison,* Moreau, *c.*1873–6.

Tate Britain, London, UK important works include: *Ophelia,* Millais, 1851–2; *Steamboat off a Harbor's Mouth,* Turner, exh. 1842; *The Awakening Conscience,* Hunt, 1853; *Flatford Mill (Scene on a Navigable River),* Constable, 1816–17; *O the Roast Beef of Old England (The Gate of Calais),* Hogarth, 1748.

Van Gogh Museum, Amsterdam, The Netherlands important works include: *The Bedroom,* van Gogh, 1888; *Wheatfield with Crows,* van Gogh, 1890; *Still Life with Bible,* van Gogh, 1885; *The Potato Eaters,* van Gogh, 1885; *The Pink Peach Tree,* van Gogh, 1888.

Museum of Modern Art, New York, US important works include: *Man with a Guitar,* Braque, 1911–12; *The Starry Night,* van Gogh, 1889; *Les Demoiselles d'Avignon,* Picasso, 1907; *Broadway Boogie-Woogie,* Mondrian, 1942–3; *The Dance,* Matisse, 1909; *Campbell's Soup Cans,* Warhol, 1962; *Number 31,* Pollock, 1950; *Bather,* Cézanne, 1885–7; *Portrait of Juan Gris,* Modigliani, 1915; *The Empire of Light,* Magritte, *c.*1950–4.

Tate Modern, London, UK important works include: *The Snail,* Matisse, 1953; *Weeping Woman,* Picasso, 1937; *Marilyn Diptych,* Warhol, 1962; *Metamorphosis of Narcissus,* Dalí, 1937; *Summertime Number 9A,* Pollock, 1948; *Composition with Yellow, Blue, and Red,* Mondrian, 1937–42; *The Sick Child,* Munch, 1907; *Red on Maroon,* Rothko, 1959; *The Three Dancers,* Picasso, 1925; *Cossacks,* Kandinsky, 1910–11; *Swinging,* Kandinsky, 1925; *The Kiss,* Rodin, 1901–4.

The Courtauld Museum, London, UK important works include: *A Bar at the Folies Bergère,* Manet, 1882; *Two Dancers on a Stage,* Degas, *c.*1874; *Mont Sainte-Victoire,* Cézanne, *c.*1887; *Nevermore,* Gauguin, 1897; *La Loge,* Renoir, 1874; *Self-Portrait with Bandaged Ear,* van Gogh, 1889.

Philadelphia Museum of Art, Pennsylvania, US important works include: *The Burning of the Houses of Lords and Commons,* Turner, 1835; *The Dance at the Moulin Rouge,* Toulouse-Lautrec, 1889–90; *The Large Bathers,* Renoir, 1887; *Nude Descending a Staircase,* Duchamp, 1912; *Japanese Bridge and Waterlilies,* Monet, *c.*1899; *The Bathers,* Cézanne, 1898–1905; *Prometheus Bound,* Rubens, 1611–12; *Pietà,* El Greco, 1571–6; *Epiphany,* Bosch, *c.*1475–80.

The Frick Collection, New York, US important works include: *St. Francis in the Desert,* Giovanni Bellini, *c.*1475–8; *The Four Seasons,* Boucher, 1755; *The White Horse,* Constable, 1819; *The Pond,* Corot, *c.*1868–70; *St. John the Evangelist,* della Francesca, *c.*1454–69; *The Forge,* Goya, *c.*1815–20; *Purification of the Temple,* El Greco, *c.*1600; *Comtesse d'Haussonville,* Ingres, 1845; *Woman Sewing by Lamplight,* Millet, 1870–2; *Elizabeth, Lady Taylor,* Reynolds, *c.*1780; *Fishing Boats Entering Calais Harbor,* Turner, *c.*1803; *Virgin and Child with Saints and a Donor,* van Eyck, early 1440s.

Alte Pinakothek, Munich, Germany important works include: *Columba Altarpiece,* van der Weyden, *c.*1455; *Self-Portrait with Fur Trimmed Robe,* Dürer, 1500; *Mars and Venus Surprised by Vulcan,* Tintoretto, *c.*1555; *The Canigiani Holy Family,* Raphael, *c.*1505–6; *Susanna and the Elders,* van Dyck, *c.*1622–3; *Entombment of Christ,* Fra Angelico, *c.*1438–40.

The Wallace Collection, London, UK important works include: *The Swing,* Fragonard, 1767; *The Laughing Cavalier,* Hals, 1624; *Madame de Pompadour,* Boucher, 1759; *Voulez-vous triompher des Belles?* Watteau, *c.*1714–17; *Venice: the Grand Canal from the Palazzo Flangini to San Marcuola,* Canaletto, *c.*1740–50; *The Lady with a Fan,* Velázquez, *c.*1640; *Titus, the Artist's Son,* Rembrandt, *c.*1657.

The Art Institute of Chicago, Chicago, US important works include: *The Bath,* Cassatt, 1891–2; *Fête Champêtre,* Watteau, 1718–21; *Seascape, Calm Weather,* Manet, 1864–5; *Two Sisters (On the Terrace),* Renoir, 1881; *The Bay of Marseilles, view from L'Estaque,* Cézanne, 1885; *Sunday Afternoon on the Island of La Grande Jatte,* Seurat, 1884–6; *At the Moulin Rouge,* Toulouse-Lautrec, 1892; *Why are you angry? (No te aha oe Riri),* Gauguin, 1896; *The Old Guitarist,* Picasso, 1903; *Painterly Realism of a Football Player—Color Masses in the 4th Dimension,* Malevich, 1915.

The Solomon R. Guggenheim Museum, New York, US important works include: *Red Balloon,* Klee, 1922; *The Tilled Field,* Miró, 1923–4; *Composition 8,* Kandinsky, 1923; *Nude,* Modigliani, 1917; *Accordionist,* Picasso, 1911; *Still Life, Flask, Glass, and Jug,* Cézanne, *c.*1877; *Le Moulin de la Galette,* Picasso, 1900; *The Hermitage at Pontoise,* Pissarro, *c.*1867.

Glossary

Abstract art that does not represent anything from the real world, but instead explores shapes, forms, and colors.

Academic art a style of painting and sculpture approved by the traditional European academies of art, particularly the French Académie des Beaux-Arts in the 19th century, which favored a blend of the styles of Neoclassicism and Romanticism.

Academy an official art school or place of training.

Allegory a story or image that contains a hidden meaning or meanings, usually moral or political.

Altarpiece an area where a deity or saints are worshipped.

Antiquity a term generally meaning the ancient Greek and Roman periods, from approximately 2 BCE to 500 CE.

Assumption in art this usually means the Assumption of the Virgin Mary, which, according to the Roman Catholic Church, Eastern Orthodoxy, Oriental Orthodoxy, and parts of Anglicanism, was when Christ's mother was taken up into heaven at the end of her earthly life.

Automatism the process of creating art without conscious thought, to work with the unconscious or subconscious mind to reveal hidden or unknown thoughts and ideas.

Avant-garde meaning cutting edge or forefront, this is used to describe artists who are unconventional, forward-thinking, innovative, experimental, and inventive.

Bauhaus a German school of art, design, and architecture founded in 1919, with a curriculum that aimed to amalgamate artistic creativity and manufacturing that had been virtually eradicated by mass production.

Benday dots colored dots of equal size named after their inventor, the illustrator and printer Benjamin Henry Day Jr (1838–1916). Depending on the effect required, the dots are closely or widely spaced or overlapping.

Canvas strong, coarse unbleached cloth made from hemp, flax, or cotton, usually stretched over a wooden frame and primed before being painted on.

Chiaroscuro an Italian term that describes the use of dramatic light and dark tones.

Classical designs or images that are influenced by ancient Greek or Roman forms, art, or principles.

Collage a form of art in which pieces of paper, fabric, and other materials are arranged and stuck onto a supporting surface. It was first used as an artists' technique in the early 20th century.

Commission an order or request for works of art to be made.

Complementary colors colors located opposite each other on the color wheel. They are: red-green, blue-orange, and yellow-violet. When mixed together, complementary colors create brown, and when placed next to each other, they make each other appear brighter.

Composition the arrangement of elements within a work of art.

Consumerism a preoccupation with and an inclination toward wanting and buying goods.

Contour lines that represent the outlines of figures or forms.

Dante Dante Alighieri (1265–1321), was born in Florence, a contemporary of Giotto and the first major poet to write in his local language of Tuscan instead of Latin. His most famous work is *The Divine Comedy*, which is divided into three books, *Inferno*, *Purgatorio*, and *Paradiso*. It has been illustrated many times by numerous artists.

Figurative in art, a work that retains strong references to the real world and particularly to the human form. More generally, figurative also applies retrospectively to all art before abstract art.

Focal point the center of interest or focus in a work of art.

Foreshortening an object in a work of art seen in perspective from close to the viewpoint so that it appears dramatically distorted.

Found objects often functional and manufactured, or naturally occurring objects that were not originally intended for artistic purposes, but have been used in an artistic context.

Fresco wall painting made on plaster. Buon fresco is made while the plaster is still wet so the image becomes part of the wall as it dries, fresco secco is made while the plaster is dry and so is less permanent.

Genre in painting, this usually means "a scene of everyday life" and generally features a person or people undertaking activities that are often quite commonplace.

Gesso mixture of plaster and glue, used to create a smooth surface for painting on.

Glaze generally meaning a thin, transparent layer of paint, often applied in several layers, to build up depth and modify colors in a painting.

Grand Tour during the 18th century, the Grand Tour became an essential part of the education of prosperous young men and some young women. It developed through an admiration of the past, especially ancient Greece, Rome, and the Italian Renaissance, and involved a long tour of certain parts of Europe.

Ground a coating applied to a support, such as canvas or panel, to make it ready for painting. Grounding, or priming as it is also called today, is a method of creating a smooth surface that can be easily painted on.

Guild an association of people of the same trade or profession, formed to protect their mutual interests and to maintain standards within their occupations.

Idealized, idealization the representation of objects and figures according to perfect standards of beauty rather than reality.

Impasto an Italian word for paste or mixture, this is used to describe a painting technique where paint (usually oil) is applied thickly, so that the texture of marks from the brush or palette knife are clearly visible.

Juxtaposition placing objects close together or side by side for comparison or contrast.

Manifesto a public declaration of a group or an individual's principles, beliefs, and intentions.

Mosaic a picture made up of small pieces. Traditionally these were made of terracotta, glass, ceramics, or marble and used to decorate floors and walls. Mosaic has been a decorative medium for over 5000 years.

Narrative this describes art that tells stories, such as religion, myth, legend, history, or literature. Some of the earliest art was narrative.

Opaque the opposite of transparent; impenetrable, or not able to be seen through.

Painterly a style of painting marked by its freedom and visible brush marks.

Palette either the board or surface on which an artist lays and mixes colors, or the range of colors used by an artist or in a particular work of art.

Patron someone who commissions or buys art from an artist.

Perspective a technique for representing objects in the visible world on a two-dimensional surface, to create illusions of depth and distance. Invented in Italy in the early 15th century, linear perspective relies on the notion that objects appear smaller the further away they are. Aerial or atmospheric perspective is a technique for creating an illusion of distance by using more blue, less brightness, and no distinct outlines.

Pigment usually powder, that makes up the color of paint when mixed with oil, water, or another fluid.

Popular culture cultural activities, ideas, or products that reflect the tastes of the general population within any society.

Relief an image that has elements raised from the flat base. Bas relief is low relief, when design elements are barely more prominent than the flat background. High relief is when design elements are boldly projected from the background.

Sacra Conversazione from the Italian meaning "holy conversation," this is applied to any altarpiece featuring saints grouped around the central Virgin and Child in a single panel.

Sfumato a blending of colors to make gradual tonal modulations, that looks blurred and smoky.

Subconscious/unconscious the part of the mind below the level of conscious perception.

Tempera a type of paint in which pigment is mixed with a water-soluble binder, such as egg yolk. Used since antiquity, most early Italian paintings were made with egg tempera.

Tone the lightness or darkness of a color or shadow. The term came into widespread use during the 19th century with the rise of painting directly in the open air.

Translucent semitransparent; allowing some light through.

Triptych a painting made up of three sections, usually a central panel with two side panels attached each side.

Index

A

Abstract Expressionism 115, 178, 206, 212
Abstraction 174, 181, 182, 185, 186
Academic art 106–107
Aestheticism 146
An Allegory of the Vanities of Human Life (Steenwyck) 80–81
The Ambassadors (Holbein) 48
American art 149, 198, 206, 212
American Revolutionary War 87
The Ancient of Days (Blake) 109
Anna Zborowska (Modigliani) 191
The Annunciation (Fra Angelico) 15
Archipenko, Alexander 182, 205
The Arnolfini Portrait (van Eyck) 16
Arrangement in Gray and Black, No 1 or The Artist's Mother (Whistler) 147
Art Nouveau 111, 146, 166, 170
Automatism 201

B

Bacchus and Ariadne (Titian) 47
The Baptism of Christ (Piero della Francesca) 24
Bar at the Folies-Bergère (Manet) 142–143
Barbizon School 107, 122, 129, 138
Baroque 58–75, 76–85
Bathers at Asnières (Seurat) 164–165
The Battle of San Romano (Uccello) 18–19
Bauhaus 174, 185
Bazille, Frédéric 139, 153
Beckmann, Max 169, 191–193
Bellini, Giovanni 9, 26–27, 29, 37, 46
Belshazzar's Feast (Rembrandt) 79
Bernini, Gian Lorenzo 58, 59
Birds in Space (Brancusi) 180
The Birth of Venus (Botticelli) 30–31
Blake, William 106, 108–109
The Blue Four 174, 185
The Blue Rider 174, 185
bodegones 71
Bonfire of the Vanities 30
Bonnat, Léon 166, 173
Bosch, Hieronymus 9, 34–35
Botticelli, Sandro 9, 30–31
Boucher, François 86, 87, 94–95, 101, 105

Boulevard Montmartre at Night (Pissarro) 141
Brancusi, Constantin 169, 180–181, 190
Braque, Georges 168, 186, 188–189
Bronzino 36, 50–51
Bruegel, Pieter, the Elder 37, 54–55
Brunelleschi, Fillipo 8, 14, 22
The Bus (Kahlo) 210–211
Byzantine art 8, 10–11, 60

C

Calais Pier (Turner) 114–115
Calla Lily Turned Away (O'Keeffe) 198
camera obscura 84, 91
Campin, Robert 8, 21
Canaletto 86, 90–91
Candlestick and Playing Cards on a Table (Braque) 188
Canova, Antonio 87, 106
Caravaggio 58, 59, 62–63, 67
Card players in an Opulent Interior (Hooch) 82–83
Caroto, Giovanni Francesco 57
Cassatt, Mary 138, 158–159
Cézanne, Paul 139, 140, 150–151
Chardin, Jean-Baptiste 86, 87, 93, 101
Charles I at the Hunt (van Dyck) 73
chiaroscuro 63, 67, 71
The Child's Bath (Cassatt) 159
chinoiserie 89
Christ Driving the Traders from the Temple (El Greco) 60–61
Cimabue 8, 9, 10
Classicism 68
Claude Lorrain 59, 74–75
Cloisonnism 160
Color Field 206
Composition with Yellow, Blue, and Red (Mondrian) 179
Constable, John 106, 116–117
Coronation of the Virgin (Velázquez) 70
Corot, Jean-Baptiste Camille 107, 122–123, 140
Counter-Reformation 58, 60
Courbet, Gustave 107, 129, 130–131, 138, 140
Couture, Thomas 142, 159
Coypel, Charles-Antoine 86
Cubism 178, 182, 186–189

D

Dada 197
Dalí, Salvador 169, 208–209
The Dance Class (Degas) 145
David (Donatello) 14

David, Jacques-Louis 87, 104–105, 119
de Kooning, Willem 169
de la Tour, Maurice Quentin 86
De Stijl 178
The Dead Christ between the Virgin and Mary Magdalene (Bronzino) 50–51
The Death of Marat (David) 104
The Death of Sardanapalus (Delacroix) 127
Degas, Edgar 138, 139, 144–145, 159
Delacroix, Eugène 46, 106, 126–127
Derain, André 168, 177
The Descent from the Cross / The Deposition (Weyden) 20
Divisionism 164
Donatello 8, 9, 14
Duccio 8, 9, 11
Duchamp, Marcel 168, 196–197
Dürer, Albrecht 36, 40–41

E

Eakins, Thomas 138
El Greco 58, 60–61
The Embarkation of the Queen of Sheba (Claude) 74–75
engravings 40, 54
Enlightenment 87, 106
Et in Arcadia Ego (Poussin) 68–69
Expressionism 163, 172–177, 184–187, 190–193, 205
The Expulsion from Paradise (Michelangelo) 42–43

F

Family Picture (Beckmann) 192–193
Fauvism 177, 189
Flatford Mill (Constable) 117
Flemish School 17, 21, 54, 59, 64, 72
Florentine School 22, 30, 32, 37, 38
The Flowered Canoe (Rivera) 195
Formalism 205
Fra Angelico 9, 15, 21
Fra Filippo Lippi 15, 30
Fragonard, Jean-Honoré 87, 100–101
French Revolution 87, 105, 108
fresco 12, 15, 22, 25, 29, 30, 32
Friedrich, Caspar David 106, 112–113

G

Gainsborough, Thomas 72, 86, 98–99
The Garden of Earthly Delights (Bosch) 34

Gauguin, Paul 139, 160–161, 163
Gentileschi, Artemisia 58, 66–67
Géricault, Théodore 106, 120–121
Gersaint's Shop sign (Watteau) 88–89
Ghiberti, Lorenzo 14, 18
Ghirlandaio 9, 32–33
Giacometti, Alberto 169, 204–205
Giorgione 26, 46
Giotto 8, 9, 10, 12–13
Girl with a Pearl Earring (Vermeer) 85
The Gleaners (Millet) 128
Gleyre, Charles-Gabriel 146, 153, 157
Gothic art 8, 10–11, 18, 35
Goya, Francisco de 87, 102–103
The Great Wave off Kanagawa (Hokusai) 110–111
Guardi, Francesco 86
Guarini 59
Guérin, Pierre-Narcisse 120, 126
guild system 8, 18, 72, 84
Guillaumin, Armand 139, 140
The Gulf Stream (Homer) 148–149

H

Hardouin-Mansart, Jules 59
High Renaissance 36–49, 54–57
Hiroshige, Ando 106, 124–125
Hogarth, William 86, 92, 98
Hokusai, Katsushika 106, 110–111
Holbein, Hans, the Younger 36, 48–49
The Holy Trinity with the Virgin, St. John, and Two Donors (Masaccio) 23
Homer, Winslow 139, 148–149
Hooch, Pieter de 77, 82–83, 84
The Human Condition (Magritte) 203
Hunt, William Holman 134, 137

I

Impressionism 84, 111, 115, 138–141, 145, 150–153, 157–159, 168
Improvisation 11 (Kandinsky) 175
Industrial Revolution 106
Ingres, Jean Auguste Dominique 87, 105, 106, 118–119, 126
interior painting 77, 83, 84

J

Japanese art 111, 125, 139, 146
John Parker and his sister Theresa (Reynolds) 96